MANET'S CONTEMPLATION

AT THE GARE SAINT-LAZARE

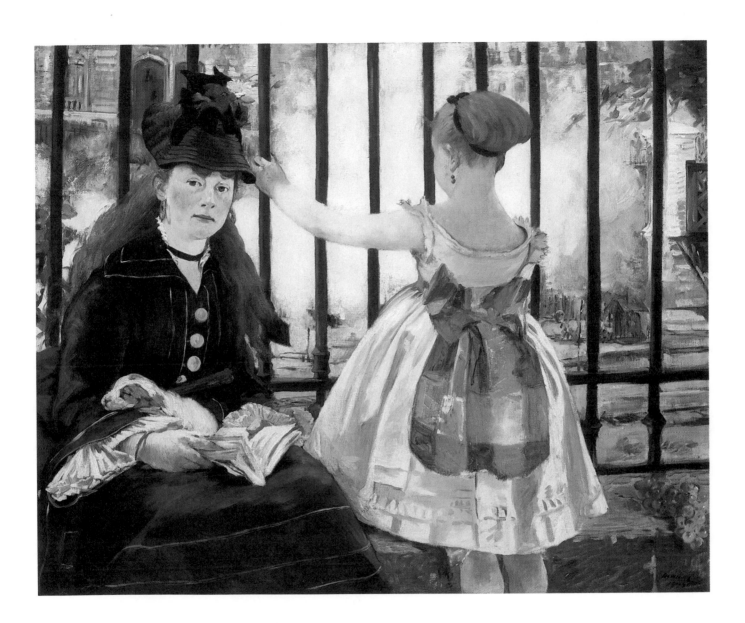

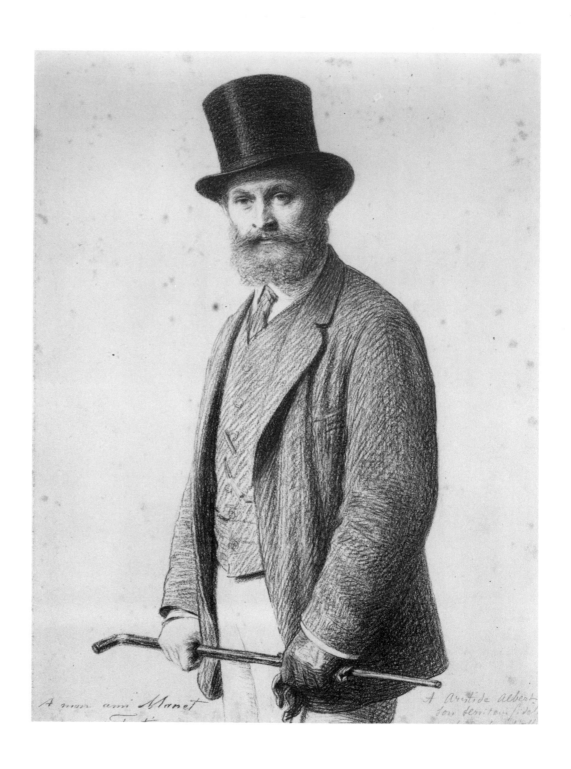

A mon ami Manet A Aristide Albert
 Fantin son serviteur fidèle

MANET'S CONTEMPLATION
AT THE
GARE SAINT-LAZARE

Harry Rand

UNIVERSITY OF CALIFORNIA PRESS
Berkeley Los Angeles London

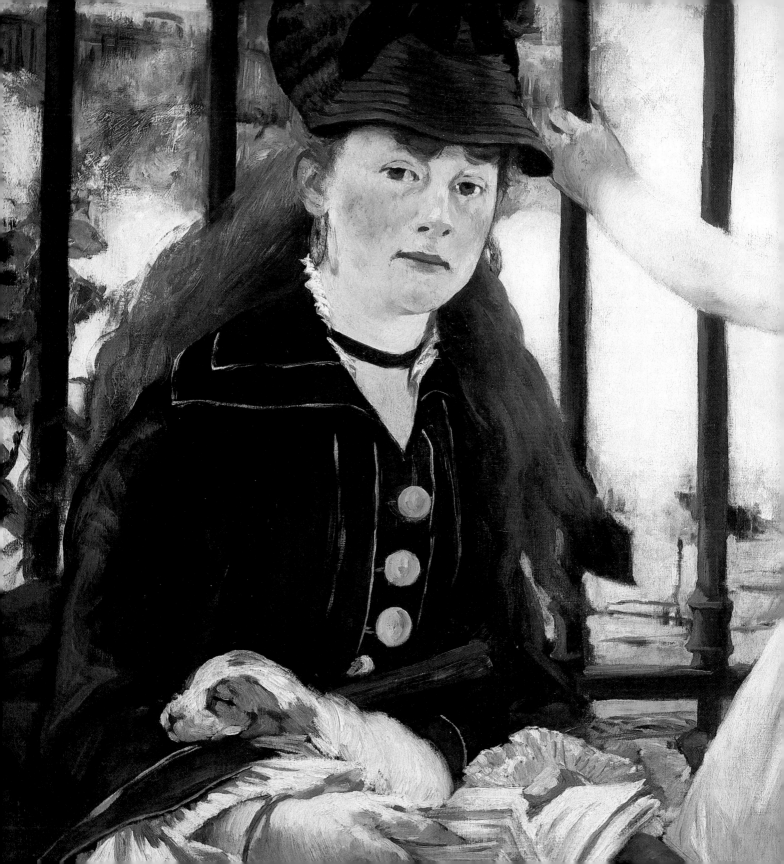

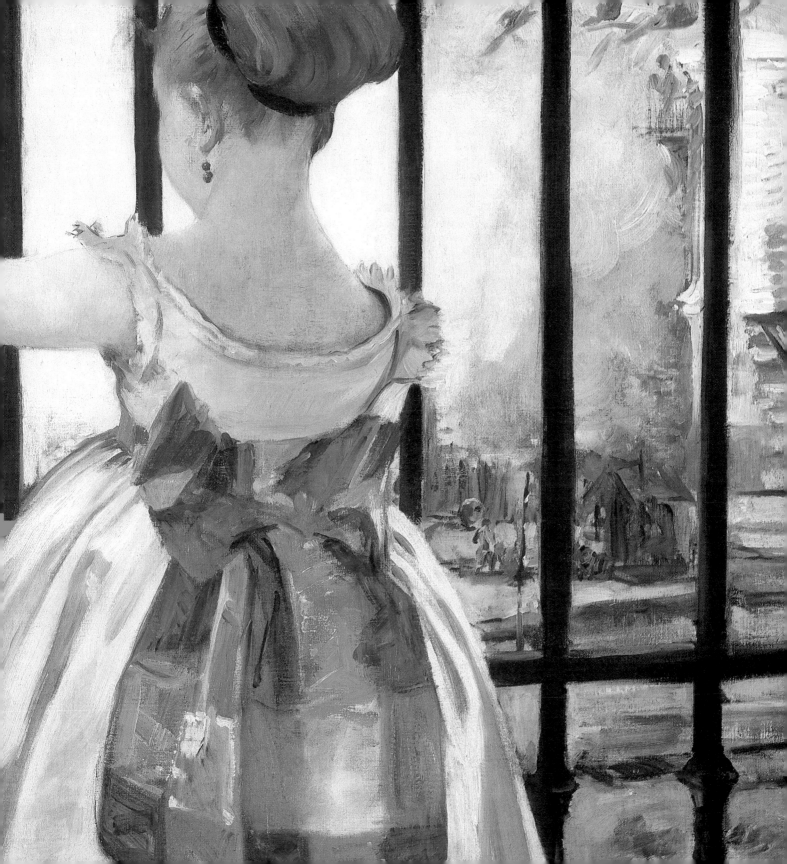

The publishers wish to acknowledge with gratitude the contribution provided from the Art Book Fund of the Associates of the University of California Press, which is supported by a major gift from the Ahmanson Foundation.

UNIVERSITY OF CALIFORNIA PRESS
Berkeley and Los Angeles, California

UNIVERSITY OF CALIFORNIA PRESS, LTD.
London, England

Library of Congress Cataloging-in-Publication Data

Rand, Harry.
 Manet's contemplation at the Gare Saint-Lazare.

 Includes bibliographical references.
 1. Manet, Edouard, 1832–1883. Gare Saint-Lazare.
2. Manet, Edouard, 1832–1883—Criticism and inter-
pretation. 3. Railroads—France—Paris—Stations—
Pictorial works. 4. Railroads in art. I. Title.
ND553.M3A67 1987 759.4 86–25077
ISBN 0–520–05967–0 (alk. paper)

Printed in the United States of America

1 2 3 4 5 6 7 8 9

FIG. 1 (p. iii)
Édouard Manet
The Gare Saint-Lazare, 1873, oil on canvas, .933 × 1.145 m.
(36¾ × 45⅛ in.). National Gallery of Art, Washington, D.C.

FIG. 2 (frontispiece)
Henri Fantin-Latour
Portrait of Édouard Manet, c. 1880 (drawn after the portrait of 1867), lithographic crayon on ivory wove paper, 15¹³/₁₆ × 12⅜ in. (400 × 312 mm.), inscribed in lithographic crayon, lower left recto: *A mon ami Manet/Fantin*; in graphite, lower right: *A Aristide Albert/son serviteur fidèle/Léon Leenhoff.* Art Institute of Chicago.

ACKNOWLEDGMENTS

T HE MANY SUSTAINED OR GLANCING REFERENCES TO numerous scholars upon whose shoulders this work rests should indicate exactly which observations are contributed by the present study. As much as with to art itself, this essay is deeply indebted to previous scholarship. Those preceding authors contributed peaks and vistas, as well as specific language as a guide to my own efforts.

If I had not acknowledged the many translators whose texts were used I could have made myself look a lot smarter. Indebted to their skill and respectful of their craft, vanity was not allowed to eclipse the many "secondary" citations the reader will find herein. Anyone familiar with Paul Blackburn's translations from Provençal, W. S. Merwin's *Cid,* Allen Mandelbaum's work, or Guy Davenport's Sappho knows what the moderns can achieve. The many translators of French upon whom I relied for their fine and precise language could not be slighted. All other translations are mine, would that they could have been laid at others' doors.

This book had its beginning long ago in the instruction of Jacob Rothenberg, Bernard Zelechow, and Yvonne Klein; subsequently Michael Fried's lectures nourished its prolonged gestation. Naturally, the above mentioned are innocent in the matter at hand. This essay's recent and accelerated development was fostered by that roving saint of language, Allen Mandelbaum (whose presence upholds a corner of heaven), when he suggested that I embark upon the actual composition of this text. His patient and benevolent ally, Stanley Holwitz, of the University of California Press, was alternately fraternal and, as needed, paternal, but always marvelously insightful

about nurturing this project. My thanks to Mary Nadler for her careful reading of this text, and her many useful suggestions to improve it, all of which was further refined by the work of Shirley Warren. Professor Carla Peterson, whose knowledge of certain arcane Gallic matters far surpasses my own, was instrumental in buttressing instinctive beliefs with the substance of fact, and Anne Yonnemura deserves much praise for ferreting out oriental obscurities I impertinently requested. The many institutions who allowed works in their charge to be reproduced are to be thanked according to the measure of their cooperation. Crafting this text into the handsome book that you see was the inspired work of Dana Levy. I should like to thank Richard Martin, publisher of *Arts Magazine* for permission to reproduce material that has previously appeared in that journal. Professor Larry Silver supplied learned and much appreciated criticism, and these commodities have never been abundant. Ruth and Jacob Kainen, who offered informed moral support, find themselves cozily sharing a sentence. Jennifer Gibson deserves a sentence to herself.

PROLOGUE

Sometimes when we ask basic questions of complex paintings the answers seem rather plain. This can be discouraging if we assume that such simple results are the total that we can extract from these investigations. But, taken together, unpromising responses to our inquiries can form an outline. Each bit of information we extract may, by itself, appear no great thing but as part of a larger organization the situation is very different. The sum of the true things that can be said about one painting can reveal a unifying pattern, and this pattern can be projected to other works by the same artist to help us understand some of the artist's underlying concerns. In short, such a pattern, a grammar, can describe far more diverse appearances than may at first seem possible. The real theme of this book is structure: how the sum of true, if simple, statements can inform a much grander entirety.

Those who require proof (truth with a large "T") of this essay's assertions will be disappointed. This work aspires to truth, but not to that species of certitude sustainable from a matrix of documentation alone. I did not seek to correlate external (archival) references or sources, but to locate, within the art, an internal consistency of sufficient merit to prove self-confirming. We begin by examining a cluster of plastic inventions. In the end, the evidence promotes a degree of probability that requires serious consideration. While plausibility does not equal proof, Manet's painting, *The Gare Saint-Lazare* yields a formidable body of substantiating evidence for my case. There is no question but that the discovery of a cache of Manet's written declarations (letters, statements, manifestos, confes-

sions, *pensées,* essays) would aid the situation, but these materials do not exist.

Whatever the references previously discovered in other of Manet's works, generally, Manet's artistic quotations have not been successfully integrated to suggest a body of thought worthy of the painter. That is to say, a crucial element was lacking, *coherence.* The present text attempts to frame the sensibility, the mentality, that could have brought forth one of Manet's great works.

The collective memory envisions the decade of 1870–80 as a smooth transmission of modernist painting's leadership from Manet to the Impressionists. In fact, the succession, the direct continuity of modernism's development, requires a close examination of the collective memory. This book assumes some familiarity with its subject.

What will seem digressions are in fact excursions from the main route to afford better, more elevated, vantages from which to view the whole panorama. A somewhat leisurely, though a rather focused reading, this essay does not ignore the terrain surrounding its main subject and we will pass through some delightful and well-studied territory on the way to another goal. Perhaps surprisingly (or disappointingly) given this book's limited range, it does not claim to be exhaustive.

For the sake of convenience this essay has been divided into brief sections, although, it ought, like a short story (by Poe), to be consumed at one sitting. In fact, in the course of writing it, this piece expanded beyond the limits of any but the most rapid or dedicated reader's abilities to finish it in a single session.

Like Mallarmé's poetry, the essay should be considered the expansion of a single insight, an unpartite glimpse that ought to correspond to our sensation of recognition when viewing Manet's *The Gare Saint-Lazare.* Either because of my limited talents as a composer, or because the material required it, the form of this essay may strike some readers as a bit odd, perhaps offputting if not objectionable. The book proceeds more like an orchestral score, with vertical themes allowed to ramify as the text advances (horizontally). The outward appearance of the page expresses that aspect of the text and should call forth an easy familiarity, rather than a guarded approach to treacherous going. A formidable appearance often belies the most gentle character.

MANET'S CONTEMPLATION
AT THE GARE SAINT-LAZARE

EDOUARD MANET APPARENTLY QUOTED SUCH DIVERSE
materials that not one of his works has yet been convincingly expli-
cated to general satisfaction, despite prolonged disputation. Luckily,
his reputation has not suffered from the disunity of his supporters.
Quite the contrary. Two generations after the scorn of his first
spectators had died away, a solid critical and art-historical admiration
of Manet arose and evolved into two camps. One camp considered
Manet to have been a genial genius, a painting "animal" from the
upper class; the other camp thought of him as secretly "difficult,"
prefiguring the "difficulty" of modern art.

In reading the most prominent art historians on Manet, one
can almost be convinced that they are writing about several different
artists. There is simply no agreement on the propelling force for this
artist, who lived the life of a bourgeois, free from basic want (un-
characteristic of striving unappreciated artists in midcareer).

Since Manet himself did not greatly enlighten us about his
ambitions, the direction he actually charted for his work and the
ideals toward which his art was moving are still debated. Even if
Manet had provided us with his own explanations, what he deemed
important about his painting in the last quarter of the nineteenth
century might not at all respond to what we must learn about him
today. After a century of earnest inquiry, we still have no consensus
about the deepest motives of Manet's art.

At a certain level Manet reveals himself to be reconcilable to
otherwise contradictory descriptions of him, and at that level appear
the critical (and heretofore frequently overlooked) assumptions that

1. For example, George Mauner's comprehensive study *Manet, Peintre-Philosophe: A Study of the Painter's Themes* (University Park: Pennsylvania State University Press, 1975) lacks a single unifying element that would convincingly satisfy our instincts about Manet's art—instincts sharpened by the writings of Reff, Hamilton, Fried, Sandblad, and others.

2. Michael Fried, "Painting Memories: On the Containment of the Past in Baudelaire and Manet," *Critical Inquiry* 10 (3) (March 1984): 552–523.

governed his art.[1] This essay attempts to locate the station of consistency in Manet's art. Although the approach taken will not be direct, our attention will not waver from a single guiding focus. The focal point will be Manet's painting, *The Gare Saint-Lazare,* 1873 (fig. 1), which will serve as the instrument by which this reconciling examination is carried out. An intensive discussion of this work will show that it engages most of the critical issues of the period of its execution and of the artist's work generally.

Several interlocking problems snare those spectators who desire overall access to Manet's art. In his youth Manet produced images of obvious thematic complexity. These works have revealed a network of tantalizing gestures toward art of the past, a past that Manet invoked by adapting motifs from the artists he most admired. A concise summary of Manet's use of sources was published by Michael Fried and is worth quoting at length:

> The problem of the meaning of Manet's use of sources first arose in 1861 when the critic Ernest Chesneau spotted the painter's adaptation in his *Déjeuner sur l'herbe* (1862–63) of a figure group from Marcantonio Raimondi's engraving after Raphael's *Judgement of Paris.* That same year, a more distinguished critic, Theophile Thoré, remarked in the course of a largely favorable review that Manet had "pastiched" Velázquez, Goya, and El Greco and called attention to certain striking similarities between Manet's art and the work of other old masters. Thereafter the topic was largely moot, until 1908 when the German art historian Gustav Pauli rediscovered the Marcantonio connection. But it was not until the 1930s and 1940s that the astonishing range of Manet's quotations from, allusions to, and adaptations of earlier works of art became apparent to scholars. Confirmed by a phenomenon seemingly without precedent in their experience, they mostly saw in it either a sign of deficiency—thus Manet was criticized for being unable to compose—or a hallmark of modernity—indicating a laudably formalist indifference to subject matter as such. By the 1950s and 1960s, it was often said or implied that Manet intended his use of sources at once to identify with and to compete with the old masters, though it was never explained why he should have felt a special need to do so or, indeed, why he should have chosen to identify with and compete with them in this particular way.[2]

Once discerned amid his early pieces, these references graph the

3. John Richardson, *Manet* (London: Phaidon, 1967), p. 27.

4. Nicholas Wadley, *Manet* (London: Paul Hamlyn, 1967), p. 7.

5. Georges Bataille, *Manet: Biographical and Critical Study* (Geneva: Skira, 1955), p. 18. Here we see Manet portrayed as a kind of idiot savant who passes through life painting but without registering much of the world.

artist's private art history—that inner vision of art's development upon which every artist bases his endeavor and which is, ultimately, a personal conviction (as is also the case for every art historian). In the early 1870s, Manet rather abruptly stopped making these intense composite pictures and turned to making sunnier and apparently simpler images. The first task of this essay will be to demonstrate that after 1870, Manet wove the materials furnished by modernity into the same complex patterns as those that united his historical sources. The patterns of thought typical of his early works were maintained throughout his life. This will be a difficult point to demonstrate, for nothing in *The Gare Saint-Lazare's* subject seems remarkable, and viewers have not been especially struck by what is depicted:

> Encouraged by having at last had a success at the Salon, by the fact that Durand-Ruel had recently bought a number of his paintings and, not least, by the gaiety which had returned to Paris with the Third Republic, Manet resumed painting scenes which would express some of the more agreeable aspects of the life of his time. Outstanding among these are *Le Chemin de Fer.*[3]

According to this prevalent view, Manet was a painter of bourgeois life, of superficial human concerns. Whatever sensibilities he possessed as a painter remained unlinked to an intellectual framework worthy of that manual skill. Unlike those tragic artists whose biographies compel our attention and whose living conditions seem to have molded their art, Manet's extra-artistic activities hardly inform his work. Occasionally, sharp political news or fierce topical events provoked the attentions of his art, but he does not appear to have taken actions that would have jeopardized his artistic or social standing. He has been described as, "respectable to the point of affectation."[4] Other descriptions of this aspect of Manet's character are neither so concise nor so kind:

> A gentleman painter, a man about town, Manet only skimmed the surface of some of the more vital things in life. The portraits and photographs we have of him fail to excite our interest. The things he had to say—as recorded by Antonin Proust and by Baudelaire in *La Corde*—amount to little more than small talk, lit up now and then by a flash of wit or plain common sense.[5]

6. George Mauner, *Manet: Peintre-Philosophe,* p. 1 n. 2. Zola's supportive article of 1866 was expanded and appeared in the *Revue du XIXe siècle* on 1 January 1867. In 1879, however, a Zola article published in a Russian journal and reprinted in France was highly critical of Manet and the Impressionists.

7. Beatrice Farwell, "A Manet Masterpiece Reconsidered," *Apollo* 78 (July 1963): 45.

According to such reconstructions of his personality, Manet was singularly undisposed to serious or difficult thought. Such an unlikely figure appears to have been a doubtful candidate for changing the quality or the course of late-nineteenth-century subject matter (fig. 2). Moreover, should this improbable character have ventured into the world of serious thematic speculation, he would seem foredoomed to failure. Unfortunately, this vision of Manet's personality cannot be dismissed out of hand, as some aspects of his art suggest that Manet never did master complex subjects. The idea that Manet was "a great natural painter with few, if any, ideas . . . derives from Zola's point of view expressed in his booklet *Edouard Manet,*" published in Paris in 1867.[6] Manet's detractors in this regard were not always academicians or conservative pedagogues.

This vision of the artist persisted in some circles until very recent times. The durability of this opinion can be attested by Beatrice Farwell's recollection that "in 1945 I heard Fernand Léger maintain that 'Manet was the greatest tragedy of the nineteenth century: a gifted painter who had nothing to say.'"[7] If Manet truly had nothing to say, that would indeed be a great tragedy. But if his statements were random—thoughtless, pointless in the aggregate, or so far beneath the level of his talents as a painter that discovering his meaning would serve only to diminish his stature—that would be an even greater tragedy. Unfortunately, Manet left no key to the images that appear in his works, and there is as yet no concordance by which we might ascertain whether a fundamental personal program threaded his career.

Our expectations of gaining his privacy have been falsely elevated by our acquaintance with overdocumented lives. The questions we pose about his career are, in many cases, answerable for his contemporaries. Neither a markedly eloquent nor a particularly prolific correspondent, Manet eludes us. We yearn to approach his flickering personality over the distance of more than a century, and our curiosity is not slaked by the little we know of him. Manet looms over his times as an intensely private man whose personal code of behavior thwarts the historian in his pursuit.

If Manet's private thoughts were not recorded to our satisfaction, neither was he especially forthcoming about what his subjects may have "meant" or "stood for" in his mind. We learn very little

8. Indeed, in the current study Manet's contemporaries' observations are not automatically awarded a preferred status, for in this interpretive essay the prime sources are the works themselves, the poems and paintings. Subsequent observers, singly and most especially cumulatively, have parity as legitimate spectators and are cited as such.

9. Françoise Cachin, "Introduction," in *Manet, 1832–1883* (New York: The Metropolitan Museum of Art, 1983), p. 13.

10. Some occasional (political) significance does not render Manet's work a completely coherent political statement. The ideal demonstration of a network purporting to display his wider intentions ought to be concise and self-contained. A minimum number of factors, all more or less related, might generate the images in Manet's art of a certain period. By implication, his art in those periods preceding the focus of this study would have their own generative assumptions ruling the assignment of meaning.

11. The model for this type of artist might be found in John Singer Sargent, who has few equals as a pure painter but who as an artist lacked the stature he might have attained by a rigorous pursuit of the implications of his art. This point separates him from Manet, another "natural" painter.

12. Michael Fried rejected Manet's involvement with "subject matter and composition." Instead, Fried thought of the artist as far more complex, engaged with a conscious agenda in which formal concerns were but a small part of his consideration; "Some historians have argued that for Manet subject matter was nothing more than a pretext for the problem of form and color that alone interested him" ("Manet's Sources: Aspects of His Art, 1859–1865," *Artforum,* March 1969, p. 28).

about this when guided by the artist's writings and from the recollections of his contemporaries.[8] What he mainly painted, "modern life," such as we see in *The Gare Saint-Lazare,* was so usual, so seemingly banal and obviously the texture of the world as it was available to countless nineteenth-century Europeans, as to be virtually invisible as subject matter in any special or allegorical sense. At first glance, *The Gare Saint-Lazare* might seem to be an unpromising spot in which to prospect for an entrance to his thinking. Indeed, even the most careful study of this painting fails to reveal anything of diaristic note. As Françoise Cachin declared, "Edouard Manet remains one of the most enigmatic, least classifiable artists in the history of painting."[9]

Historians wishing to impute special meaning to Manet's works require that his subjects be assigned some extraordinary potency. Art history was aided in this quest by circumstance, as Manet's sources describe a network of references that gloss the art of the past.[10] We thus confront two Manets. One was a rather frivolous type, a genial member of the upper class who, regardless of his innate painting skills, seemed unable to substantially advance the plastic imagery of his time or to prefigure the future.[11] The other is a fleetingly glimpsed figure of subtle mind and limber wit whose furthest thematic explorations have hardly been charted.

Some have argued that Manet's subject matter contributed only modestly to his art, except arcanely, as a subterranean criticism of Western culture itself—a convenient reading of him as an ancestor, or progenitor, of modernism.[12] The treatment of Manet as the fountainhead of modernism precludes (and almost proscribes) the presentation of certain kinds of evidence to demonstrate the character of his thinking. According to this view, Manet's stylistic proclivities were employed to depict his pedigree for modern art— Velázquez, Rubens, Raphael, Le Nain, and others. Adaptations from the work of these artists served as homage in a subliminal network of references by which Manet selectively invoked and deferred to a special view of history. According to this reading of *The Gare Saint-Lazare,* Manet's formal genius, yoked to a wonderful painterly craft, simply chose a delightful location in which to expand his talents as a painter. Yet, Meyer Schapiro warned us to look closely at the situations of Manet's art:

13. Meyer Schapiro, "Review of Joseph C. Sloane's *French Painting between the Past and Present: Artists, Critics, and Traditions from 1848 to 1870,*" *Art Bulletin* 36 (June 1954): 164. Schapiro continues by noting "the intense contemporaneity of so many of Manet's themes and his positive interest in the refractory, the independent, the marginal, and the artistic in life itself." By this Schapiro may have meant the opportunity that observations from life afforded Manet for expressing the relationships upon which he founded his art (symbolism), or he may have meant that in the texture of quotidian life something noble and worth recording was transpiring (realism). The efficiency of Schapiro's phrase exactly duplicates the elegant complexity of Manet's densely referential, yet gracefully executed painting.

14. Henri Perruchot, *Manet,* trans. Humphrey Hare (Cleveland and New York: World Publishing, 1962), p. 201.

Manet has chosen only themes congenial to him—not simply because they were at hand or because they furnished a particular coloring or light, but rather because they were his world in an overt or symbolic sense and related intimately to his personal outlook.[13]

Despite Schapiro's alert to scholars, little has been written concerning the bivalence of Manet's art. On one hand Manet recorded the commonplaces of life in the nineteenth century and shared with Zola and other naturalists the foundation for his art in the passage of everyday life before the eyes of the viewer. On the other hand, in addition to clearly rendered observations of the flow of unexceptional events around him, Manet treated those almost nondiscursive refinements toward which the first Symbolists strove. In other words, despite its appearance of being firmly grounded in and composed of the appurtenances of reality, Manet's art strives to penetrate to a world of thought that is perfectly immaterial, replete with emotions and ideas.

FIRST NOTICES

He heard the devastating, the incredible news that the Salon Hanging Committee had accepted only one of the three canvases he had sent in: *Le Chemin de Fer*. Both *Les Hirondelles* and *Le Bal masqué* had been rejected. Manet had clearly not kept to the straight and narrow path which *Le Bon Bock* had seemed to promise. . . . Indeed, the Hanging Committee had accepted one of his works only as an example by which the public could judge how far he had gone astray.

<div align="right">Henri Perruchot[14]</div>

To DATE, THE LITERATURE THAT HAS CONSIDERED *The Gare Saint-Lazare* has overlooked the importance Manet himself attached to this painting as well as the place it occupied in his production. In this painting Manet successfully dilated the borders of the canvas to control large surface shapes, and he simultaneously worked unabashedly in the Impressionist method. Yet, at the time, his venture into the Impressionist technique did not figure as a

15. Theodore Duret, *Manet and the French Impressionists* (New York: Crown, 1937 [1910], 1971), p. 77.

16. The most famous singer of his day, Jean-Baptiste Faure bought *The Gare Saint-Lazare* from Manet in November 1873, before it was shown in the Salon. In 1877 a portrait of this theatrical figure (who was next to Durand-Ruel, Manet's greatest patron) was executed in oils in *Faure dans le rôle de Hamlet* [Folkwang Museum, Essen, Germany] and in a pastel [Marcus Wickham-Boynton Coll. Burton Agnes Hall, E. Yorks]. See Mauner, *Manet: Peintre-Philosophe,* pp. 143, 145).

17. George Heard Hamilton, *Manet and His Critics* (New York: Norton, 1969), p. 177.

18. Trans. in Pierre Courthion, *Edouard Manet* (New York: Harey N. Abrams, 1962), p. 114. Remarking on the painting's place in Manet's career with regard to Impressionism and in particular, on his use of color at that moment, Hamilton observed that

> under Monet's influence he was working with a much brighter palette, although the range of color and the intensity of particular hues did not approach that of the Impressionists themselves. In details he continued to eliminate contour modeling as his vision more accurately recorded natural appearances at a given distance. (Hamilton, *Manet and His Critics,* p. 178)

19. Trans. Hamilton, *Manet and his Critics,* p. 179.

dominant aspect of the criticism of the painting, for the novelty of this method of execution was simply not understood. As Duret noted, "The *Chemin de Fer* in 1874 had scarcely been recognized as an open-air work."[15] That Manet was both familiar with this method and on good terms with its inventors is clear. The year after *The Gare Saint-Lazare* was painted, Manet went to Argenteuil, where he painted beside Monet and Renoir.

Appearing in the Salon in 1874, this was the first plein-air work to be exhibited in a Salon, but this aspect of the painting—which automatically distinguishes it in history—went overlooked at its reception.[16] "For those who had been able to accept the subdued color and relatively precise definition of the *Bon Bock, The Railway* was a new outrage."[17] One after another the reviewers contributed their obloquies to the almost uniform consensus. Here and there a glimmer of sympathy surfaced. Philippe Burty came to the aid of the work that was to receive so much scorn. In the 9 June 1874 issue of *La République Française* Burty noted the plein-air technique, and he singled out for praise

> the blue twill frock of the seated young mother. Above all, we recognize M. Manet's desire to strike the right note without the help of any artifice of style or pose and his application of painting out of doors.[18]

Even the painting's supporters could not bring themselves to unalloyed admiration. In the 19 June 1874 issue of *Siècle,* Castagnary faltered into a discussion of the work with a sense of dogged exhaustion:

> Finally, since I am listing the paintings, and so that nothing should be forgotten, there is Manet's *The Railway,* so powerful in its light, so distinguished in its color, and a lost profile so gracefully indicated, a dress of blue cloth so broadly modeled that I ignore the unfinished state of the face and hands.[19]

Thus, Courbet's supporter mustered only the most categorical and qualified praise for a work that otherwise was not well received at all. The 6 May 1874 issue of *Le Charivari* mocked the painting and produced a playlet for its readers:

20. The vitriol of this playlet has not been explained. Louis Veuillot (1813–1883) was a journalist, writer, and served as editor-in-chief of *L'universe* which he made the most famous French conservative Catholic and pro-Vatican journal. *Le Charivari*'s invidious comment pitted the Catholic Veuillot, as reactionary arbiter of mores and behavior, against "Papa" Manet, the "Pope" of modernism.

For this playlet I have used Pierre Courthion's translation (*Edouard Manet,* p. 114).

21. Some spectators have noted the apparent reliance upon the precedent of the Japanese woodblock and especially on compositional devices introduced from the Orient. Anne Coffin Hanson observed that *The Gare Saint-Lazare* "can be precisely related to Japanese sources."

In particular, Hanson noted that "Japanese courtesans were popular subjects for wood-block prints" and that "they are frequently shown in their quarter in Yeddo called 'Yoshiwara' against bamboo window dividers which separate figures in the frontal plane from the distant action in the landscape beyond" (Hanson, *Manet and the Modern Tradition,* p. 190). The foreclosure of rear space was hardly limited to portrayals of the secluded precincts set aside for courtesans. On the contrary, this device was frequently employed in prints of kabuki plays, such as this woodblock print (fig. 4) by Gototei Kunisada (1786–1864), a work produced not later than the early 1830s, when the artist assumed this name. On the left is Ichikawa Danjuro (probably the VII, 1791–1859, a great actor who was eventually banished from Tokyo for living too conspicuous a life for an actor), and on the right stands his relative Ichikawa Ebizo, cloaked and posed before a water cask. The play, as depicted in this diptych print, contains a scene in which the actor confronts a broken ladder before a wall.

Granting the design source from the influx of Japanese woodblock prints and Manet's awareness and appreciation of "Japonisme," the present discussion focuses on the novel uses to which Manet put *all* his compositional and technical devices in the service of a special subject matter.

M. Veuillot:	It is a case of acute pictorial delirium.
The Executioner:	Shall I. . . . ?
(The executioner strikes furiously at the bars of the cage.)	
The Little Girls *(laughing)*:	Bad Luck! You can't get at us. Papa Manet made the bars enormous! [20]

How odd the modern reader finds this note of madness concerning so placid and seemingly inoffensive a painting. The 15 May 1874 issue of *Le Charivari* echoed this diatribe when the caricaturist Cham (fig. 3) declared of the picture: "The lady with the trained seal. These unfortunate creatures, finding themselves painted in this fashion, wanted to flee! But the artist, foreseeing this, put up a grating that cut off all retreat." [21] In addition to the ridicule aimed at the picture because of its powerful, and apparently objectionable, composition, the predicament of the two subjects caused further merriment in the press. On 10 May, *Le Tintamarre* printed a caustic doggerel, which refers to the insane asylum of Charenton:

Ce tableau d'un homme en délire
a, pour étiquette, dit-on
"Le Chemin de Fer," il faut lire:
Chemin de fer pour Charenton [22]

(This picture by a crazy man
has been labeled, as intoned
"The Railway Train," it ought to scan:
Train to Charenton)

Yet it is hardly an act of madness, of "delirium," that we witness, but the coolest, most reserved exposition. Somehow the painting presented a sharp irritant. What appears to us to be docile clearly incited some part of the serious public in Manet's time. It is all too easy to pity or revile those who disdained the picture, but dismissing the critics does not illuminate the source of their irritation. [23]

This work, which today seems either wonderful as a painting or rather neutral as an excursion into subject matter and which occupies a footnote in art history because of its introduction of plein-air painting to the Salon, meant a great deal to Manet. Indeed,

22. A month later, in the 13 June issue of the *Journal amusant,* Stop framed the following description: "Two madwomen, attacked by incurable Manet-mania [*Monomanétie*], watch the passing train through the bars of their padded cell" (trans. Hamilton, *Manet and his Critics,* p. 178). This barb combines both the objection that the work conspicuously and heavily bars the rear of the picture, as it repeats the theme of madness.

23. Hamilton notes that "in *L'Illustration* on May 23, Bertall alluded, not very kindly, to Manet's new-found patron: 'The *Railway,* or the departure of Faure for England, which explains the woebegone expressions of the figures. This is no happier for Manet' " (Hamilton, *Manet and his Critics,* p. 178).

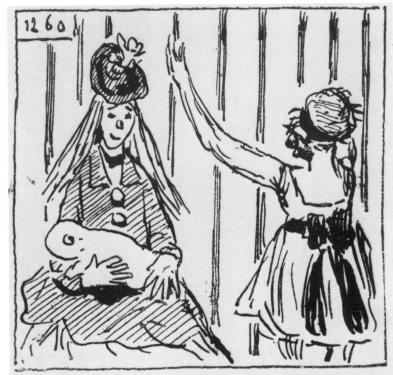

FIG. 3
Cham [Amédée de Noé]
Caricature wood engraving from 15 May 1874
Le Charivari. Bibliothèque Nationale, Paris.

24. His submission was refused, and the jury's rejection forced him to consider entering his works for a general jurying, as would any novice, notwithstanding that some of these paintings had already been shown in official Salons. Manet chose instead to forgo exhibiting.

25. Duret, *Manet and the French Impressionists*, p. 82. In the context of a discussion of *The Gare St. Lazare*, this remark recalls another, even more tantalizing observation made by Camille Lemonnier. "M. Puvis refines the ideal. M. Manet refines reality. No color mind you, but an idea." (Camille Lemonnier, *Salon de Paris* [of 1873] [Paris: Morrel, n.d.], p. 38, trans. Joseph C. Sloane, *French Painting: Between the Past and the Present, Artists, Critics, and Tradition, from 1848 to 1870* [Princeton, N.J.: Princeton University Press, 1973], p. 171). Issuing from a contemporary observer, such a suggestion teases the modern reader by mocking our inability to guess exactly how much of Manet's personal program was available and understood by his audience.

26. Silvestre continued, noting that "A work so conceived must have only two qualities: truth and beauty of color. Well then, it is hard to imagine anything more truthful than this painting" (trans. Hamilton, *Manet and his Critics*, p. 180).

when the time arrived to propose works for the consideration of a juried exhibition held in association with the Universal Exposition of 1878, Manet submitted a list of thirteen pictures, of which nine had already been exhibited at the Salon. One of these was *The Gare Saint-Lazare*.[24] Manet's special esteem for this painting was evidenced by how he treated it over the years. Yet, however urgent that communication intended for and repeatedly presented to Manet's contemporaries, it was not understood either in its time or for several generations thereafter. Nor was Manet the type to rush into print to defend or explicate his paintings. By their consistency and coherence his works had to support their own internal arguments. Even Manet's great friend and advocate Duret could not fathom this work. Summarizing the painting's critics, Duret noted that

> In addition to the objection that the color scheme was too vivid, the subject was pronounced to be unintelligible. Properly speaking, there was no subject at all; no interest attaches to the two figures because of what they are doing.[25]

In this remark Duret reiterated, at some distance, what had originally appeared in print in the year of the painting's appearance before the public. In the 19 June 1874 issue of *L'Opinion nationale*, Armand Silvestre first sounded the note that would be repeated most frequently up until the present, that *The Gare Saint-Lazare* was a triumph of style over subject matter:

> I should understand how one might disapprove of the style of the work and even that one could grow indignant. But what is the problem? What has the painter wanted to do? To give us a truthful impression of a familiar scene.[26]

To the extent that we may list the details of this scene, that we are able to reconstruct the time and place of its origination or can specify the persons who are depicted, then to that degree the work is indeed "truthful." Accordingly, the work is not a "fiction." The models do not pretend to be others, and they do not assume or express other personalities. Indeed, their personalities are not an issue with which this painting is at all concerned (something the painting's first vexed viewers considered to be an inexcusable omission). The models' costumes are contemporary, and the place is neither exotic nor historical. Plainness would have been permissible

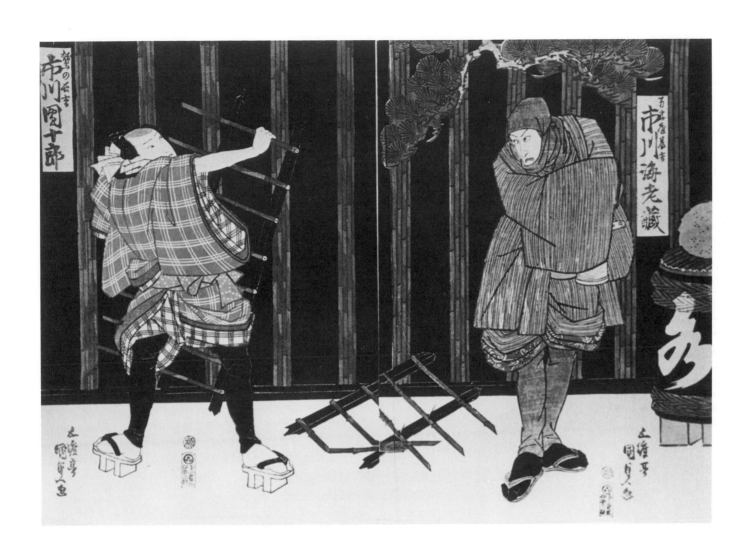

Fɪɢ. 4
Gototei Kunisada
Kabuki scene, diptych woodblock print, c. 1830,
private collection.

13

27. Curiously, the artistic sympathy that we readily feel between the work of Bazille and that of Manet (and to a lesser degree in the figurative works of Caillebotte) seems to have had its social counterpart (fig. 5). It appears that Bazille first brought Manet in contact with the future Impressionists. According to Jean Renoir,

> Bazille, my father's new acquaintance, came from a wealthy family of the old Parisian bourgeoisie. His parents were acquainted with Edouard Manet, and he had been invited several times to visit the master in his studio. "Manet is as important to us," he said, "as Cimabue or Giotto were to the Italians of the Quattrocento." (Jean Renoir, *My Father* [Boston: Little, Brown, 1958, 1968], p. 106)

to the academically minded had the work treated contemporary royalty, politics, or those of high station (distinguished by great acts or lucky birth). Liberal factions might have been satisfied had Manet painted the miserable, whose wretchedness affronts us and challenges conscience. Instead, his bland muteness offended most spectators and baffled all. A century later we recognize the situation as a moment in the life of Paris: this is a real garden at an address in the Batignolles quarter; we can know the models' ages and histories. But such information can never accumulate into a sufficiently large parcel of truth to capture the essential character of Manet's art.

His painting absorbed the observational assumptions of the Impressionists, as it had first subsumed the Old Masters, then the frank figurativeness of Realism (so different from what Impressionism would become with the death of Bazille).[27] Manet endeavored not only to include but also to transcend Realism. His ambitions arose from a nominalist and descriptive address to the world (denotation), but Manet *arranged* appearances so as to surpass an inventory of the world and to *mean* (that is, connotation). The nominal truth of the situation can be inventoried as a list of portrayed things, but that meager honesty pales beside another truth that governs the disposition of the painting's deep relationships. That other truth, in its grand ambition, abides beyond the imagining of the work's early viewers. The plain representation of an instant in the swirling activity of nineteenth-century Paris does not, despite the obvious superficial veridicality of the painting's description and despite the charm of the painting, reveal why this scene had to be painted. Appearances notwithstanding, it was the relationships between the figures themselves as well as between the figures and their environment—contrived relationships that could not have been more clever or more exquisitely adjusted—which occasioned the painting. In *The Gare Saint-Lazare*'s only partially sensed implications lay the offense to Manet's own public.

TO THE GARE SAINT-LAZARE

After having examined these photographs of nude models, some of them poorly built, overdeveloped in places and producing a rather disagreeable effect, I displayed some engravings by Marcantonio [Raimondi]. We had a

FIG. 5
Frédéric Bazille
Manet at His Easel, 1869,
charcoal on paper, 28 × 22 cm.
Metropolitan Museum of Art,
New York, Robert
Lehman Collection, 1975.

28. Most commentators remain mute about the place of this work in Manet's career. In "a study of the painter's themes," the *Gare Saint-Lazare* is not discussed at all (Mauner, *Manet, Peintre-Philosophe*). Therefore, the importance I am according this work in the artist's production ought not to be assumed, despite the painting's frequent reproduction in the art historical literature.

29. Gabriel P. Weisberg, "Aspects of Japonisme," *Bulletin of the Cleveland Museum of Art,* April 1975, p. 126. Some of Weisberg's observations can be borne out in the present study while others fare less well. For example, he notes that

> *Gare Saint-Lazare* depicts a mother and child sitting near a traincut in Paris. It is an important work, for two aspects of Manet's interests at the time seem intertwined: his involvement with photography and his study of *ukiyo-e* prints. The former is indicated by the momentary glance of the woman who looks up from her open book in the direction of the viewer, as well as the randomness of the entire scene, which gives the impression of continuing beyond the confines of the canvas, much like a snapshot image.

In fact, the couple may not be a "mother and child," and the appearance of randomness, so carefully cultivated, is shed after gaining familiarity with the picture's inner workings.

30. In the mid-1850s, Manet painted two copies of *The Barque of Dante* (Musée des Beaux-Arts, Lyons [fig. 8]; the Metropolitan Museum of Art, New York [fig. 9]) and used the occasion of securing permission to copy as the pretext for a visit to Delacroix's studio.

31. In the purest sense, narrative—that is, storytelling—can have no meaning except with regard to language. Thus, in the visual arts any references to a narrative signals the invocation of a story-as-occasion-for-an-image (or cycle of images). Questions of reference, with more-or-less clear designations in linguistics, possess only analogical equivalents in the visual arts. Except in the most conventionalized situations, fundamental "signifier-signified" relationships (such as those postulated by Saussure) are of little importance to the visual arts; more useful is the trinomial arrangement of a

feeling of repulsion, almost of disgust, at their incorrectness, their mannerism, and their lack of naturalness; and we felt these things despite the virtue of style . . . let a man of genius make use of the daguerreotype as it is to be used, and he will raise himself to a height that we do not know. . . . Down to the present this machine-art has rendered us only a detestable service: it spoils the masterpieces for us, without completely satisfying us.

<div align="right">

Eugène Delacroix in his *Journal,*
21 May 1853

</div>

D ELACROIX'S ADAMANT (WAS HE EVER LESS?) CHALlenge—to build upon a new confidence sprung from an as yet unknown faith—was expressed in all his work. His charge was taken up by Manet who, as we know by the history of his copying, envisioned Delacroix as the foremost exemplar of grand painting. That generational connection, its nature and expression, is less easily specified in particular works. Hardly ignored by recent scholarship, *The Gare Saint-Lazare,* proffers the ideal opportunity for a test reading precisely because on first viewing it does *not* seem part of the rich allegorical network affiliating much of the rest of Manet's production.[28] In fact, it proves to be one of the special works of his career, functioning as a keystone for the assumptions supporting his mature production. As we shall see, Manet himself probably considered *The Gare Saint-Lazare* to be one of his most important works.

The picture was under way as early as 1872, when it was seen in Manet's studio, where he sketched in the basic composition. Its conception thus preceded Manet's venturing out and setting to work in front of his models. It is entirely possible that the composition was established in a posed *tableau vivant* that Manet had photographed as the basis for this work. Gabriel Weisberg notes that "while no specific photographic source has come to light, the impact of this medium (then also a craze in Paris) cannot be underestimated in helping Manet toward the final realization of his composition."[29] Photographic instantaneity—the perfectly isolated moment hewn from the flow of time—attracted painters from the moment of its appearance.

A generation before Manet, in Delacroix's time, new terms were being devised. Théodore Géricault's huge *The Raft of the*

symbol [accidental]-signified-referent, in which the final term is understood to mean the extended contextual product of art-historical research. Tautologically, what must be explained about a picture is narrative, just as (linguistically) what is translatable is the *story*.

The present essay will intermittently solicit the concept of the *narrative* even as I maintain the ultimately nonpictorial character of storytelling; nevertheless, this function was a mainstay of art for most of history in most cultures.

32. Although Nicéphore Nièpce was capturing images on prepared polished plates of pewter as early as 1816–29, the practical history of photography might well be dated to 1829 when, on 13 March, Nièpce and Daguerre became partners. The potential for photography's wide dissemination awaited Daguerre's 1835 invention of the latent image. Thus, no claim is made herein for the impossible influence of an as yet nonexistent photography on early Delacroix, only for a shared and widely held sensibility that helped promote the development of the photograph.

33. Nor should Delacroix be held culpable for such continuing engagement of the spectator. Overt solicitation of the viewer's attention (dubbed *theatricality* in the recent literature, especially by Fried), by early nineteenth-century artists, directs our vigilence. But certain descriptive refinements should rightly be introduced. Delacroix (and here one could also recite Jacques Louis David's position in this development) attempted (in works like the *Massacre on Chios* and *Liberty Leading the People,* or *Greece Expiring,* or even *The Death of Sardanapalus* with its complex drama of pagan stoicism and extravagant slaughter), a "psycho-petitioning" address. These works beseech the viewer to consider occupying a special psychological state. Not mere editorializing, Delacroix hoped (or expected) his works to supplicate their audience on behalf of, not merely the momentary political instance that occasioned the work but a condition of mind, august, removed, but profoundly compassionate.

Delacroix thus proved essential to (as a predecessor), and removed from, Manet's cool observation.

34. Weisberg, "Aspects of Japonisme." Manet also recognized the photograph's potential for mass

Medusa, 1819, depicts a singular moment in the story of a naval, human, and national calamity (fig. 6). The spectators' knowledge of those circumstances must serve as the basis for appreciation of Géricault's selection of that instant. This narrative's highpoint comprises one of the principal affective elements of that work. Ultimately, however, as the scene is embedded within the flow of a story, Géricault's work—however daring in scale, artistic conception, and political audacity—remains essentially a history painting. Similarly, Delacroix's *The Barque of Dante,* 1821–22 (fig. 7), depicts one moment in a narrative. Soon after executing this work, however, Delacroix began to question the fundamental character and assumptions of history painting.[30] In comparison, the maturing Delacroix speculated on the "length" of the instant, as he sought to compress narrative into a single representative construction.[31] *Scenes from the Massacre on Chios,* 1821–24 (fig. 10) arose from Delacroix's urge toward the nonnarrative, which same tendency gave birth to photography. Under the aegis of that (photographic) aesthetic, Delacroix sundered the progress of a story in order to present a single, synthetic moment that combines many separate incidents heaped together to form something like a sculptural monument.[32] The distance traveled from *The Barque of Dante* to *Scenes from the Massacre on Chios* distinguishes that essential difference between the painting as the depiction of the critical moment in a story known to the spectators and the painting as an independent construction. The former epitomizes illustration and relies on an external, textual source, while the latter is a self-reliant entity that comments on its sources (that is, it reconfigures its sources to comment upon them). Under the hand of Delacroix, painting assumed a life parallel to, but no longer submerged within, the fabric of a "text." Autonomous, painting could now surpass its role as a colophon to literature, although Delacroix was not to realize this potential.[33]

Inheriting the implications of the painting as an uncontingent creation, Manet relied on the documentary authority of the photograph's aesthetic, its instantaneity. He may have actually depended on photographs for his composition of *The Gare Saint-Lazare.*[34]

Saturated with the most advanced thinking of its time, *The Gare Saint-Lazare* arises from photography's nascent aesthetic and its sibling philosophies, Realism and plein-air painting. *The Gare Saint-Lazare* was executed out-of-doors in the garden of Manet's

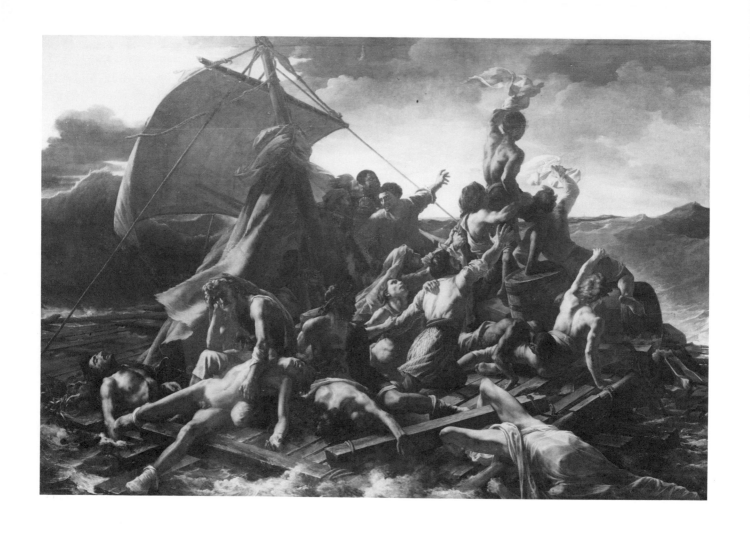

Fig. 6
Théodore Géricault
The Raft of the Medusa, 1818–19, oil on canvas,
c. 16 × 23 ft. Louvre, Paris.

communication. Reproduced mechanically, it surpassed even the lithograph in combining faithfulness to the original image (produced without the intervention of another draftsman) with limitless facsimiles.

Additionally, Manet was on good terms with the most eminent of photographers:

> Manet, we know from documents, saw the two Maja paintings and commissioned his good friend, the photographer Nadar, to make full-scale photographic reproductions of them. After Nadar completed his work, Manet, in an amicable gesture of gratitude, presented him with *Espagne à l'éventail,* which bears the inscription "A mon ami Nadar." (Fred Licht, *Goya: The Origins of the Modern Temper in Art* [New York: Harper and Row, 1979], pp. 89–90)

It seems probable that Manet intended *The Gare Saint-Lazare* to be reproduced in some mass-circulation publication on the occasion of the Salon of 1874, since he had it photographed (by Godet); in addition, a photographic print (18.8 × 22.7 cm) was colored in gouache and watercolor by Manet as a record of the work. This photograph undoubtedly supplied the basis for the wood engraving by Alphonse Prunaire in precisely the dimensions of the photograph (Durand-Ruel & Co., Paris. See Theodore Reff, *Manet and Modern Paris* [Washington, D.C.: National Gallery of Art, 1982], pp. 58–59).

35. The painting engendered particular attention from the artist's first biographer Edmond Bazire (*Manet* [Paris: 1884]) who

> adopted the extreme position that *In the Garden* initiated the Impressionist movement: "Light inundates the painting; it is translated in all its values, and dissolves in reflections and patches. The landscape is vibrant with light. . . . The school of *plein-air* painting originates with this picture." (Trans. in Charles S. Moffett, *Manet, 1832–1883* [New York: Metropolitan Museum of Art, 1983], p. 319)

36. Ibid., p. 320. The letter, written and dated from Paris on 8 December 1889, has been alternately translated. (*The Complete Letters of Vincent Van Gogh* [Greenwich, Conn.: New York Graphic Society, 1959], III: 557)

friend and fellow artist Alphonse Hirsch. It was not Manet's first plein-air painting however; in 1870 he painted *In the Garden* (fig. 11) which depicts the backyard of a Parisian house (16 rue Franklin, the home of the Morisot family).[35] In the foreground, Tiburce Morisot (Berthe's brother) reclines on the grass, lending a kind of casualness to the work we would recognize today in a snapshot. Charles Moffett observes that

> the seemingly random character of the composition is integral to its convincingness. The partially blocked figure of the man contributes significantly to the sense of realism. At first, he seems to have been included simply because he was there, like an extraneous or incidental detail in the background of a photograph; but on closer examination he is seen to affect the mood and possibly the meaning of the painting. . . . It was probably his presence that led Theo van Gogh, in a letter to his brother Vincent, written in 1889, to remark: "This is certainly not only one of the most modern paintings, but also one in which there is the most advanced art. I think the pursuits of Symbolism, for example, need proceed no further than this canvas, in which the symbol is uncontrived."[36]

Thus, nineteenth-century observers attest that *In the Garden* unites plein-airism's apparently informal versimilitude, photography's potential for casualness born of factuality and, paradoxically, Symbolism's utterly unstraightforward cleverness. A compact masterpiece, this unassuming and gentle work won new territory for modern art. Inconspicuously, the picture pointed the way to other uses for plein-airism's potential—to insinuate the appearance of documented existence into artifice. While *In the Garden* was the first of Manet's works painted fully in the open air, *The Gare Saint-Lazare* was probably the first plein-air painting ever shown in a Salon.[37]

Today, more than a century after the Impressionists revolutionized art by painting at the scene of their observations, plein-air is a commonplace. For Manet, however, painting *The Gare Saint-Lazare* outdoors created problems. This choice of an open-air setting added to the misunderstanding of the painting and contributed to the myth of his naïveté: "The oldest and most persistent of the alleged weaknesses of the painter, his lack of imagination, originates with his confession of his need for a model."[38] *The Gare Saint-*

FIG. 7
Eugène Delacroix
The Barque of Dante, 1821–22, oil on canvas,
188 × 241 cm. (74 × 95 in.). Louvre, Paris.

37. The official program (p. 181) of the ninety-first Salon, 1874, shows Manet as residing at 4 Rue de Saint-Pétersbourg, with his entry as:

1260—Le chemin de fer.
(Appartient à M. Faure.)
(*Voir* DESSINS.)

This last entry may refer to drawings for the painting itself.

The title *The Railway* (Le chemin de fer) (or less frequently *The Railroad*) seems to have been altered when Durand-Ruel brought the painting to the United States. Understandably, the American public's limited command of French would hardly be expected to ponder the wit of a painting called "The Railway" that did not depict a railway, but that same public would likely be entranced by the "Frenchness" of the *place*. The title, *The Gare Saint-Lazare,* is thus truthful in its specificity and tells us something the original title does not. I prefer the secondary French title, and will try to treat the painting without slighting the railroad, which I believe to have been a minor theme in the work.

Lest too much meaning be connected to these works' titles, it should be noted that some of Manet's titles are not those he himself first intended. For instance, the *Déjeuner sur l'herbe* began its public life as *Le Bain.*

38. George Mauner, *Manet: Peintre-Philosophe,* pp. 2–3. Mauner notes that "Manet himself, by his words and deeds—transmitted by his friends and supporters, notably Antonin Proust—has contributed substantially to this confusion." Proust was Manet's friend and onetime fellow student.

Fig. 8
Édouard Manet
The Barque of Dante (*copy after Delacroix*), mid-1850s, oil on canvas, 36 × 43 cm., unsigned. Museé des Beaux-Arts, Lyons.

Fig. 9
Édouard Manet
The Barque of Dante (*copy after Delacroix*), mid-1850s, oil on canvas, 33 × 42 cm., unsigned. Metropolitan Museum of Art, New York.

39. Duret, *Manet and the French Impressionists*, p. 82: "The rail formed the boundary of a small garden overlooking the deep cutting of the railway near the Gare St. Lazare."

40. Victorine Louise Meurent (sometimes written Meurend) was long a favorite model of Manet's. She posed for the last time for him in *The Gare Saint-Lazare*. Afterward, she traveled to America. On her return to Paris she resumed an intimate relationship with Alfred Stevens and continued to pose for other painters. At the time of *The Gare Saint-Lazare* she lived at 1 Boulevard de Clichy. After ending her relationship with Stevens, Victorine herself aspired to be an artist, studied with Étienne Leroy, and sent a self-portrait to the Salon of 1876, where it was little noticed. In 1879 and 1885 she again sent work to the Salon. She took to making the rounds of the cafés and nightclubs of the Place Pigalle. Becoming a street singer who was reported to travel with a guitar and monkey, she drank heavily and was known as "La Glu." Thus she reverted to what she had been when Manet painted her in 1862 for *The Street Singer* (see fig. 15).

41. Beatrice Farwell, *Manet and the Nude: A Study in Iconography in the Second Empire* (originally a Ph.D. dissertation, UCLA, 1973) (New York: Garland York, 1981), pp. 161–162. Of course, this tie to the past would have been exactly the sort of connection that Manet would have most sought out. More convincingly than the supposed harsh charm of her features, Victorine Meurent's link to Delacroix could have proved an irresistible attraction as a bit of living history.

Opposite
Fig. 10
Eugène Delacroix
Scenes from the Massacre on Chios, 1821–24, oil on canvas, 422 × 352 cm. (166 × 139 in.). Louvre, Paris.

Lazare's dutiful record of an out-of-doors setting did not exhaust Manet's ambitions for this configuration. A secreted libretto animates the apparently neutral and inactive scene.

The scene's location contributed to the work's meaning. Hirsch's garden overlooked the railway cut.[39] Behind an iron grating at the rear of the work the steam and smoke of a passing train obscure the tracks and, indeed, any view of the train.

To attempt a major work of ambiguous exposition, at one moment forthright and in the next instant self-consciously mired in the conventions of his art, Manet repaired to familiar supports. Victorine Meurent, who had now been Manet's model for a decade, posed as the young woman.[40] In addition to her long association with Manet, Mlle Meurent may have worked for Manet's seniors, as Farwell notes:

> Among the unbound photographs of the nineteenth century preserved at the Bibliothèque Nationale is a group by Quinet, lithographic editor, in 1852 and 1853, representing a model in various poses and various degrees of undress who is almost certainly Victorine Meurent. . . . If she is Victorine, this would constitute evidence, besides that of her posing for Manet, of the class of woman to which she belonged. Moreover, she would have to be at least 17, perhaps 20, in these photographs in 1852–3, making her 27 to 30 in 1862–3. This does not seem inconsistent with the way she looked when Manet painted her for the first time. It would also account for her looking so much aged in *The Railroad* [*The Gare Saint-Lazare*] in 1873, when she would by this accounting have been 37 to 40. . . . Assuming this model to be Victorine, another interesting fact surfaces: she is the model whose likeness in the hands of Delacroix became the small *Odalisque* of 1857. Delacroix owned at least two prints of her, in one of which the model is in the same pose as the *Odalisque*. . . . We have then the remote possibility that Victorine Meurent regaled Manet in 1862 with reminiscences of posing for Delacroix, even though only for the photographer.[41]

Hirsch's daughter, Suzanne, posed as the little girl. (The two figures are not a mother and daughter, as sometimes thought. The idea seems to have started with Philippe Burty.) For some viewers the work's subject was simply portrayal. Anne Coffin Hanson noted

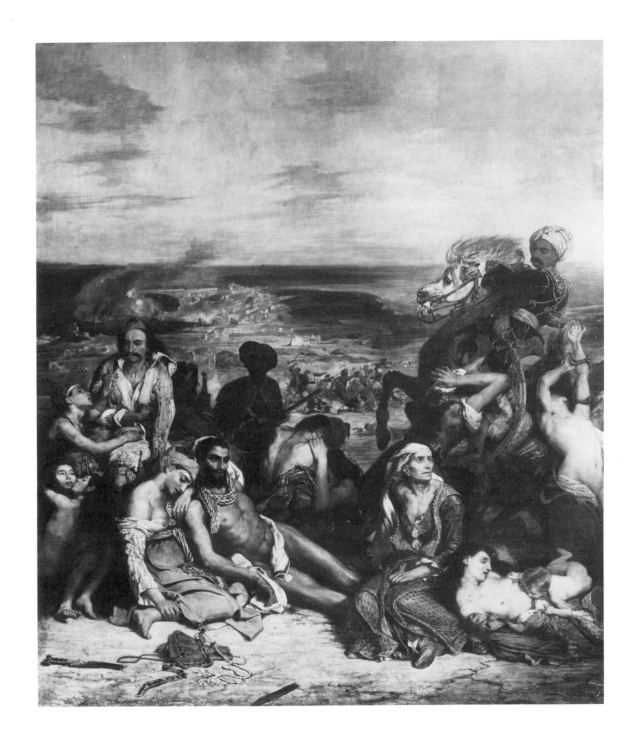

42. Anne Coffin Hanson, *Manet and the Modern Tradition* (New Haven and London: Yale University Press, 1977, 1979), p. 77.

43. The notion of a "historical epoch" is an interpretive construct based on a constellation of facts. For the historian, facts are not so different from those in science; they mark the intersection of observation and utility, but documentary material is not subject to empirical reconfirmation. Facts mark the coincidence of data and the assumptions that raise data to a level of situational pertinance. The historical model embraces as much pertinent material (facts) as can be subsumed into a coherent unit. For the art historian the situation is somewhat different from that facing other historians, sufficiently so to invalidate Peter Gay's assertion that

> Art, in short, inhabits the same past as business, religion, or politics. It is only that the art historian selects his distinct quarter of the past, in his distinct way. (Peter Gay, *Art and Act* [New York: Harper and Row, 1976], p. xi)

His last phrase is telling, inasmuch as Gay equates art history with a method and not with the differentiating characteristics of its subject, primary among which is the *presentness* of the art object to the art historian's reexamination—a luxury unknown to the modern chronicler of the Battle of Blenheim or the effect of diet on fourteenth-century urbanites. These and other typical historical questions could not be more different from the art historian's confrontation with the extant object. For the art historian, some part, often the crucial part, of the past is still among us.

44. Duret, *Manet and the French Impressionists,* p. 6.

45. Courthion, *Edouard Manet,* p. 10. Earlier in this same passage, Courthion reveals his prejudice that "today when I think of Manet, who painted luminous flesh and shining eyes in the world's loveliest light, I seem to see a veritable procession of delectable women."

that "works like *The Railroad* and *The Conservatory* are portraits in the sense that they fulfill Castagnary's aim and allow the spectator to use them to reconstruct an epoch."[42] What the character of an epoch might be, or might have been, touches precisely upon the job of the art historian, since the "epoch" is a historical model.[43] At least superficially, we can suspend the obligations of history and genially concur with Duret who noted that "Manet was the painter of real life."[44] But to accept at face value this work's documentary potential to illuminate the past, unattended by critical history, puts us at the mercy of a gentle evocation. Unfortunately, this method of deriving our notion of the nineteenth century eventually would be discovered to have produced a very different image for each of us—lovely poetry but not expositional history.

If *The Gare Saint-Lazare* merely presented the opportunity for portrayal, Manet's ambitions might have been fairly simple. Painters need no excuse to exercise their art in adulation of light and women in the city. To the degree that he dealt with specific, particularized depictions, Manet engaged portrayal; when he generalized, he engaged in allegory or general history. These figures might have been but objects that he exalted by selecting them as the target of his painting so that "the women are not mere images. Manet has given them a personality and a background of their own. And above all, he relishes them as he would ripe fruit."[45]

There is no diminishing either the sensuality of Manet's painting, or his sensuality as an observer. Yet what we know of Manet's treatment of subject matter in other works, the sources he tapped, as well as his approach to the profession of painting suggests an enormous seriousness of purpose. A vision of his massive artistic responsibility should restrain Manet's commentators from assuming that any vague, hasty, or frivolous intention might have compelled such work. Still, viewers would hardly suspect that Manet's focused artistic concerns posited grand meaning for *The Gare Saint-Lazare.*

If one conceives of subject matter in terms of narrative or portrayal, for example, then certainly nothing like traditional subject matter appears in this picture, and Duret would have been right in assuming that nothing was transpiring in the painting. The issue of narrative construction would not have arisen for Manet's contemporaries, because the painting does not seem pertinent to storytelling at any point (except that through such stillness, reductionism, and

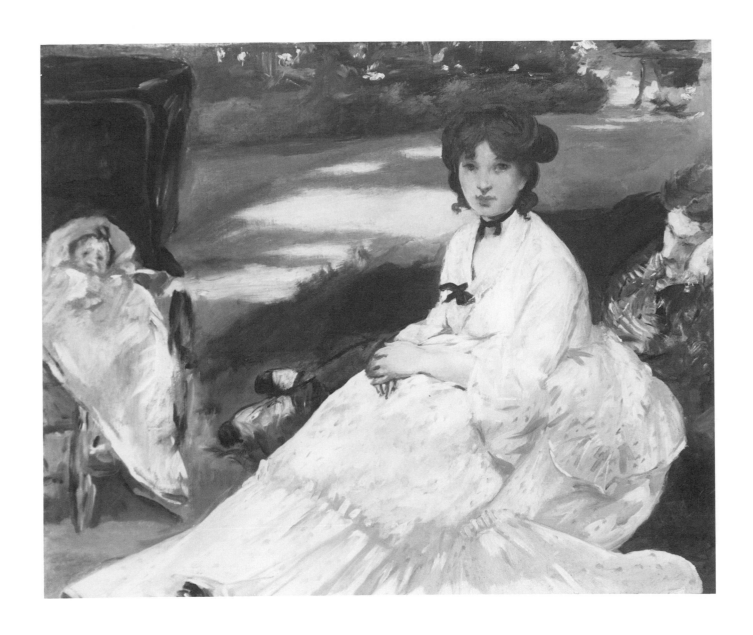

FIG. 11
Édouard Manet
In the Garden, 1870, oil on canvas, 45 × 55 cm.,
signed. Shelburne Museum, Shelburne, Vermont.

46. The present attempt at description does not suppose an emotional relationship between the two figures or any past associational history for them. The woman and the girl are not assumed to represent anything that is not pictured, nor should we merely suppose—or need we construct—any putative extrapictorial relationship for these figures beyond what we observe (for example, that they are a mother and daughter). Unsupported personalities for the subjects (suppositions introduced on the occasion of an analysis) would yield only spurious conclusions, however tempting this solution might be to dramatize what appears to be an almost hopelessly vacant situation.

narrow focus Manet may have questioned the very limits of narration). Modern writers have not engaged this work as narrative in either a traditional or a special reading. To recount either a fictional or actual event in art, the spectator and the artist must share a sufficiently broad understanding of the subject for the recognition of characters, sequence of events, and action to be legible through the chosen style. Generally, the visual arts cannot tell a story, but the viewer can be *reminded* of an event or sensation. Since these are not portraits of celebrated personalities, the spectator brings no associations to this work, and there is no obvious storytelling occurring. The frustration of Manet's critics was complete. *The Gare Saint-Lazare* was neither portrayal in any traditional sense nor recitation of any obvious event. Depicted things (a portrait, still life, or landscape) can refer back to the style of depiction and can thus identify a métier. *The Gare Saint-Lazare* does not obviously describe motion (a local gesture) or process (an allegorical generality), nor does it offer the overt performance of an "action" that transforms the situation (a localized incident of which narrative is built). It neither names any self-evident cluster of things nor does it tell any evident story. The painting can thus be likened to neither a noun nor a verb.

At the Gare-Saint Lazare

To grasp the full import of this painting, we ought to begin by simply cataloging its subject matter without imputing motives to the portrayals or injecting relationships (that is, traditional narrative relationships).[46] The picture does not inform us concerning the personalities of its subjects, a fact with which we must at first reconcile ourselves and which will later prove to be a pivotal feature of the work. Created, or willed, relationships for the figures (unsupported by evidence in the painting) would supplant whatever actual concerns may underlie the picture.

Biographical research could reveal the personalities that animated Victorine Meurent and Suzanne Hirsch in life, but such information was not generally known to Manet's spectators and was therefore probably not a major component of the work. Surely,

Manet was engaged by a challenge that surpassed the inventing of plastic expressions for individuals already knowable to his audience (that is, caricature). The temperaments of the depicted individuals are not part of the picture's significant cargo. Exactly this lack of overtly expressed personalities—a trait typical of much of Manet's work—distinguishes this painting. Revoking so many possibilities for drama, Manet (and his work) appeared singularly devoid of a limber wit or agile intellectual faculties. We may initially suppose, as Zola did, that Manet was an unthinking painter.

To impute serious ambition to Manet, we must attend to the actual disposition of things within the work. To construct psychologies for the subjects would oust the painting's ample self-evidence for a false notion. The resulting narration, forcefully insinuated for the convenience of the perplexed spectator, would link the two figures in a web of meanings, endlessly arguable and utterly without pictorial foundation. Yet to subtract the possibility of this sort of consideration would make the picture so bereft of traditional subject matter that it begs the injection of some outside supporting matrix in order to diminish what appears, in a superficial reading, to be nothing but commonplace and inconsequential. This dilemma greeted the painting's first critics; we know their response. Subsequent spectators have appreciated the paint handling and controlled light in *The Gare Saint-Lazare* without questioning Manet's objectives for the work.

Remarkably, reciting a detailed inventory of the painting's subject matter reveals the components of a compelling argument. A plain reading of the depicted situation thus allows us to measure the range of concerns of *The Gare Saint-Lazare*. Arising from the firmest of sources—the work itself—the disclosure illuminates something of Manet's intentions and his interests when he composed the picture.

AT THE GARE-SAINT LAZARE: A LADY AND HER BOOK

WE CAN BEGIN THE INVENTORY OF THE PAINTING'S SUBject matter with the dominant figure of Victorine Meurent. Fingers interleaved in a book (fig. 12), she had been reading with great

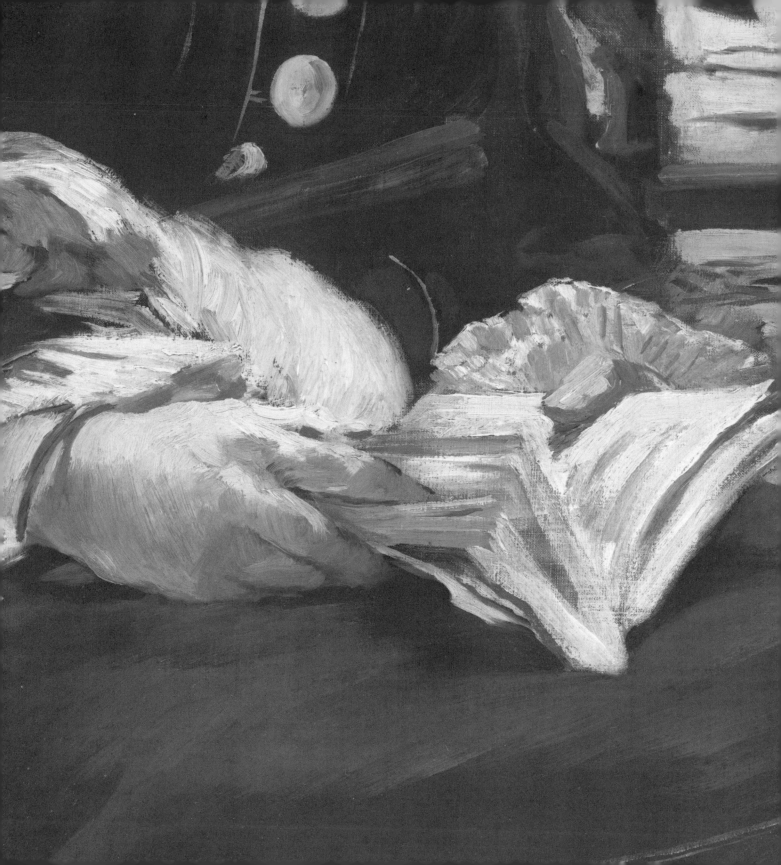

47. Perhaps she had been reading aloud to Hirsch's daughter, but then the interruption that had raised Victorine Meurent's eyes might have turned the head of the little girl, whose attention is fixed beyond the bars, down on the tracks. (Although remote, the possibility exists that Manet intended Victorine Meurent to be holding two books in her hands, both open for consultation. Because of the broad paint handling in this passage that details the spine of the book, one cannot be certain just what Manet may have wanted the spectator to see [one paperback book, or two]. Nevertheless, the sense of consultative reading is the essence of this motif.)

The paint handling for the pages of the open book is necessarily broad, but, because of the dark smudges that represent the text, we know Mlle Meurent was reading, and not looking at pictures and that, moreover, the irregular spacing of those lines suggests she might have been reading poetry. Not a crucial point in the pursuit of the picture, it is certainly worth noting that Manet left this possibility open to interpretation.

48. This shed appears in several of Monet's studies of the Gare Saint-Lazare. His *Exterior of the Gare Saint-Lazare,* 1877 (Wildenstein #444) and the 1878 *Exterior of the Gare Saint-Lazare* (Wildenstein #443) both depict this workers' shed. Today, as a somewhat eery resurrection of a century ago, a similar structure (this one made of waffled aluminum) rises just a few feet from where Manet and Monet depicted the old shed.

FIG. 12
Édouard Manet
Detail from *The Gare Saint-Lazare,* 1873. National Gallery of Art, Washington, D.C.

concentration and seriousness. Not only are the pages held open to what lies directly before her but she also marks another place with the index figure of her right hand, perhaps another with her left index finger, and possibly yet a different page with her right thumb. As if in a close reading, she had been moving back and forth through the book, perhaps comparing passages, consulting a footnote, examining illustrations, or weighing the merits of one poem against another.[47] Clearly, she was engrossed. Her reading insulated her from the roar and hiss of the trains passing behind her and from the usual street noises. Oblivious to the noise, she followed the intricacies of the text (although her focused concentration on reading also admitted an unconscious awareness of the child's safety). Yet something has wrested her attention from reading: when we encounter her, Mlle Meurent raises her eyes at our presence and stares out toward us, perhaps recognizing the spectator, perhaps not. She is now alert. Her attention which has expanded from the closure of intensely focused reading to embrace the wider field of which we are a part (but only a part) is now free to swing in a wide arc that embraces all of Paris, the street before her, the noise of the railyard behind, and potentially everything else in the visible world. None of this activity and wealth of sensation, so apparent to the spectator of the painting, would have been noticed by her when she was submerged in her text. An instant before our "appearance" her eyes had scanned the pages of her reading and now she looks at us through the space of the painting.

AT THE GARE SAINT-LAZARE: THE CHILD AND THE BUNCH OF GRAPES

IF VICTORINE MEURENT'S INTERRUPTED ATTENTION TO her volume describes one sort of concentration, a more diffuse and perhaps deeper kind is represented by Suzanne Hirsch, who stares through the iron fence into the steam. Only a railroad shed in the middle right might distract her attention. There, two tiny figures are placed, one in the door of the shed and the other striding toward the right.[48] But the child pays no notice. Instead, she looks down and to the center, into the very swirling heart of the steam. Unlike

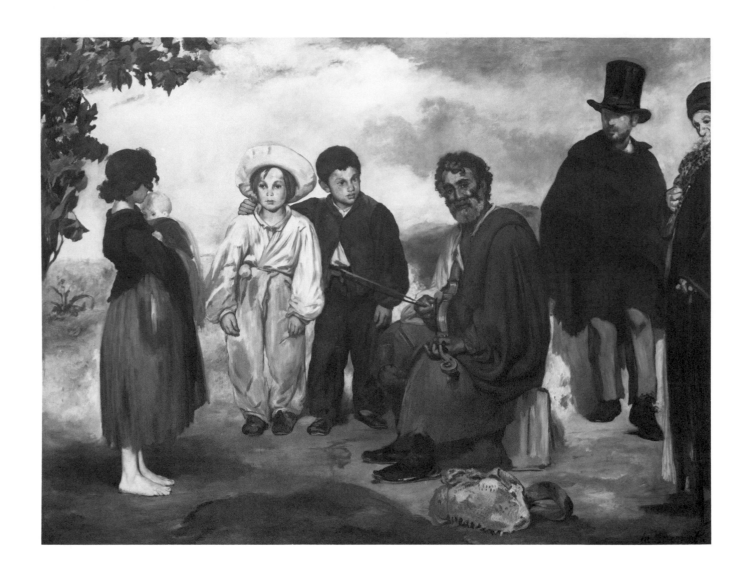

Fig. 13
Édouard Manet
The Old Musician, 1862, oil on canvas, 188 × 248
cm., signed and dated. National Gallery of Art,
Washington, D.C.

49. We cannot know with absolute certainty that Suzanne Hirsch is actually eating the grapes as we view her in the picture, nor can we be certain that she is *not* eating them. Moreover, the grapes appear as the book's counterpart (in compositional and sensual contrast) and as part of the constellation of introspective sensations that the painting examines.

the adult, the little girl ignores our gaze. Her back to us, Mlle Hirsch is painted with a lost profile, and we can only suppose her features. She is rendered anonymous, her features general. We share something of her musings as she stares into nothingness, since we can only guess at how she absorbs that imprecise and steamy image.

Once before Manet had employed the lost profile for a central figure, also a little girl, in *The Old Musician,* 1862 (fig. 13). Holding an infant, the ragged waif on the left looks back, into the center of the composition. She, who may have been a gypsy, meets the gaze of other figures within the painting, and an internal resonance is established, knitting the whole together. Unfortunately, the rest of the composition is too flimsy to really bond the other figures. The work is often described as treating alienation and displacement, which may be the case, but the figures' isolation and their lack of artistic integration bespeak Manet's limited powers in the early 1860s more than it does alienation.

By the time of *The Gare Saint-Lazare,* Manet had mastered his compositional problems regarding the placement of self-absorbed figures in proximity. In place of the exchange of glances in *The Old Musician, The Gare Saint-Lazare* richly affiliates many kinds of eye contact to engage us, the painting's viewers. Prominent in this repertoire of devices that modulate sight is the lost profile. For the spectator of the painting, the face (and identity) of the beholder of the steam are unseen, and one imprecision symmetrically matches another: the drifting blank cloud, without describable shape (and therefore simply a "type" [cloud]), has been given its perfect equivalent in the child's missing expression. Suzanne Hirsch is known to us only in a generic sense, as a little girl dressed in a certain way. Although her lost profile might have been coincidental or required by the composition, in this context her gesture of turning away complements and amplifies Victorine Meurent's attentiveness.

Similarly, the bunch of grapes placed near the little girl indicates that she has been (absentmindedly) eating.[49] Whatever the compositional demands of the scene, the grapes are not placed *between* the figures to imply that they are being shared. Rather, they lie at the extreme right of the painting, where they are as much an "attribute" of the child as the book is of the adult. This snack of fresh fruit has been brought to satisfy the cravings of the youngster, who cannot distract herself by reading. Just as she exhibits a lost

50. Duret speculates that the little girl holds the bars with both hands, but there is no way of knowing whether this is so and no overriding reason to believe that this is the case (Duret, *Manet and the French Impressionists,* p. 78).

51. The whole gustatory apprehension of the world, that dimension explored by cooking, represents a truly nonobjective art (except to the extent to which, say, eating seafood "reminds" us of the sea because of the salty aromas of the food. Such recollections, however, do not recall the ocean by the substitution of another symbol for it. Rather, they present us with a small sample of the ocean by which the whole is represented). To only name the flavors assigns designations in a procedure that advances no farther than the originating flavor or scent in creating descriptive analogies to worlds and experiences. The symbolism of taste is that of exemplification—a food may be salty, sweet, hot, cold, etc.; it is not a general symbolism, capable of wider implications.

52. Cooking and food, however soul satisfying or magnificent, can never attain to high art. For reasons having nothing to do with cooking's impermanence (the same toll of evanescence rules theater and dance), cuisine cannot be high art precisely because it lacks *symbolic* content. The meal, although culture-bound to a grammar, can never gesture away from its own constituents to a world of other substances and situations, unless it is a ritual meal or is structured along programmatic lines. It is precisely in this regard that the high, the "fine" arts distinguish themselves, as they transfigure one set of sensations into meanings beyond the realm of the incidental faculty. The artistic intelligence exhibited by the greatest artists in their play of forms and structures is never mistaken for the total intention of an art, yet such is the total expression of cooking—the most formal and nonobjective of the arts, sprung from basic need. Although arising from the mere need for nourishment and for the satisfaction of hunger, cooking surpasses a craft when practiced in its more august reaches or in a purely folkish manner that minimally alters its ingredients.

53. In the lower left of *Los Borrachos,* the only figure with a lost profile and his back to the spectator gazes into the center of the composition; this

profile, the child also exhibits a "lost gesture": her right hand, perhaps still holding a grape, is raised to her mouth. As we must invent her face, we must also imagine her gesture.[50] In contrast to reading, with its conscious, deliberate, and conventionalized symbols for the adult's pleasures, the child is absorbed in unnameable cares. Even more certainly than the mathematical relationships of music, which seem so abstract in comparison with the other arts, the symbolism of taste is totally abstract and nonobjective in that it refers to nothing else.[51] Manet essayed the contribution of the senses as attentively as he construed the other elements of the work.

The totally interior, saporific universe tasks the visual artist to create images that suggest taste. The intimate emotions engendered by seeing, which challenged the Impressionists, are subject to communal verification at a distance; we can point at what we see, requesting confirmation. Taste, however, locates an intimacy much less subject to substantiation. Manet eloquently matched the quality of taste, the perception of flavor, with a figure whose features remain unknown to us. We espy the girl engaged in complete self-absorption, committed to the most personal of perceptions. Her nibbling from the bunch of grapes proposes a thoroughly mental, interior, nondiscursive, and phenomenally absolute set of considerations.[52] To picture the consumption of food is to show a coarse bodily function. Indeed, so strongly corporeal is eating that scenes of eating and drinking have been employed throughout the history of Western art to show rowdiness, drunken good nature, and to accompany lust. Certainly, one of the supreme expositions of the mischievous effects of "the grape" is Diego Velázquez's *Los Borrachos,* c. 1628 ("The Drunkards") (fig. 14), in which a young man, crowned as Bacchus with vine leaves, bestows a leafy coronet upon one of his "followers." In fact, this mock-classical scene depicts a group of deeply inebriated contemporary Spaniards in every range of reaction to insobriety.[53] A full spectrum of reactions to drinking is essayed, from leering riotousness, to introspective (if temporary) self-reproach, to momentary religious experience, to stupefaction.[54] This amazing early work by Velázquez was a special favorite of Manet's. Although Manet seems never to have copied the work in oils, its image peers centrally from his *Portrait of Zola.* The appeal of *Los Borrachos* to Manet may have stemmed from its remarkable conceptual program, which spanned the total range of psychological reactions to wine.

FIG. 14
Diego Velázquez
Los Borrachos ("The Drunkards") or *The Triumph of
Bacchus,* c. 1628, oil on canvas, 1.165 × 2.25 m.,
Museo del Prado, Madrid.

33

device for entry into the piece appears in Veláz-quez's *Surrender of Breda* (Prado), where a man at the left, the only one with a lost profile, looks *into* the work, the same position occupied by the little girl in *The Old Musician*.

In Manet's copies of *Les Petits Cavaliers* (a painting executed around 1855, in which Manet substituted himself for the figure then thought to be Velázquez), and in an etching in several states, 1860, a gentleman on the left looks into the composition from among a cluster of cavaliers, one of whom gestures into the center of the work. This design was based on a Spanish painting in the Louvre, *Cavaliers,* that in Manet's lifetime was thought to be by Velázquez. Thus, Manet *thought* he was copying his revered master, and this device for binding the composition may have been a principal attraction, sufficiently strong to warrant the copying. Perhaps this mechanism's most adroit demonstration appears in Velázquez's *Las Meninas,* where the painting upon which the artist is shown at work (probably the very picture that we view), serves—in the same position in the lower left of the picture—as the "lost profile," the figure whose face, gazing into the depth of the painting, we cannot see. This function surfaces in two objectified relationships in *The Gare Saint-Lazare:* the little girl whose lost profile directs our gaze into the picture (and invites our speculation about her features), and the book (another "lost" surface that invites our speculation about its text).

54. *Los Borrachos* spurred Manet's interest in (or introduced him to) the figure who engages the internal space of a painting by looking back into the space we examine from outside. The painting also describes human reactions to wine, and something more. The picture enumerates the states wine passes through as it matures. The old cloaked man on the right, for example, holds a cloudy glass of must—the fermenting, already mildly alcoholic juice that is partway toward becoming "new wine." We recognize the hazy beverage, full of sediment because Velázquez contained it in a clear glass tumbler—an informal vessel for a popular drink, tasty if bespeaking impatience. In the rear of the painting the reclining seminude holds an elegant clear wineglass of new wine, less cloudy than must, but still murky; we can still see the difference by comparison. The grinning figure in the center of

the picture holds the mature clear vintage in a classical ceramic as the drinker returns our glance and offers a quaff.

55. In an earlier work, *The Street Singer,* c. 1862 (fig. 15), Manet attempted to introduce the sensation of taste into his work with the flavor of cherries eaten by Victorine Meurent. A frontally explicit presentation of her eating worked counter to his purposes, and this element of the painting has never won support from spectators. The motif never realized its potential and has been conspicuously singled out: "The cherries in the sheet of yellow paper held in the crook of the woman's arm are another inexplicable detail. . . . Whether intended or not, details such as the hat and the cherries signal the composition as a fiction created in Manet's studio" (Moffett, *Manet, 1832–1883,* p. 109). I believe such details were intended to be explicable and were meant to engage as wide a range of sensations as possible, although until *The Gare Saint-Lazare,* Manet's conceptions were imperfect to this task.

56. In general, parallel and prolonged illustrative relationships between a superficial representation and a deeper meaning would betoken allegory. Such an extended metaphor has no place in Manet's art in which the particular is never made an emblem. Allegory's circumscribed sets of fixed (denotational) associational networks were not Manet's objective, and such distinctions in the operation of "symbolism" underlie the present discussion.

As the adjunct to religion or in regard to ritual meals, eating's baseness can be set aside, as in paintings of the Last Supper, or of the Supper at Emmaus. Otherwise, it seems impossible to depict the act of eating and still solicit the ethereal qualities and ephemeral sensations of aroma and taste. Manet solved this problem by showing someone *not eating* but only suggested as eating. The sheer savor of food and the indescribable sensation of tasting fruit can enter the iconography of art, but only with the most exquisitely careful preparation of a scene.[55] The figures' contrivances suggest that Manet wished to invoke this impalpable world of taste as part of a greater scheme. A range of sensations passes through the little girl, from her tangible, sure grasp of the iron fence (touch), to her lost profile as she observes the steam (sight, both outward and inner), to her lost gesture of raising the fruit to her mouth (taste).

The paradox of a spiritual state, represented by the coarsest sort of absentminded consumption, recalls analogies of carnal love extrapolated qualitatively—and sometimes by an order of magnitude—to represent divine ardor (a prime example are the apologias for *The Song of Songs'* canonical status). *The Gare Saint-Lazare's* representation of simple consumption was meant to connote something beyond the literal depiction. Thus, it does not "stand for" another state in a simple one-to-one substitution of a symbol for an idea.[56] The child's nibbling of her grapes animates a richer situation than what appears superficially to be a mildly innocent portrayal. The graphic prominence of the bunch of grapes (lying separated on a ledge, the center of its own circle of compositional focus) suggests, however tentatively at first, the classical world. Another level of references is thereby introduced: literary symbolism.

This nibbling, a tantalizingly unseen (corporeal) act, embraces a wide range of implications. Its very absence from the apprehensible front of the image robs it of the specificity that would contain and limit the gesture's possible pictorial alignments. The motif can suggest an analogy to immaterial things, to a certain aura of the past, as well as to the child's interior psychological world. All these different readings, simultaneously sustained and mutually supportive, hover before us because of the context within which this image occurs. So resonant is the image (of the inviting and archaic icon of the grapes, whose taste we know, and of the little girl who consumes them, whose face we do not know) that once we fix upon this

57. Émile Bernard, "Le Symbolisme pictural, 1886–1936," in *Charles Baudelaire* (Brussels, n.d.), p. 45, trans. P. S. Falla in *French Symbolist Painters* (Arts Council of Great Britain, 1972).

58. Even poets who did not seem to partake of Symbolism's inheritance maintained assumptions of the movement. For example, in 1917, Ezra Pound cautioned the artist that "As for "adaptations," one finds that all the old masters of painting recommended to their pupils that they begin by copying masterwork, and proceed to their own compositions" (Ezra Pound, "A Retrospect," in *Pavannes and Divisions* [1918], reprinted in *Literary Essays* [New York: New Directions, 1954] p. 10). We recognize this as Manet's pattern of self-education. But at the heart of modernist poetry, in either its Objectivist or Imagist avatar, was a credo never stated more forcefully than by William Carlos Williams's, "Say it, No ideas but in things." (*Paterson*, Book I [New York: New Directions, 1963] pp. 14, 18) which is the central tenet of Symbolism and the theme of the current essay. I am not claiming that Pound and Williams's French experience supplied the direct influence of Mallarmé, for other channels of experiment were far more attractive to these Americans, notably the writings of Jules Laforgue. But, via Mallarmé's intellectual descendants, who were legion, and through the general character of the times—strongly affected by Mallarmé's writing—fundamental assumptions came to occupy the core of much writing that could not be ascribed to a direct Mallarmean model.

59. Trans. Guy Michaud, *Mallarmé* (New York: New York University Press, 1965), p. 24.

arresting contrast we must disenthrall ourselves from these two related elements. Together the (unseen) gesture and the object (grapes) compound a new specific meaning, realizable only by this ideographic combination. Each constellation of images in the picture resounds until it suggests other states wholly removed from the original condition, and no one motif by itself asserts that world of relationships which unites the entirety of *The Gare Saint-Lazare*. Together these frank pictorial elements compound a richness that supports the entire painting as a prime example of the Symbolist mentality.

Symbolism Espied

What then was the end proposed by pictorial symbolism? The same as that proposed by literary symbolism: to unite form and content while at the same time raising the work of art to a level to transcend idealism.

Emile Bernard[57]

In *THE GARE SAINT-LAZARE,* MANET INTERRUPTS READING to remind us of what the absorption of reading is like. Not showing us the act of eating he reminds us of flavor. He contrasted reverie and attention to induce the feeling of concentration. Neither describing ideas with traditional allegory nor presenting emotional states by dramatic poses, Manet suggests ideas and emotions. All of this was accomplished by means of otherwise unexplained symbols, symbols outside the flow of a narrative and uncodified in emblem books. This formulation of unique imagery rests at the core of Symbolism as practiced by poets.[58] The introduction to *The Gare Saint-Lazare*'s construction recalls Mallarmé's words about his special, purposely concise techniques for summoning memories in order to reawaken in the reader stirrings far beyond the apparent powers of text: "One must always cut the beginnings and the end of what one writes. No introduction, no conclusion."[59]

Manet's compositional intelligence, which had once borrowed from disparate sources to construct a dialogue with painting and history, now combined diverse occurrences in his own world to form a synthetic meaning of a higher order than the original elements could by themselves conduce. The different forms of the two models'

60. Certain art historians of an archival bent will want documentary proof of this sort of statement; I, too, would like apodictic proof of this book's general argument. Lacking the discovery of a cache of Manet's letters or notes, however, we must be directed by his work. The skeptic must cope with what, under other circumstances, might seem a high proportion of secondary sources.

attentions have each been perfectly assigned, although first appearances do not suggest a complex symbolic program for the painting. The contrast between the two figures is not that of pure opposition, with an isometric balance of one trait for another, a dialectic of only two contrasting sets of considerations. Rather, *The Gare Saint-Lazare* affords the occasion to examine many points within an enormous stratified range of behavior. In the painting's every aspect Manet expended extreme care to afford counterparts for each level of consciousness. Accordingly, the picture materializes in its entirety as a mechanism for discourse on the nature, types, and occasions of consciousness itself.

Victorine Meurent's book, with the white of its pages—vessels of meaning with the potential to convey all the world of ideas, of discursiveness—is utterly differentiated from the girl's reverie. If the child's state were exhibited by an adult, we might call it meditation, for it is wordless and expunges the ego. These different measures of consciousness might at first be taken to represent a thematic coincidence. But certain symmetries begin to appear, such as the obvious spatial one in which the adult turns toward us, and out of the painting, while the child turns away, into the picture and its blank world. Not coincidentally, the child stares raptly at the "blanc," the white emptiness. An emissary, perhaps from the white world, the child wears white with a blue sash; the adult is attired in exactly the opposite colors, blue with white highlights. Were this opposition of states of mind (as well as a third condition, that of the adult's absorption in reading) happenstance, Manet's intentions for *The Gare Saint-Lazare* would not be indicated clearly enough to fashion a case for his methodical calculation. But the insistent reinforcement of the theme of consciousness and the spectrum of its various states appears throughout every part of the painting.[60]

AT THE GARE SAINT-LAZARE: A CREATURE DREAMS

EVEN MORE INTANGIBLE THAN ANY WAKING STATE, however meditative or diffuse, is sleep, and in sleep lies the great mystery of the dream. This condition dwells beyond discursive

Fig. 16
Titian
The Venus of Urbino, 1538, oil on canvas, c. 4 ft. × 5
ft., 6 in. Galleria degli Uffizi, Florence. Art Resource,
Inc.

FIG. 17
Édouard Manet
Olympia, 1863, oil on canvas, 130.5 × 190 cm.,
signed and dated. Musée d'Orsay (formerly Galeries
du Jeu de Paume), Paris.

61. Manet painted a series of dog portraits, beginning in 1866 with a *Spanish Dog,* for which there is also an oil study. In 1875 he painted three such pictures: *"Tama," a Japanese Dog, "Bob," a Rough-Haired Terrier,* and *"Douki," a Yorkshire Terrier;* and *"Minnay," a Terrier,* was painted in 1879. All these pictures are of compact animals, and are painted on small canvases. None has any background details, and all are pure portraits. Obviously fond of dogs, Manet's distinctive equanimity and sense of proportion balanced affection with necessity. A few years after the last of these canine portraits, as his life was drawing to its close,

> the days passed painfully for his friends. However, he continued to work while each of us tried to keep him amused. One day Mallarmé called with his dog, Saladin. "Don't be stupid, Mallarmé, your dog will smash up thirty thousand francs worth of canvas for me." The dog was put outside. (*Memoirs of Antonin Proust* [Paris: H. Laurens, 1913])

62. A constellation of the book, the sleeping puppy, and Victorine Meurent's lap, in which the other two elements reside, cross-reference one another in an insistent canon. The poem-as-book (or art itself) arises from desire; blind urges, such as lust (sex, or more general appetites as represented by the grapes), lead us toward goals we cannot anticipate. It is hard to imagine a denser cluster of images more carefully arrayed to assume the appearance of an "artless" deployment, a thing seen and recorded without further thought. Within the work, this group is attractive and compelling. Yet the very existence of such meaning-laden ideograms has been excluded from a dominant view of Manet's art, "because of Zola's insistence that Manet simply set up his easel in front of his model and went to work, even Baudelaire may not have been aware of the way Manet collected and remembered images, creating a large vocabulary from which he could draw" (Anne Coffin Hanson, *Edouard Manet: 1832–1883* [Philadelphia: Philadelphia Museum of Art, 1966], p. 80).

63. *L'Après-midi d'un faune* (1865) does presume on the interior life of a beast, and it supplies a precedent for such artistic and psychological spec-

knowledge, although we attempt reconstructions when we return from that distant country. With words, we try to piece together the meanings of dreams that are prelinguistic, or protolinguistic, and that both generate a symbolism beyond our waking capacities and order those symbols in a grammar that is elusive and rare. To complete the graph of consciousness—which peaks with the high noon of adult wakefulness, descends through the concentrated field of the adult's reading and its directed imaginings, and then dips into the world of a child's thoughtless nibbling at her grapes and into her wandering attentions—the dream would have to be accounted. And how much more profoundly dreamlike, mysterious, more unknown (and unknowable, since it lurks outside the very possibility of linguistic retrieval), are the dreams of an animal, and not just any animal, but a baby animal, a puppy, its own consciousness a blank.[61] What are the dreams of a puppy?[62] Fresh and newborn, it is both uninformed in its canine world and impossibly distant from the human imagination. In its sleep—thrice removed from us, by slumber and dreaming, by species, and by infancy—it occupies a state we cannot know.[63]

As great as the distance that separates the little girl from the sleeping puppy, the same proportional analogy distinguishes the child from the experienced and literate woman—who may, to express herself, call upon all the inventoried creations of world literature.[64]

If Manet had wished to chart the extremes of animal consciousness, he ignored nothing. By placing the sleeping puppy in immediate proximity to the book, he fashioned a grand ligature between culture and biology, between experience and its sublimation in artifacts, of which painting is a special example. This is the true afternoon of dozing animals, of all animals including those who, like the child, graze. The states of human and animal consciousness have been enumerated.[65] It should be noted that the general term *fauna* in English, for animal life, is homonymic with the French word *faune,* for a particular animal.[66] Manet has rendered a naturalist's factual account of the "fauna" one might encounter while wandering the precincts of a great city. The differing interdependencies of this "ecological niche" identify a small corner of the closely observed modern world. The subject was arranged to render a densely focused meaning—but, then again, in art nature always conveys an unnatural, anthropocentric meaning.

ulations. Significantly, the two works' shared concerns begin to suggest Manet's proximity to Mallarmé.

64. Nor was Manet the first to employ the dog as an entry into a psychological level of a painting. In a work that may rightly be called one of Edgar-Hilaire-Germain Degas's masterpieces (*A Carriage*) *At the Races*, 1870–72 (Museum of Fine Arts, Boston) situates a dog—its back turned as it sits with the coachman—looking down into a carriage in which an infant is being nursed beneath an umbrella. Beyond the carriage are the spectators of the racecourse and the activities of the track. From such a compact work (14¼ × 21⅝ inches), one might re-create a lost civilization.

65. Except for madness, of which the critics of this work accused him, Manet has accounted the normal range of healthy reactivity, although not its affective states: anger, joy, sorrow, longing, and so on.

66. *Fauna,* "animals collectively; especially, the animals of a particular region or time" (*American Heritage Dictionary of the English Language*) compares with *faune,* a feminine noun, "ensemble des espèces animales que renferme une région, un millieu" (*Petit Larousse*). *Faun,* "one of a group of rural deities represented as having the body of a man and the horns, ears, tail, and sometimes legs of a goat," compares with *faune,* a masculine noun, "divinité champêtre, chez les Romains."

67. For a compact survey of nature's roles, the values it contributed to society, and the ideals it epitomized, see Arthur O. Lovejoy, "'Nature' as Esthetic Norm," in *Essays in the History of Ideas* (Baltimore, Md.: Johns Hopkins University Press, 1948).
The interdependency of urban organisms—the ecology of the city—Manet captured with none of the social and sentimental bias of romantics or expressionists. Class was not an issue. Neither Millet's work, nor his emotional descendent Van Gogh, nor Toulouse-Lautrec's art (nor Brassaï's photographs, probably Lautrec's spiritual heir) resemble Manet's record of the city and suburbs. (Perhaps only Atget gazed with the same moral neutrality.) The great city contains as many specialized functions as a complex natural system: a jungle, coral reef, or prairie. Manet observed this

If "nature" is a cultural artifact, how much more artifice was required to reflect back on art itself?[67] A reprise, *The Gare Saint-Lazare* also summarized certain of Manet's past concerns. This sleeping puppy's artistic pedigree descends from the slumbering lapdog that curls at the feet of Titian's *The Venus of Urbino,* 1538 (fig. 16).[68] The Venus had served as the model for Manet's *Olympia,* 1863 (fig. 17), but in that work Manet had substituted a black cat for the faithful dog. When Titian painted the charming goddess identified with love, she was more chaste than the strumpet whose open lasciviousness affronted nineteenth-century Paris. For his insolent treatment of the Parisians' open sexual traffic, the black cat served Manet's purposes in the *Olympia.* Reinstated in *The Gare Saint-Lazare,* the brown-and-white parti-colored dog rests in his mistress' lap, a surrogate for, or displacement of, the pubis.[69]

While no apparent sign of lust unites the puppy with references back through the *Olympia* to the *Venus of Urbino,* the painting's lineage is nonetheless direct. In *The Gare Saint-Lazare* other details are held in common. The bangle worn on the right wrist by Titian's *Venus* and by the *Olympia* appears once again on Victorine Meurent's wrist in *The Gare Saint-Lazare.* The thin black choker Mlle Meurent wore as *Olympia* is also worn at the Gare Saint-Lazare (fig. 18). Venus's pearl earrings appear again in the *Olympia,* but they are replaced by gold ones in *The Gare Saint-Lazare.*[70] A quietly repeated motif, this distinctive jewelry contributes an ornamental unity that underlies Manet's portraits of Victorine Meurent. Aside from how she is clothed, the most basic difference between Mlle Meurent's situation in *The Gare Saint-Lazare* and her role in other works is the model's seated, frontal pose. This confrontational deportment arrives in Manet's work from the storehouse of art history.

One source configures the pose, the upturned gaze, the reading, and the garb of a blue-clad figure: the "Virgin of humility." The motif, visible to Manet in myriad examples throughout Europe, is suggested by the blue color of what Victorine Meurent wears and by how she sits: upon the ground, reading. The Virgin epitomized the theme of humility when she sat plainly on the earth, without her throne.[71] Characteristically, the Virgin sits reading within her chamber at the moment of the Annunciation, as in the central panel of Rogier van der Weyden's dispersed triptych (Louvre, Paris). In such works the Virgin's reading is interrupted by the archangel Gabriel,

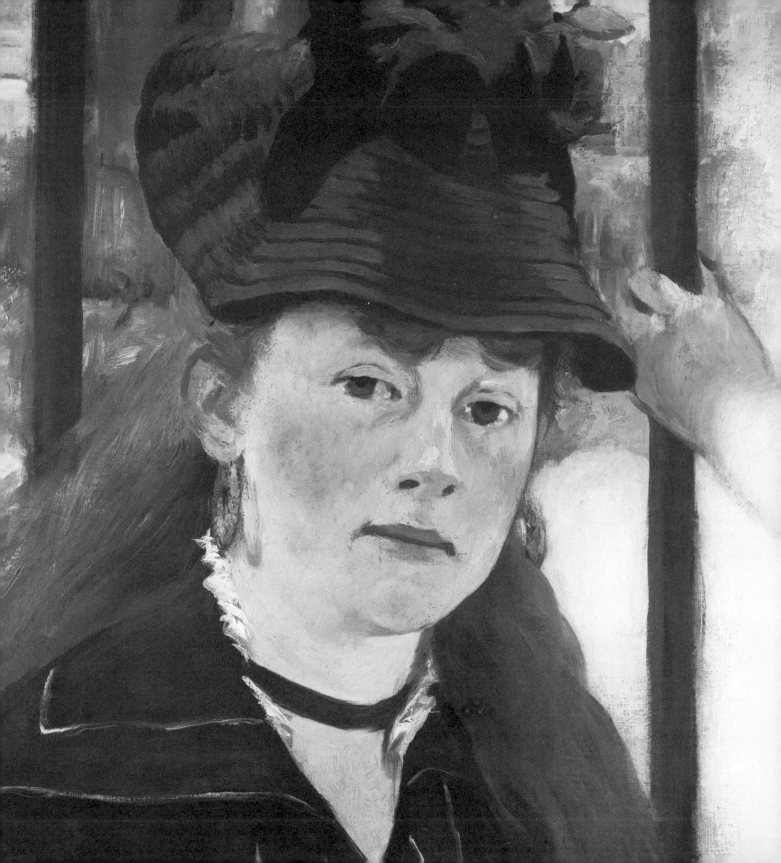

Fig. 19
Rogier van der Weyden
The Magdelen Reading, panel (fragment of an altar-
piece), 24¼ × 21½ in. (616 × 546 cm.). The
Trustees, National Gallery of Art, London.

Opposite
Fig. 18
Édouard Manet
Detail from *The Gare Saint-Lazare*, 1873. National
Gallery of Art, Washington, D.C.

rich urban variety, and from it drew what interested him, not for the purposes of composing manefistos. Instead, he concentrated a gestural distillate to serve themes he virtually exhausted. After Manet, this nonanecdotal diversity *passed through* the art of painting and reemerged in modern poetry.

68. As early as 1856, Manet made a copy of the *Venus of Urbino,* when he stayed in Florence during his second visit to Italy. Two years earlier Manet had copied Titian's *La Vénus du Prado,* which was known at the time as *Jupiter et Antiope.* This work, too, displays a reclining nude (which might have served as the source of Manet's *Young Woman Reclining in Spanish Costume,* 1862 (Yale University Art Gallery, New Haven, Conn.).

In a remarkable piece of detective work, using x-ray photography, recent scholarship has revealed a *Reclining Nude,* very much of the type and pose that we know as the *Olympia,* beneath Manet's c. 1858–60 sketch for *La nymphe surprise* (Nasjonalgalleriet, Oslo). This discovery appears in Juliet Wilson Bareau's catalogue to the exhibition at the Cortauld Institute Galleries, *The Hidden Face of Manet* (published by *The Burlington Magazine,* London, 1986). Thus, at a date no later than the last years of the 1850s, Manet had already arranged the basic lineaments of what was to become his great *Olympia,* a work previously thought to have arisen directly from studies for it and from remembered sources; Bareau's discovery should alert us to how long Manet could maintain a continuous, if subterranean, meditation on a theme.

In Madrid, at the Prado or in Vienna (in another version), Manet could have seen Titian's *Diana Receiving the Golden Rain* (another copy of which is in the Hermitage). In this painting a sleeping puppy rests in the lap of the goddess.

69. For a discussion of hair displacement in the *Olympia,* see T. J. Clark, *The Painting of Modern Life: Paris in the Art of Manet and His Followers* (New York: Alfred Knopf, 1984), pp. 136–137.

70. Victorine Meurent also wore a choker and drop earrings for Manet's first picture of her, *Portrait of Victorine Meurent,* 1862 (Museum of Fine Arts, Boston). Manet's other great confrontational image, after the *Olympia,* was the *Bar at the Folies Bergère,* 1871, in which the barmaid also wears a thin black necklace and a bracelet on her

FIG. 20
Rogier van der Weyden
Granada Altarpiece, "Christ Appearing to His Mother" (right panel) [Louvre, Paris, and Metropolitan Museum of Art, New York]. Metropolitan Museum of Art, New York.

right arm. By the time of the *Bar at the Folies Bergère* a certain bluntness characterized Manet's use of the direct glance, and this work seems to lack some of the delicious balance and range of qualities found in *The Gare Saint-Lazare*. Indeed, much of the complexity of the *Bar at the Folies Bergère* evaporated for me when, as a boy visiting Paris for the first time, and without my parents, I went to the Folies Bergère and was astonished to find that the bars in the lobby are truly circular and the barmaids attend them exactly as in Manet's picture, which seems, therefore, to have been discussed mainly by art historians who had not availed themselves of the beautiful and innocent sights at this precious entertainment.

71. "So popular was the humility posture in the Netherlands and Northwest German art that it was employed even in the context of the Annunciation, that great mystery which by its very nature does not readily lend itself to an idyllic or informal mode of depiction" (Erwin Panofsky, *Early Netherlandish Painting* [Cambridge, Mass.: Harvard University Press, 1971], p. 128).

72. Luke 1:28–38 contains the crucial passage of the Annunciation, "And when she saw him, she was troubled at his saying, and cast in her mind what manner of salutation this should be" (Luke 1:28), which more or less describes the situation of Victorine Meurent in *The Gare Saint-Lazare*. Yet, another aspect—that of the subject's virtue—cannot be ignored once this identification is posited. (*L'Evangile De St. Luc*: L'ange, étant entré dans le lieu où elle était, lui dit: "Je te salue, toi qui as été comblée de grâces; le Seignor est avec toi." Elle fut troublée de ces paroles, et elle se demandit ce que signifiait cette salutation.) After all he had suffered at the hands of the critics, posing Victorine Meurent in this liminal reference to the woman "full of grace" and beloved of God afforded Manet and Victorine slyly understated revenge. The model/courtesan is greeted as openly as in Whitman's *To a Common Prostitute*, or as the angel Gabriel greets the Virgin.

73. A direct relationship between Victorine Meurent's role in the *Olympia* and her reappearance with reference to seated biblical figures might be suggested by comparing her pose with that of who, coming upon the woman unawares, startles her.[72] In one other situation, that of "Christ Appearing to His Mother" (as in Rogier van der Weyden's *Granada Altarpiece*, right panel) (fig. 19) the Virgin is suddenly and unexpectedly roused from her reading, an occupation in which she is often engaged as the model of piety.[73] In this pose and occupation (reading), in her garb (blue dress and covered head), and in the action of her crucially interrupted reading, we recognize the Virgin of the Annunciation (or the Virgin when Christ appears to her). Since Victorine Meurent is lacking only a halo, how are we to differentiate her from her evident source? We are, after all, dealing with an artist whose concerns, attested in several paintings, were not wholly secular. Manet painted religious scenes out of an authentic need and from a Christianity against whose church he is not recorded as having made anti-Catholic pronouncements. His Catholicism, inherited as part of the national culture and his *haute-bourgeois* upbringing, was practiced, if at all, with grandly deliberate Parisian consciousness.

Once the associations of Victorine Meurent's pose and its implications for *The Gare Saint-Lazare* have been recognized, the figure assumes its place at the end of a chain of overtly religious citations—finally, another adaptation.[74] In the past, Manet had dressed Victorine as *The Street Singer*, c. 1862 (see fig. 15), and as a transvestite for *Mlle V . . . in the Costume of an Espada*, 1862 (fig. 21); the next year he undressed her for the *Olympia*. Now, a decade later, he could borrow the blue dress and pose of a seated Virgin. Although it may be considered a strange concept, it is really no odder to find this modern Parisian as a Holy Virgin than to find many of the other adaptations/transformations that Manet worked into his art.

Accordingly, three observers occupy the apex of the painting's visual cone, the spot at which Victorine Meurent stares. The artist, at whom the model gazes (as he works), resides (simultaneously and coextensively) with us, and he and we are integrated at the vantage from which we view the picture. Also, the spectator who peruses the painting meets the eyes of the seated woman, as the archangel Gabriel when he startled the seated Virgin. *The Gare Saint-Lazare*'s spectator assumes the role and position of the angel Gabriel, and we are stand-ins for Manet. This compression of the tripartite spectator—not the first in art history—occurs at the point in space at

Rogier van der Weyden's reading *Magdalen* (fig. 20). In this pose the Magdalen is compared to the Virgin.

74. For an artist regarded as the quintessential secular painter, Manet turned to religious themes surprisingly early in his life. He painted *Christ au Roseau* in 1856. Also in that year he painted *Christ à la Houe* (*Le Christ Jardinier*), painting a second version in 1858. In 1865 there followed *Jesus Insulté par les Soldats* (as well as a fragment of a second version that survives), which received disastrous reviews when it appeared in the same Salon as the *Olympia*.

75. Jane Mayo Roos notes: "at the Salon of 1864, Edouard Manet exhibited two paintings on the subject of death: *Les Anges au tombeau du Christ* and *Episode d'une course de taureaux*" ("Edouard Manet's *Angels at the Tomb of Christ:* A Matter of Interpretation," *Arts Magazine* 58 (April 1984).

76. The figures in *The Gare Saint-Lazare* are not part of a parable. They do not *stand for* conditions in which their properties are transferred to another designated object—that is, *The Gare Saint-Lazare* does not reside in the universe of metaphor. Its components do not serve as an analogy; rather, the *entire* painting stands, unpartite, for other paintings meant to be recalled exactly to the degree to which the spectator is familiar with the history of art. The individual painting becomes a simile for paintings. It reminds us of the kinds of things that painting can do—and the more of these demonstrated properties, the better. As familiarity with languages introduces us to the idea of language, so, apparently, for Manet the painting, if sufficiently rich in conception, could array the possibilities of painting.

77. Albert Aurier, "Les Peintres symbolistes" (April 1892), in *Oeuvres posthumes* (Paris, 1893), pp. 293–295. Trans. P. S. Falla in *French Symbolist Painters* (Arts Council of Great Britain, 1972).

FIG. 21
Édouard Manet
Mlle. V . . . in the Costume of an Espada, 1862, oil on canvas, 166 × 129 cm., signed. Metropolitan Museum of Art, New York.

which Victorine Meurent focuses. Recalling the occasion when the Virgin was thus seated, the artist could have imagined himself as the wounded Christ.[75] His sufferings caused by the *Olympia* may have turned his mind to archetypal suffering, which prompted him to produce the *Christ with Angels,* 1864, the year after the *Olympia,* and now a new sort of synthesis brought religion to mind once more. If Manet discovered Victorine Meurent's pose in the form of the seated Virgin and then compounded this image with references to both his own *Olympia* and its other intrinsic sources, we discover an especially complex network of signals to the art of the past. This sophisticated painter, who had gleaned the past for esoteric references to sustain the composition of the *Déjeuner sur l'herbe,* would have been precisely the sort to combine such variously gathered material again.[76]

THE CRUCIAL MISUNDERSTANDING

The nineteenth century—which in its childish enthusiasm has for eighty years vaunted the omnipotence of scientific observation and deduction, declaring that there is no mystery which does not yield to its lenses and scalpels—seems at last to becoming aware of the absurdity of its boasts and the emptiness of its efforts. Man is still surrounded by the same mysteries, the same formidable, enigmatic unknown, which had only become darker and more terrifying since it has been the fashion to ignore it. . . . For some years past it has been clear to even the most casual observer that intellectual and artistic development in France is subject to two conflicting currents.

Albert Aurier, 1892[77]

THE GARE SAINT-LAZARE'S COMPONENTS ARE NOT INDIvidually esoteric, but the manner of their organization, Manet's way of thinking, is "difficult," much as modern poetry (starting with Mallarmé) seems "difficult" and obscure. From commonplace materials Manet, too, arrived at such obscurity; he inquired into the very manner of our comprehension. For if *The Gare Saint-Lazare* is "about" anything, it concerns our awareness and our manner of apprehending the world. These topics appear as unexpected implications. Such corollaries suggest that Manet's contemporaries' accep-

78. Mauner, *Manet: Peintre-Philosophe,* p. 4. I cannot be sure what Mauner distinguishes between "content" and "overt subject matter," since these two do not, in usual usage, have much in common. It seems that in Mauner's statement, "content" refers to the catalog of nameable things (girls, fences, books, dogs) and "subject matter" to types of relationships (still life, battle scene, landscape, portrait, historical scene, etc.).

79. Trans. Linda Nochlin, *Realism and Tradition in Art: 1848–1900* (Englewood Cliffs, N.J.: Prentice-Hall, 1966), p. 73.

tance or rejection of the painting may have arisen from the treatment he afforded his subjects. As noted earlier, the work was first treated with an obloquy that does not reveal how this seemingly ordinary subject could engender such critical vilification. Yet modern writers, too, have noted the opacity of Manet's subject. For example, Mauner remarks that "it is clear that what we know least about in Manet's art is his content, to what extent it resides in his pure painting and to what extent it is to be found in his overt subject matter."[78] The principal objections to viewing Manet's art as consisting of legible entireties (at least for those paintings of the period starting with *The Gare Saint-Lazare*) issues not from anything Manet himself said or wrote but from a supporter, who was, paradoxically, one of the major voices of his day: Émile Zola.

The great naturalist writer "excused" Manet from literary engagement, even while certifying the artist's intimacy with current writers. Zola deformed Manet's intentions to correspond more closely to his own naturalist bent and goals. Manet, reticent if not supremely self-reliant, never objected but simply continued to paint as his needs dictated. Also, Manet's career and reputation were not so well established that he could risk estranging Zola's enthusiastic support in order to cavil over minor points when his entire artistic enterprise was under attack. In a striking passage, Zola championed Manet's art, but in terms that deflected subsequent investigation:

> I will use this opportunity to protest against the relationship that has been asserted between the paintings of Édouard Manet and the poems of Charles Baudelaire. I know that a lively sympathy has brought the poet and the painter together, but I think I can affirm the latter has never made the blunder, committed by so many others, of wanting to put ideas in his painting. The brief analysis I have given of his talent proves with what naïveté he places himself before nature . . . he is guided in his choice only by the desire to obtain beautiful color areas, beautiful oppositions. It is silly to try to make a mystical dreamer out of an artist obedient to such a temperament.[79]

The consequences of such a statement, and of many similar statements, decisively influenced subsequent viewers. In this text was born the image of Manet as the "painting animal," the bland unthinking naturalist, a realist painter who advanced Zola's stance. Zola's position mandated, and to some degree dictated, that successive

spectators observe Manet's art in terms of Baudelaire's massively important criticism while discounting any fundamental artistic harmony, contemporaneity, or shared sensibilities between Manet and Baudelaire. That Manet was the archetypal painter of his time was never in doubt for Zola or for the many readers who followed his proposal. Simultaneously, Baudelaire very much set the tone of writing for a certain, increasingly important sector of the world of letters. That Manet and Baudelaire might have been engaged in similar programs never really entered the question, and Zola dismissed the possibility, although it has long been clear that Manet's art is far from a simple exposition of any obvious propositions. Thus, following the tone first set by Zola, for subsequent chroniclers Baudelaire seemed to remain an ardent and hardly disinterested, although somehow disengaged observer, who had made a direct contribution to Manet's art only through his critical writing. Baudelaire's personality and his presence in the life of Manet was severed from Baudelaire's thinking and writing. That Zola may have contributed to the bifurcation of these two streams is highly probable. On one hand, the criticism fostered by Baudelaire eventually carried the day and has posited the basic terms by which we view Manet's art. On the other hand, the subject matter of Manet's art and his approach to art itself have not been successfully aligned with Baudelaire's own position.

THE PORTRAIT OF EMILE ZOLA

ZOLA HIMSELF SHOULD CERTAINLY HAVE UNDERSTOOD that Manet was guided by a great deal more than "the desire to obtain beautiful color areas," since Manet's portrait of the writer abounds with insinuations of their shared theoretical and artistic concerns. Manet's *Portrait of Emile Zola* (fig. 22) was painted between November 1867 and February 1868, as an expression of gratitude for Zola's defense and "explanation" of Manet to the public. During the time that he sat for the portrait, Zola visited Manet's studio for seven or eight sessions (suffering the strain and subsequent aches of a model, with his stiffness resulting from the rigid position he was required to take).

80. One of the most important vectors in bringing Japanese art to Paris' attention was the passionate advocacy of Philippe Burty. Burty willingly made available his enormous collection of Japanese art, for the enjoyment and edification of his acquaintances, among whom he counted most of the significant writers of the time, as well as "avant-garde painters such as Edouard Manet, with whom Burty was an exceptionally close friend" (Gabriel P. Weisberg, "Philippe Burty And A Critical Assessment of Early 'Japonisme,'" in *Japonisme in Art: An International Symposium* [1980], p. 110).

81. By the end of the 1850s and the start of the next decade, the aesthetics of Japanese prints began to work its way into the vocabulary of French artists. Genre scenes that we would today regard as examples of realism were common to the Japanese print, as was a reliance on brightly flat monochrome passages that emphasized a work's surface design (and diminished that illusionistic space which had been the Occident's standard of expectation since the Renaissance). One of the artists associated with the introduction of Japanese art to Paris was none other than Hirsch, in whose garden *The Gare Saint-Lazare* was painted.

82. This identification of the print as *The Wrestler Onaruto Nadaemon of Awa Province* first appeared in E. P. Wiese, "Source Problems in Manet's Early Paintings" (Ph.D. diss., Harvard University, 1959), p. 228.

83. Inexplicably, Fantin-Latour awarded Renoir a tertiary eminence after Manet and the seated Astruc. Renoir's head is placed at the center of a picture frame that surrounds his face like a halo, a reference impossible not to observe.

Formality suffuses the work at every level, and the author's geometrized pose reveals only the most superficial aspect of that organizational substrate. In this painting nothing is accidental; all has been arranged to express those interests that the artist shared with his subject. For example, the overall flatness of the painting— with Zola turned in a profile view that compresses him into a silhouette—only hints at a pervasive Japanese influence in many other pictorial elements.[80] In the last third of the nineteenth century, aligning oneself with the Japanese aesthetic and its growing influence in the West daringly asserted the most advanced taste of the time. No contemporary viewer could have failed to have understood so explicit an announcement.[81] A silk screen on the left with a flowering branch pattern salutes Japanese taste, as does a ukiyo-e print on the wall in the painting of a sumo wrestler by Kuniaki II.[82] (The image of the enormously powerful wrestler may slyly comment upon the artistic "battle" in which Manet and Zola were engaged as colleagues and combatants, although at the time such images were thought to represent actors.)

Hardly happenstance, this treatment and the Japanese motifs bear overwhelming testimony to the artists' concerns. Henri Fantin-Latour wove these strong associations into his adulatory company portrait of the Impressionists gathered around Manet, *A Studio in the Batignolles Quarter,* 1870 (fig. 23). All the artists are grouped to the right and are observing the seated Manet, who is painting a canvas unseen to the spectator. The only other seated figure is Manet's defender, the critic Zacharie Astruc, whose portrait Manet might be painting. (The other figures in the painting are Otto Scholderer, Auguste Renoir, Émile Zola, Edmond Maitre, Frédéric Bazille, and Claude Monet.)[83] As he turns toward the company of artists, looking away from the canvas on which he paints, Manet's gaze directs our attention away from the likely subject of his work. At the far left of the picture (in a spot originally occupied by the figure of Degas in Fantin-Latour's studies) stands a cluster of objects: a Japanese tray, a contemporary polychrome ceramic work by Bouvier (which in turn draws its inspiration from a Japanese source), and a statue of Athena. In short, as Weisberg notes in his careful study, the painting was a clarion call to the young artists to strive to achieve in Manet's wake

the same heights of creative excellence, perhaps through the imagina-

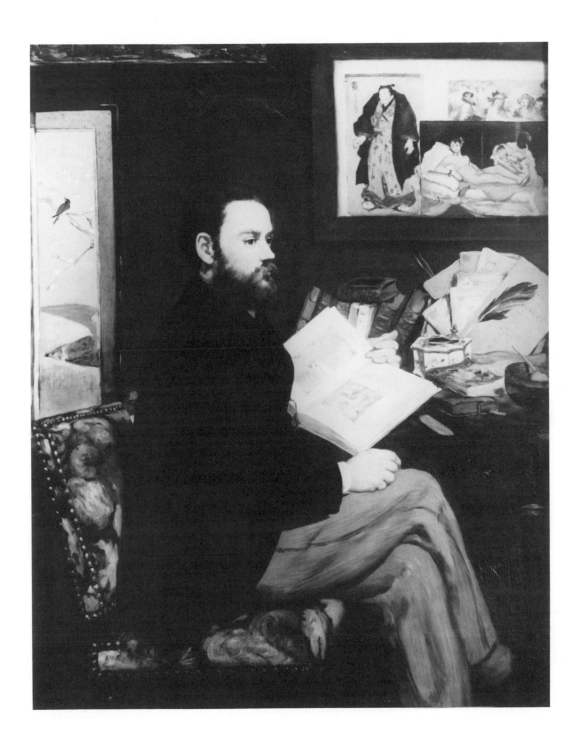

84. This carefully calculated work has been vigorously studied by Gabriel P. Weisberg in "Fantin-Latour and Still Life Symbolism in *Un Atelier Aux Batignolles,*" *Gazette Des Beaux-Arts,* sixth series, 90 (December 1977): 213.

85. Indeed, if we consult *A Studio in the Batignolles Quarter* in the reverential spirit in which it was painted, it appears that the picture on which Manet works—whose subject we cannot see—is specially situated. This painting occupies the same place in the composition and has the same spatial relationship to the painter as does the depicted canvas in *Las Meninas.* Unlike the canvas on which Velázquez showed himself working, self-evidently, the Fantin-Latour picture cannot be the painting on which Manet is working. *Las Meninas*—since it includes a self-portrait of the artist at work (even though *every* self-portrait necessarily pictures the artist at work)—may be the very painting we both behold and see depicted from the back. As a participant (as a surrogate for a lost profile) and as the field of action (as the arrayed incidents that we puruse), the canvas turned away from us offers rich possibilities.

As part of his homage to Manet, Fantin-Latour played with complex pictorial relationships, considerations that, since they indicate the sort of accomplishment Manet would have found most praiseworthy, are far distant from the concerns of high Impressionism.

86. Moffett has also questioned Manet's position at the center of the Impressionist movement, pointing out that his centrality to that movement was assumed as early as the first years of the 1870s ("Manet and Impressionism," in *Manet, 1832–1883,* p. 32).

87. Theodore Reff, "Manet's Portrait of Zola," *Burlington* CXVII (January 1975): 35.

88. Weisberg, "Fantin-Latour and Still-Life Symbolism," p. 214.

89. When the *Portrait of Zola* was submitted to the Salon of 1868 it did not fare particularly well, although a contemporary critic, P. Mantz, noted the obvious Japanese component of the work: "M. Manet is quite successful with his still-life subjects;

tive devices that lay concealed in Japanese art and which Bouvier had equalled in his ceramics. . . . The statue of Athena also suggests that the new ideas that these men possessed . . . must be added to the already existing classical system.[84]

The admiration expressed by the cluster of artists observing Manet at work indicates that Fantin-Latour esteemed Manet for reasons that have little to do with values we traditionally associate with Impressionism.[85] The other artists may not have shared Fantin-Latour's admiration to the same degree, but they would not have posed for this work if its program were repugnant or misleading. The Batignolles group (only part of which was comprised of Impressionist painters) and Fantin-Latour in particular may lay claim to being Manet's real "followers"—that is, those who inherited his agenda for art, if not his mantle of accomplishment. However appealing to chart a course in art history from one peak of quality to the next, there seems ever less reason to suppose that Manet's true followers were the Impressionists and more of a compelling case for beginning to see Manet as a bridge to the Symbolists.[86] Indeed, the *Portrait of Zola* may prove the direct spiritual forerunner of Fantin-Latour's multifigure composition of 1869–70. For, as Reff notes,

from the time Manet exhibited his portrait of Zola at the Salon of 1868, his novel treatment of its setting has been recognized as its most striking feature. By depicting the figure as merely one among many elements in an evenly illuminated field, Manet broke with the traditional subordination of the background to the figure that had persisted, despite the importance then attached to the concept of "milieu," even in a period of realism.[87]

That the background elements could obtain parity with the putative subject of the "portrait" was a lesson quickly learned by Manet's disciples. By the next year, in Fantin-Latour's work, we can see that "through the careful analysis of the still-life objects . . . these objects assume as much importance as the main protagonists in the atelier."[88]

Manet had allied himself with the tradition of Western classical painting. He invoked Goya, Watteau, Velázquez, Titian, Giorgione, and Marcantonio Raimondi's Raphael when the occasion suited. He now interwove a new network of associations, that of the Japanese.[89]

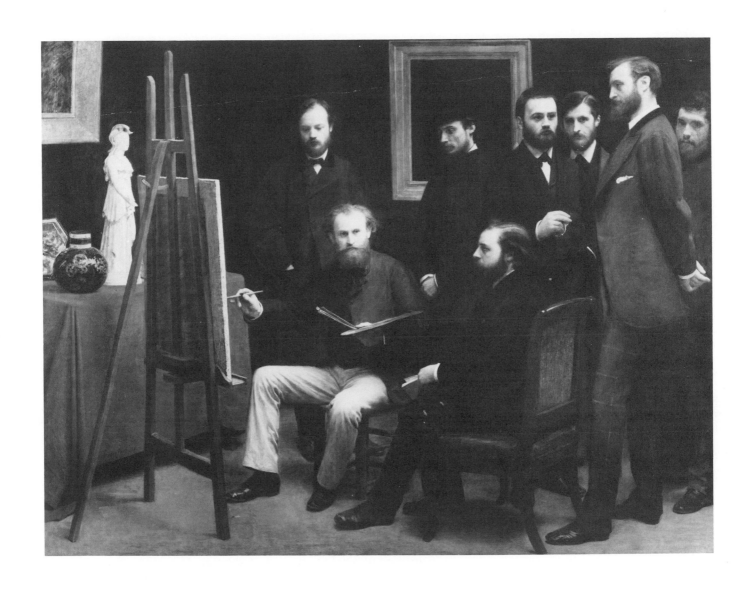

FIG. 23
Henri Fantin-Latour
A Studio in the Batignolles Quarter, 1870, oil on
canvas, 171 × 205 cm. (67 × 81 in.). Musée d'Orsay
(formerly Galeries du Jeu de Paume), Paris.

he is less happy as a portrait painter. In the portrait of Émile Zola, the main interest belongs not to the sitter, but to certain Japanese drawings which cover the walls."

90. Jean C. Harris remarks that

> Manet must have been familiar with Goya's etched copies of paintings by Velázquez (Goya's etching after *Los Borrachos* appears in the upper right corner of Manet's portrait of Zola), for both Manet's etching after the so-called Velázquez portrait of Philip IV in the Louvre and the etched version of *Les Petits cavaliers* are similar to Goya's prints ("A Little-Known Essay on Manet by Stéphane Mallarmé," *Art Bulletin* 46 [1964]: 563).

Thus, the inclusion of *Los Borrachos* was a double homage to Velázquez through Goya (as Manet would subsequently honor Flemish painting through Velázquez).

His own contribution to the cluster of images surrounding Zola is represented by an etching of *Olympia* that Manet made in 1867, after the painting of 1863. In the *Portrait of Zola, Olympia,* the courtesan turns her gaze toward the elegant sitter instead of straight ahead, as she does in the actual painting. Zola had praised *Olympia* as Manet's masterpiece and had complimented him on the work's pure colors, which he found comparable to those of a Japanese print. The painter's sources and something of Manet's artistic paternity are attested by an engraving of Velázquez's *Los Borrachos*.[90] This citation not only reiterates Manet's homage to Velázquez but may also affectionately refer to the raucous conviviality of the modern café society, within which he and Zola operated. In the portrait of his advocate, Manet's standards of ideal European painting, his own artistic enterprise, and the beacon of Oriental art by which he and Zola charted the direction of modern art are all reposited together. The portrait clusters precise references that extend the sitter's identity and specify an intellectual pedigree. Unannounced in any obvious way, the painting indexes the intellectual stance shared by the writer and painter and also hints at Manet's special relationship to Zola.

Behind the porcelain inkwell and the writer's metonymic quill is tucked a pamphlet reprint of Zola's 1867 article in praise of Manet. The booklet's blue cover, emblazoned with Manet's name, links the two artists. The clear use of his name on Zola's text signals Manet's willingness to be *represented* by his friend's polemics, even as he was representing Zola. As no other signature but this publication's title appears on the painting, the emblazoned text's inclusion serves a double duty: it is the actual signature for the work, and it indicates Manet's debt, his acceptance of Zola's championship of his cause. Yet, even when every zone of his own portrait shimmered with glinting references to the worlds of art, ideas, history, literature, theories of symbolism, and aesthetics, Zola believed that Manet never committed the blunder of putting ideas in his painting.

The accretive nature of the statements Manet injected into the *Portrait of Zola* was noticed by one of the painting's earliest critics. Long before he was recognized as a major artist, Odilon Redon (who was twenty-eight years old at the time) published a lengthy critique in the 9 June 1869 issue of the newspaper *La Gironde* in which he that dwelled upon the *Portrait of Zola*:

91. Trans. Hamilton, *Manet and His Critics,* pp. 128–129.

The varied nuances of the books and pamphlets on the table attract the eye and are rendered with a true painter's talent . . . but that is where it is all wrong since it is a question of a portrait. . . . The *Portrait of Zola* does not seem to us worth imitating; it is rather a still life, so to speak, than the expression of a human being. . . . Manet, who appears to us especially well equipped for still-life painting, should limit himself to that, which is not of an inferior order when it is treated with such talent.[91]

That Manet treated his subjects flatly, and dismissed (or was incapable of expressing) the inner life of mind and passion except by external symbols occurred to at least this one perspicacious reviewer. Unlike Zola (whose lapse is remarkable), Redon was not in a position to assume that such a "still life" recorded a genuine expression as the commutative product of the signs that permeate the entire work. This accumulation of emblems has only to be noticed before the viewer begins to construct the intended, unambiguously potent statement.

That Zola's portrait does not take as its model and ultimate standard the psychological depth of, for example, Rembrandt, still does not bar the picture from the realm of portraiture. Rather we establish, as did Manet, amended criteria to judge the efficacy of the painting, and in the wake of this amendation a new set of suppositions arises concerning the "meaning" of the artist's other works. Covert subject matter furthered Manet's requirements for a complex art of subtle reference, which sustained a form of privacy amid an essentially public enterprise.

The hidden and self-referential complexity of the *Portrait of Zola* hints at the circumspection with which Manet, never publicly demonstrative, held to the values of his class. His quiescent, "still-life" treatment of the task of portrayal masked an active, agile, intellectual inquiry to which the public was not invited. If the imagery in this work is not secretive, neither is it displayed candidly *as symbolism.* Instead, it appears as the normal accoutrements of the space in which the sitter was painted. Coincident with the forthright rendering of Zola's portrait, within the picture there transpires a richly arcane description of contemporary circumstances and opinions and the confederation of one artist with the other, none of which is immediately apparent to the casual viewer.

92. Duret recounts how effortlessly Manet negotiated public situations. Raised from birth to command the rules of etiquette and proper bearing, Manet was so at ease in the world of social interaction that he could be formally creative within the rigorous code of courtesy, and his personality imprinted situations within which his behavior was always proper if expressively inventive:

> He had a brilliant wit; his sayings could be very bitter, but at the same time there was a large geniality, sometimes even a kind of artlessness in his manner. He was extremely sensitive to the respect or disrespect which was shown to him. (*Manet and the French Impressionists*, p. 111)

Describing Manet as a radical liberal, or a progressive, would seem to be an act of self-hallucination.

A Personal Symbolism

DESPITE A SUBTERRANEAN AGENDA FOR HIS ART—which advanced from Courbet's paint handling, included Realist subject matter, and subsequently incorporated Impressionist technique—Manet presented his work for general approval and establishment praise. He sought the official confirmation of the Salon and other trappings of certification for his achievement. He avoided exhibiting with the Impressionists, whose devotion to him was unalloyed and whose work he admired.

As noted, Manet spoke so little about his art that he was taken to be unthinking on the matter. He was fastidious about his person, bearing, speech, and social responsibilities—the genuinely self-reliant dandy. His upbringing indoctrinated him in advanced etiquette, and his personality was ornamented by mastery of traditional social forms.[92] But central to his manner, which was otherwise impeccably conservative and gracious, was his craving for privacy. This need produced some startling behavior. Manet was so characteristically laconic about his personal affairs that in October 1863 his friends were surprised to learn that, after a quick trip to Holland, Manet had returned with a wife. He had in fact been living in Paris with Suzanne Leenhoff (a Dutch pianist from a musical family) for more than eleven years, beginning shortly after she had entered his parents' home in 1850 to tutor Édouard and his brother Eugène in their music lessons. This situation, in which outward appearances disguised actual circumstances, would have surprised Manet's friends all the more. Blue-eyed, plump, exceedingly fair, and talented, Suzanne was kept in a Parisian apartment, along with her mother. Manet treated Suzanne as a wife without arousing his friends' suspicions.

In addition to mysteriously introducing his wife into society without any advance notice to his friends, Manet had also apparently fathered a son by her, Léon-Édouard Koëlla, who was born on 29 January 1852 in Paris. Manet took on the role of the boy's godfather. Léon appears in more of Manet's paintings than anyone else. During the artist's life Léon Koëlla was introduced as Suzanne's brother (or half brother) and treated very much as a son by Manet. Léon was

93. Manet, whose unalloyed passion for things Spanish was well known, must have been aware of the miniaturist Alonso Sanchez Coello (born c. 1531, Valencia; died 1588, Madrid), of whose work several examples are present in the Louvre. Yet, there is no pertinent reason to suppose that Manet would have named his son in honor of this obscure artist, to whom he seems not to have owed either an artistic or an intellectual debt.

Nor does the more imposing figure of Claudio Coello (1642–1693) seem to fit the bill as a reasonable namesake for Manet's son. This Coello was immensely successful through official channels (a form of recognition after which Manet longed), becoming court painter in 1683, then *pintor de càmara* in 1686. Manet could have seen his art either in Spain or in "a small group of drawings of some of the figures who appear in the *Sagrada Forma* . . . extant in the Louvre" (Edward J. Sullivan, "Politics and Propaganda in the *Sagrada Forma* by Claudio Coello, *The Art Bulletin* LXVII [2] [June 1985]: 243.) Moreover, though separated by two centuries, there is an eery resemblance between the artistic personalities of the two painters:

> Unlike some other masters of seventeenth-century Spanish painting, such as Zurbarán or Murrilio, Coello rarely relied on one specific source (e.g., Italian or Flemish prints) for his pictures. A just consideration of the multitude of images that the artist may have employed directly (as well as those which served as more general precedents for the type of representation created by Coello) leads us to a variety of works by masters of different nationalities working over a span of several generations (Sullivan, "Politics and Propaganda," p. 247).

94. Another theory, propounded by Steven Kovács ("Manet and his Son in 'Déjeuner dans l'atelier,'" *Connoisseur* CLXXXI [729] [November 1972], p. 202 n. 1) supposes

> that this unusual name was invented by Manet and Suzanne and that it was suggested by *goëland,* the French word for seagull. Manet's ocean voyage was still very fresh in his mind at the time of Léon's birth. In his letters home he expressed wonder at seeing these birds so far from land: "Il est étonnant de voir autant d'oiseaux si loin des côtes, tels que goëlands" (Édouard Manet, *Lettres de jeunesse,* 1848–49,

never legally recognized as Manet's son, although there is no record of anyone named Koëlla, his putative father.[93] If such a person ever existed, he has disappeared without a trace. If he did not exist, and if Manet was Léon's father, then we might wonder to what the name "Koëlla" refers.

The diacritical mark over the "e" in Koëlla indicates a specific phonetic value that liberates the vowel "e" from the complex sound of an otherwise diphthongized elision that slides from the vowel "o" to the adjacent "e." Separated into two sounds, pronounced "co-ella," we recognize the Spanish pronoun for "her," *ella* (close to the French *elle*). Thus, the name (a sort of private "back-formation" to the Spanish forms *conmigo* "with me," or *contigo* "with you") literally means "with her." Léon was the product of Suzanne and Édouard Manet. In honor of his mother's own surname (Leenhoff) the son's first name, Léon, may have been bestowed as a contraction. He may then have been called Édouard after his father. Each part of the child's name referred to the union of Suzanne Leenhoff and Édouard Manet. The name was thus constructed with the same relationship of parts to the whole as one of Manet's paintings.[94] Like the graphic elements in Manet's paintings, phonetic elements were transformed beyond easy recognition of their source but were selected in homage to their origins. Assuming that the total complex had a coherent reference, that it meant something as a whole, the boy's name becomes richly allusive. Each part of the name cited something dear in Manet's life. Adapted for a new entirety, the child's name structurally resembles the adaptations Manet made of art historical citations.

Only after his father's death and after his inheritance was secure did Manet marry Suzanne, and their eleven-year-old son Léon Édouard Koëlla was one of the guests at their wedding.

The reticence characterized by Manet's outwardly quiet personal life was mistaken for an undisturbed nature. His artistic stature ascended on the robustness of his painting, while inquiry into his intellectual compulsions remained dormant. That he did not align himself with the intelligentsia, a classless—or rather, a transsocial—force should not surprise us. Such an allegiance and self-identification would have contradicted all the other generative values of his life. Had he behaved in a manner more befitting a professional intellec-

voyage à Rio" [Paris, 1928] p. 22). The bird might come to symbolize for Manet not only a gracefulness but also an unbounded freedom which he had experienced at sea and which he must have felt in carrying on an affair without public knowledge.

95. Nor ought we to assume the depth and direction of Manet's sympathies in his overtly political works, such as those that intermittently appear throughout his career: *The Battle of the "Kearsage" and the "Alabama"*, 1864; *The "Kearsage" off Boulogne-sur-Mer*, 1864; the four versions of *The Execution of the Emperor Maximilian*, 1867; and the works of 1871 on the subject of *Civil War* and *The Barricade*, both lithographs. By and large, French sympathies lay with the Confederacy during the American Civil War, and the naval engagement—however much it attracted Manet the painter, former sailor, and curious citizen—carried an implicit political burden.

French disgust at the death of the puppet-emperor of Mexico is treated in Manet's works on that subject. Manet's gradual withdrawal of the psycho-petitioning aspect of his work in favor of the ostensible "facts" of a situation served to diminish the range of expression open to him. Yet, from the constellation of his political subjects we can gather a clear inkling of his loyalties. His repugnance at useless bloodshed makes of Manet's *The Barricade* a pathetically world-weary comparison with Delacroix's *Liberty Leading the People*, whose inspired breaching of bulwarks declares an earlier generation's faith in cleansing revolution.

96. Despite the generally flattering picture we have of him, Manet embodied a cool aristocratic aloofness and was not above deeply wounding those with whom he came in contact. He urged Renoir to give up painting for lack of talent. No less a witness than Monet recounted grave insults suffered at the hands of Manet.

When Monet's early works were shown in an art dealer's window, Manet, sauntering by with some friends, exclaimed within hearing of the impoverished young artist, "Just look at this young

tual, we would have abundant clues to the direction and impetus of his art.

Manet published no manifestos, made no protest but with his art. He did not behave like a member of the bohemian avant-garde, nor did he consistently act on behalf of the avant-garde. His reserved and somewhat contradictory deportment was accepted as a facet of his personality that, in isolation, bore no apparent relationship to what he painted. This separation of his class allegiance from the world of ideas (which nevertheless fascinated him) was first proposed, unwittingly, by Zola and was thereafter never effectively challenged.

A gentleman does not publicly contend, except with another gentleman whose honor may be tested, nor does he declaim in the marketplace, debasing himself before those who will not understand and are unworthy to receive such polite urgency. In his art, no less than in his other forms of conduct, Manet maintained the rigorous standards of his fading class, which suited his predilection for a cloaked silence. That Manet informed Zola of the truth in a painting and apparently did not deign to reconfirm his beliefs—and his view of the nature of their common bond—in conversation ratifies our sense of the painter's witty aloofness and personal isolation. Yet, in the portrait of Zola, as in so many other of Manet's works, we find the evidence that his silence about art did not exclude him from the latest thinking. He was a reflective observer, a protagonist for a special viewpoint, and an effective critic of those values of the past by which the worth of the present is gauged. He clung tenaciously to his class identity even while actively engaged in a profession that advanced the inquisition of the assumptions governing society.[95] For the sake of art, Manet straddled the stability-loving upper class and the revolutionary-minded artists of the avant-garde. The confusion of his mixed conservatism and progressivism has haunted the studies of his work since his own time.[96]

From the *Portrait of Zola* we learn, unequivocally, that Manet's secreting of a coherent network of signs and references in his work predated *The Gare Saint-Lazare*. If the complexes of images discovered in *The Old Musician*, *Le Déjeuner sur l'herbe*, the *Portrait of Zola*, or even *The Gare Saint-Lazare* indicate anything in the broadest sense, it is that while Manet seems always to have thought about constructing his pictures in the same way, periodically during his

man who attempts to do the *plein air*! As if the ancients ever thought of such a thing!" Moreover, Monet contended that Manet had an old grudge against him because of an episode in which Manet had mistakenly been complimented for Monet's work (Trans. Linda Nochlin, *Impressionism and Post-Impressionism: 1874–1904* [Englewood Cliffs, N.J.: Prentice-Hall, 1966], p. 42). Only later did the two become painting comrades and mutual admirers.

It should also be recalled that Manet was not above enforcing his opinions at the point of a sword. On 23 February 1870 he fought a duel in the Forêt de Saint-Germain with the novelist and critic Edmond Duranty (1833–1880), who was slightly wounded and whose friendship Manet again shortly sought and won. That same year, Manet was an unsuccessful candidate for the Salon jury and also served as a lieutenant on the National Guard staff (coincidentally, under the command of the academician Meissonier, who was a colonel). Selected from one, admittedly crucial year, these conservative actions should start to indicate something of Manet's potential for, and reservoir of, snobbery.

97. Ambroise Vollard recorded the painter Charles Toché's memories of Manet:

> A few weeks before his death I went to the rue d'Amsterdam. I found the great artist alone, sad and ill. "I am working," he said, "because one must live." . . . He shrugged his shoulders, rammed his flat-brimmed hat on his head, and said to me, with a smile that drew up the corners of his moustache, "Let's drop all that! We'll go and have something good at Tortoni's." He felt one of his pockets. "Good!" he said, "I have my sketch-book. There's always something to jot down in the street. Look here." And he showed me a charming study of legs pinned to the wall. "A waiter was opening a syphon the other day, at the café. A little woman was going by. Instinctively she picked up her skirt." (Ambroise Vollard, *Recollections of a Picture Dealer,* trans. Violet M. MacDonald [Boston, 1936; New York: Hacker, 1978], pp. 157–158).

career the subject of his work changed profoundly and decisively. However subtly it was compounded of different measures of personality and class-bound expectations, Manet's temperament seems to have been fixed early in life. Although his technique, style, and ideas evolved, his firm character represents a guiding principle, a polestar by which we can steer in an attempt to understand his art.

Manet willingly incorporated other artists' plastic inventions in his own work (and his predilection for assembling images from a variety of sources represents a fairly stable aspect of his artistic development). His friends remarked that he sketched constantly, carrying a notebook with him wherever he went. He was always recording the quotidian facts of modern life, or a gesture, or some bit of information about the disposition of the world, to add to the storehouse of art history.[97] Manet registered graphically whatever he witnessed. His observational powers were never underestimated by his contemporaries, although none guessed for what purposes he sketched or how often and or in what manner these citations appeared integrated into a larger whole. Recognizing Manet's working method, we can begin to understand his aims for subject matter.

His subjects play three special and separate roles in his art. The apparent subjects that we observe are women, men, cats and other animals, and clusters of groups that we can identify as still lives, or portraits, or multifigure compositions—putatively, the sum of Manet's subject matter. Until the first sleuths began to uncover fragments of his citations, Manet's works were considered to consist of nothing but singularly undramatic records of modern life. Hence, he was "relegated" to the stature of a Realist, with an uneasy and unexplainable relationship to the Impressionists.

The citations and paraphrases from art history in Manet's work represent a sometimes witty, but more often intensely serious dialogue with the past. This submerged subject was only available to spectators through a knowledge of art history. Nowhere does a graphic sign signal for the uninitiated viewer the presence of other strata of meaning. There is no single part of a composition to which the spectator can point and therein recognize a key to this covert conversation with the past. Rather than a single dramatic substitution of signs that would indicate that appearances did not exhaust the matter of his work, Manet's picture gains meaning incrementally.

The spectator can reconcile these adaptations only by delecta-

98. An investigation of Manet's understanding of these implications risks positing an unintended significance. But here, reliability (that is, the frequency with which Manet's other works are veined with secreted relationships) suggests that the current study is not excessive. Both reliability and validity must be considered in an examination of Manet—or of any other artist or earnestly pursued communication.

tion of the undisclosed whole. The subject, formed of exquisite constituent elements, can be seen to accrete and to cohere, although only the whole work can bestow significance on these otherwise disparate parts. The recombination of bits of art history, injected with and invigorated by contemporary observations, alters the components in a manner that recalls the connotational changes played upon words by their neighbors. The degree and direction of Manet's transformations of his source material becomes, through reflexivity, part of the communication of his awareness.

In their configurations and relationships to one another, his figures, and their clothes, and gestures—and even his choice of props—produce meanings that surpass the nominal sum of the parts. This additional level of understanding could not have been predetermined from the putative subject matter. Instead, a transcendent subject appears from a symbolic reading of the works. In addition to the apparent subjects and the personal iconography by which Manet engaged history, another, a virtual subject matter resides at the core of his art. That is to say, when one reads the different objects in his works not as a happenstance jumble issuing from "reality" but rather as accretive symbols bound in a grammar, a coherent statement emerges which would otherwise remain unsuspected. A purposeful iconographer of the modern world, Manet thought about the wider implications of his undertaking.[98] Clearly, he enjoyed manipulating the symbolic programs available to him in modern guise. Over time he refined his vocabulary, and by introducing suggestive overtones and subliminal linkages he prolonged the resonance of each symbolic arrangement. Michael Fried reflected on the mechanisms by which Manet's pictures were made resonant, and it is useful to quote a substantial part of his argument's summation:

> It is worth noting, too, that [Constantin] Guys' images, by virtue of their extreme modesty, bear no significant relation to the art of the museums, and in fact Baudelaire strongly implies that he was drawn to Guys as a catalyst for his observations partly on those grounds. . . . Baudelaire describe's Guys' art as essentially mnemonic, by which he now means that it seeks to project a sort of "memory of the present" which, acting despotically on the spectator's imagination, will recreate the impression produced by the original scene on the imagination of the artist. He thus continues to assert the preeminence of memory while confining its operations to the present or, at most,

99. Fried, "Painting Memories," p. 533.

the immediate past. And this suggests that Baudelaire may have come to suspect . . . that *all* ambitious new painting inevitably bore a relation to the high art of the past that his gravest predispositions led him to reject: as though only by evading high pictorial ambition could the sheer intrusiveness of the past be brought under control. Manet, too, may be understood as seeking to contain that intrusiveness, though in a largely opposite spirit and by radically different means.[99]

If Manet's "opposite spirit" was an urge to subsume previous art, then "imagination" (as it is cast in the above quote) can perhaps be understood as the sensation that announces the spectator's self-consciousness of art history. If images were to be recalled from the past and transformed, the grammar of their organization might seem familiar, if unspecifiable. Simultaneously, the putative subject might "disappear" by virtue of its banality. Nor are such readings of Manet's works "literary" interpretations—that is, creations of the modern viewer. Were this the case, the consistency of meaning within single works would not (and could not, by randomness) achieve the coherence we discover therein. Such a compatibility of internal elements can only point to a level of intention which, if achieved so gracefully as to have previously gone unnoticed, was forcefully willed.

The implications of such a position can reconcile the several conflicting views of Manet's art. If in place of a fixed agenda for his art we posit a fixed personality, aloof, intensely private, and (at least to some degree) fickle and easily bored by anything less than the quintessence of sophistication, then Manet can be viewed as having engaged throughout his career a continuous train of related but not identical concerns. This vision of Manet's work, propelled by successive paradigms—mainly used as methods of adapting underlying citations in a wider network of reference—is fully borne out by what we already know of his previous production. The painter of *The Old Musician,* the *Déjeuner sur l'herbe, The Death of the Emperor Maximilian,* and the *Portrait of Zola* (as well as other works whose obvious "surface subject matter" is buoyant upon an ocean of more or less concealed references and emblems) did not at the start of the 1870s suddenly abandon his thoughtful manner of artificially bonding provocative elements. During that decade and thereafter, Manet lost none of his wit nor his appetite for complex subtlety. His interest in ideas was undiminished. Now he addressed slightly different, somewhat more evolved thoughts, but always in terms of the same

100. Richard Shiff, "Review Article: Pissarro Literature," *The Art Bulletin* LXVI (4) (December 1984): 683.

101. Michaud begins his classic monograph, *Mallarmé,* with what he believes is a critical statement about his subject's self-perception: "In his autobiography, Mallarmé says that since the time of the Revolution one or another of his ancestors on both sides had been employed as a civil servant in the Registry" (p. 1). Manet shared this heritage, and it may have predisposed them to friendship based on mutual understanding—a legacy of values to be accepted and questioned. Likewise, both men admired women, loved home life, and neither distinguished himself with bohemian excesses or a bent toward self-destruction.

Paul Valéry relates an odd tale of bureaucracy skirmishing aristocracy:

> A few years after my conversation with Degas, I happened to pick up some history book or other . . . it was about the Revolution. I was going to close it again when the name [François-Auguste] Mallarmé caught my eye. I read that a member of the Convention named Mallarmé had been instructed by the Committee of Public Safety, to investigate the Verdun case. . . . I lingered agreeably over the delightful idea of a Mallarmé taking so much trouble to guillotine a Degas (*The Collected Works of Paul Valéry,* vol. 12, "Degas, Manet, Morisot," trans. David Paul [New York: Pantheon, 1960], p. 28).

Valéry further notes (p. 32) that, in the Lorraine, Mallarmé's ancestor was succeeded by Charles Delacroix, father of the painter Eugène.

102. Robert Rey, *Manet,* trans. Eveline Byam Shaw (New York and Paris: Hyperion Press, 1938) p. 12.

personality. The 1870s mark Manet's transition, and advance from his oblation to art history. The past would be visible in the present, as the present portrayed the past.

THE GARE SAINT-LAZARE: THE LOCALE

Art history cannot rest with the discovery of a lack of spontaneity, without explaining why and how such a lack could once have been seen as a presence, as an adequate fulfillment of the artistic aim of spontaneity or immediacy. Furthermore, art history must establish the relationship between Impressionism's new meanings and its old one.

Richard Shiff[100]

THE PSYCHOLOGICAL GAUGE SUBMERGED IN *The Gare Saint-Lazare* employed neither geographically exotic nor arcane imagery. The picture's exposition proceeds through the most forthright, unremarkable incidents. Yet these commonplaces were carefully selected in every instance. Even the setting tells us more than might be expected.

Manet's mother, the daughter of a diplomat whose career was spent in Sweden, had (Charles Jean-Baptiste) Bernadotte (later King Charles XIV of Sweden) for a godfather. Manet's father, Auguste, was a civil servant who rose through the ranks and ended his career as a judge, with the position of chief of staff at the Ministry of Justice.[101] Auguste Manet inherited from his father 150 acres near Argenteuil in the Parisian suburb of Gennevilliers. The *haut-bourgeois* Manet family regularly summered there in one of the houses on the estate. When the time came to compose the *Déjeuner sur l'herbe,* Manet (who in turn inherited this beautiful land on the Seine) "made innumerable studies for the landscape background in the neighborhood of Gennevilliers."[102] If he wanted to execute his first important painting in the open air, he could have worked in the comfortable and familiar setting of his own estate. Besides his dislike of leaving Paris, something must have drawn Manet to this location at the edge of the Gare Saint-Lazare. The very peculiarity of *steam* in a landscape, visible from Hirsch's garden, attracted the artist to

103. Gay, *Art and Act,* p. 105. Gay goes on to admire the picture, noting that

> *The Railroad* is a poem about speed contemplated in tranquility. . . . I know of no nineteenth-century painting that celebrates modernity more unreservedly than this. . . . The puppy sleeps, oblivious to the noise, the smell, the smoke of the train. The girl is riveted to her spot; she is watching the passing train, possibly with interest or, more probably, with the calm indifference that habituation brings. (Pp. 107)

104. As magnificent a construction as the Pont de l'Europe that spanned its tracks, creating a plaza in air, the Gare Saint-Lazare was an engineering feat of no small accomplishment. Robert L. Herbert describes Monet's use of the impressive site for his suite of paintings:

> Monet has drawn our attention to these spindly iron columns on either edge. In doing that he has caught the spirit of Eugène Flachat, the engineer who made of this shed one of the most daring of contemporary structures. Clever use of iron supports and overhead braces let Flachat construct a very wide span, which he pierced with those huge skylights. Monet lets the sunlight flood down from those skylights on to the tracks in the foreground, and he gives as much prominence to the geometric shadows of the overhead network as to the tracks ("Industry in the Changing Landscape from Daubigny to Monet," in *French Cities in the Nineteenth Century,* ed. John M. Merriman [New York: Holmes and Meier, 1981], pp. 160–161).

105. Richard Shiff, "Review Article [Pissarro]," *The Art Bulletin* LXVI [4] (December 1984): 683.

the spot. Peter Gay has gone so far as to argue that "the steam is the hero—the modern hero—of this painting."[103]

The railroad had attracted artists since the powerful engines first appeared in the countryside. J. M. W. Turner's thrilling *Rain, Steam and Speed: The Great Western Railway* salutes a human challenge to the elements, a manmade force that, knifing through storm, disputes the dignity, and will, of nature. The vast natural sublime was contested by a device that shrank distance with terrific swiftness. Even the railway station had its more sedate devotees. William Powell Frith (1819–1909), of a generation midway between Turner (1775–1871) and Manet, painted *The Railway Station,* 1862 (fig. 24). For artists such as Frith, the railway station radiated the glamor of speed and power. Lacking the imagination, artistry, or ambition to address sublimities, for these artists the railroad's effects became the subject: the reunification of families, the promising start of trips, the possibility of distant commerce, the bustle of the station itself.

Manet's contemporaries painted similar scenes that seem nominally to address the same subject matter. In any case, there are numerous transcriptions of this locale. Monet painted the billowing steam of the Gare Saint-Lazare to test the emergent science of observation that he was bringing into being. Light filtering through the train shed, and the shackled cloud under the station's roof, afforded an unprecedented optical situation and opportunity. Time and again Monet entered the huge train shed to capture the black shapes of the trains spewing their thick vapor, so different from either the transparent glass above or the bright sky beyond (fig. 25). His aim in this partially theoretical endeavor was observational or, more precisely, optical, and the train station offered the most varied situation within which light performed.[104]

There is no cleaving Monet's enterprise into an intellectual and a sensual component, since the very endeavor of treating "'sensation' refers to both a received impression and an evoked emotional response."[105] For Monet, the train station, as much as the countryside or shimmering waters, offered myriad optical situations, from the opacity of the great engines, to the spidery girders overhead, to the translucent steam, to the clear sky. Although the rose windows of Rouen barely resembled its grimy glass, the train station was not for Monet a cathedral of modern life, but was just another opportunity to paint light. Having satisfied himself with an exposition of the

FIG. 24
William Powell Frith
The Railway Station, 1862, oil on canvas, inscribed:
"W. P. Frith fec. 1862," 116.7 × 256.4 cm. In the
Collection at Royal Holloway College and Bedford
New College, University of London.

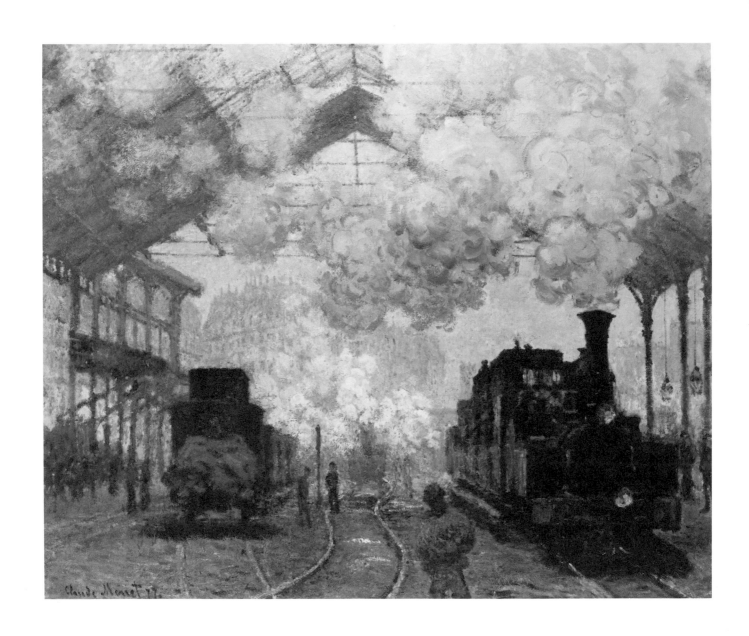

Fig. 25
Claude Monet
The Gare Saint-Lazare, 1877, oil on canvas, 82 × 101
cm. Fogg Museum, Cambridge, Massachusetts.

106. T. J. Clark, *The Painting of Modern Life: Paris in the Art of Manet and His Followers* (New York: Knopf, 1985), p. 73.

station's optical properties in his series of works of 1877–78, Monet never returned to paint the Gare Saint-Lazare.

THE PONT DE L'EUROPE

AT THE RIGHT EDGE OF MANET'S *The Gare Saint-Lazare,* there intrudes a bit of the giant trusswork and one pier of the enormous structure—really more an elevated plaza than a bridge—known as the Pont de l'Europe, so called because rail lines radiated from this spot to the rest of the continent. When Caillebotte painted *Le Pont de l'Europe,* 1876–77 (fig. 26) as observed by a dignified, dapper stroller, the rising steam in the background saluted and celebrated the brawn of the modern industrial city. Here, thick vapors rising in a column signaled that machinery and men performed heavy labor. The gentleman who observes the scene has a clear understanding of that business, spawned in the nineteenth century, which we still call "smokestack industry." Industry, the building of modern Paris, and the stream of production that went forth to furnish a modern world are invoked by this image, in which the Pont de l'Europe—the hub of an empire—plays a major role. The brute symbolism of Caillebotte's picture could not have spoken more forcefully to a contemporary spectator. The enormous bridge, an engineering marvel in its day and the site of many Impressionist paintings, is seen by Caillebotte as a brawny truss framing distant signs of work.

In his previous version of the picture, 1876 (fig. 27), Caillebotte had emphasized his point. Observing the massive trusses of the structure, first in close-up and again as a distant vignette, the principal spectator of the vast urban energy that lay below and beyond the bridge was "a worker looking out of the street without sides."[106] The loitering worker's curiosity heightens the titanic scale of the distances involved, both social and geographic. In Caillebotte's second version of the *Pont de l'Europe,* the white-gloved bourgeois, momentarily still as he gazes upon the empire of machines (in which he undoubtedly holds shares) plays against the aimlessly waiting worker, who stands to his left. A partial figure strides out of the

107. Moreover, tendencies toward realism, narrative continuity, and social comment on a scene extracted from actuality all separate Caillebotte from the complex skeins of meaning that glitter throughout Manet's work.

108. The distinctions I have tried to introduce into this discussion will not be subscribed to by all readers. For example, Robert L. Herbert to some degree unites these artists in their treatment of the engineering in and around the train station:

> A few artists, however, including Edouard Manet and Gustave Caillebotte, had made paintings of the tracks and bridges near Gare St. Lazare. Like these two artists, who were among his friends and supporters, Monet was committed to a form of naturalism which sought the characteristic truths of a scene or activity. ("Industry in the Changing Landscape," p. 159)

Of course, there are many *truths* at any scene.

109. Presenting it as an example of Realism, Linda Nochlin viewed this work in a very different way from that in which it is being discussed in the present study. She noted that

> in *The Railroad,* the urban setting, while not stressed is an essential ingredient of the painting, the iron bars, the steam, and the fragmentary glimpse of industrial actuality endowing a woman and child with an explicitly contemporary vividness. (*Realism* [New York: Penguin, 1971], p. 162)

She further incorporates this painting into a network of Realist considerations when she notes that

> Manet was a great admirer of railroads, considering them the epitome of modern life. He thought of railroad drivers as "modern heroes," and looked forward to painting them. (Ibid., p. 264)

Although Manet never seems to have gotten around to painting railway engineers (he painted sailors—and had himself done a stint at sea early in life—as well as painting *Road Menders,* 1878, whom he most certainly did not consider "modern heroes") yet Nochlin's view is assumed in the present study and is subsumed into a larger view that incorporates the "realist" component of

composition, rushing past at the busy tempo native to this bustling place, where the two momentarily still figures are the exception. Although Caillebotte exhibited with the Impressionists, presenting eight works in their second show of 1876 and supporting them with his regular purchases, his work does not advance the Impressionist agenda.[107]

Caillebotte, a marine engineer (and hence the careful transcriber of structural facts), was a moralist at the Gare Saint-Lazare. Through Monet's eyes we see the light effects that brought him to the train station. In Manet's art, however, we are offered the possibility of viewing a special nineteenth-century sensibility. We have but to learn to read his means of transcription.[108]

Distinguishing among these three different approaches exceeded the critical discernment and literary means of Manet's contemporaries. Indeed, only now are such distinctions manageable. That Manet's *The Gare Saint-Lazare* presents neither a mere cityscape—a paean to modernity—nor simply a multifigure portrait is a revelation beyond his contemporaries' powers of intuition. We are not obligated to maintain the procrustean terms native to Manet's misunderstanding the nineteenth century. The interior dialogue that sustained and united the painting's components placed it beyond popular or, indeed, contemporary understanding. This privileged, specially accessible subject was supported by Manet's obvious, exoteric Realism.[109] The sensibility that enmeshes the figures of *The Gare Saint-Lazare* in their situation surpasses the Realist sensibility, and we do not associate such a work with that movement. No obvious social consideration appears in the painting. This absence removes the work from such speculations, particularly to the degree that social observation compelled the development of the novel as a literary form. For example, the painting is not studded with insignia that require consultation with books of symbols, although the elements turn out to be composed with the same network of cross-references as an allegory. The openness and the *availability* of this painting's imagery to unprepared comprehension, supplied solely from its own resources, suggests something of Manet's goals. Rewald noted that

> although Manet himself rarely made any allusions to his sources, he often used them with so little disguise that it would have been easy

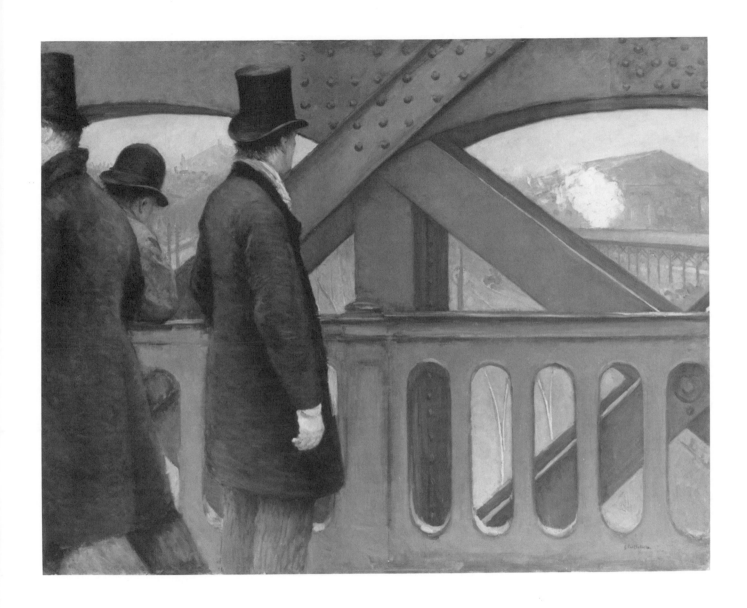

FIG. 26
Gustave Caillebotte
Le Pont de l'Europe, 1876–77, oil on canvas, 105.3 ×
129.9 cm. (41½ × 51⅛ in.). Kimbell Art Museum,
Fort Worth, Texas.

Manet's work. This realist element can now be understood to be only one constituent of multiplex ambitions incorporated into his vision of what *The Gare Saint-Lazare,* and his subsequent work, might become. To the degree that Manet was a Realist before 1873, the present study argues that he was ever less so thereafter, and starting with this painting the distance between him and the Realist sensibility grew ever wider.

110. John Rewald, *The History of Impressionism* (New York: Museum of Modern Art, 1961), p. 86.

111. Indeed, compared with an artist like Whistler—whose formalism often produced pictures contrived to display color schemes, compositional devices, and so on—Manet relied on his subjects' evocative power and sought out poses, situations, references, locales, and compositions, all of which contributed to an extrapictorial meaning. Such considerations are often refined almost beyond delectation, to the point of evanescence. Yet, Manet's pictures decidedly engage a world of inquiry broader than that contained by the stream of pure visual speculation and sensation. He refers backward to art history and occasionally to the political situation of his own day. Manet's pictorial world was replete with human consideration.

112. The title of *Las Meninas* derives from the Spanish *menor,* the comparative "lesser." Hence, I prefer the translation of the title that stresses the subordinate (*Young Ladies in Waiting*) rather than the grander term (*The Maids of Honor*). Bowing to convention, however, for the sake of clarity, I have used the more widely known title throughout the text.

Manet's admiration for Velázquez is legendary, but an anecdote can perhaps illuminate a side of Manet's proprietary humility toward the Spanish master. Pierre Schneider notes that when Manet was in the Louvre, "he met a young man engaged in drawing an *Infanta* by Velázquez directly on the etching plate. 'What gumption! You'll be lucky if you carry it off!' exclaimed Manet. The young man introduced himself: his name was Degas." (*The World of Manet* [Alexandria, Va.: Time-Life, 1968], p. 21)

113. For example, Held and Posner's description could adequately serve as a gloss on the Manet:

to identify them had anybody cared to do so. But in Manet's case the whole question seemed of little importance, since what mattered was not the subject but the way in which he treated it.[110]

Once again we encounter, in a far more sophisticated form, the twin arguments that Manet's work is veined with a covert subject of unquestioned ulterior purpose but that regardless of the subject's purpose it is secondary to his style. Discounting Manet's subjects (aside from their relationships to sources) proves to be self-fulfilling, since his treatment (style) is all that remains to be examined. This has already proved to be the dominant theme in the Manet literature. The growing body of explicated works demonstrate how Manet liberally mined art history in order to supply the pose and spatial relationship of his figures. The account that we currently possess regarding the ways in which Manet exploited his sources is sufficiently rich to suggest the high intelligence of Manet's selections and design, of the constellation of his subject matter's components, and of its cumulative implications.[111]

Prominent among those to whom Manet looked to measure the possibilities of painting was Diego Velázquez whose masterpiece of 1656, *Young Ladies in Waiting* (known as the *Maids of Honor,* or sometimes as *Portrait of the Royal Family*) (fig. 28) contains one of the most versatile essays on spatial relationships ever achieved.[112] Back and forth through the space of the picture the viewer's glance shuttles, until the entire depth of the picture is alive with its intelligent lineaments. In addition to supplying both a panoply of royal portraits and a self-portrait, the work is a dazzling essay on optical theory, geometry, the variety of diverse species of direct and reflected light, and the nature and uses of perspective. In the midst of the work the artist himself is seen, painting and looking up to the viewer. He stands midway between the picture plane, located *in front of* a reflection in the distant mirror, and the pierced rear wall through which a figure exits into light. The viewer shares the space in front of the picture with the king and queen of Spain.

On many levels *The Maids of Honor* performs the psychological and spatial functions Manet assigned to *The Gare Saint-Lazare.* In particular, the coextension of several spectators at the same point claims a long and noble intellectual pedigree.[113] Velázquez himself was undoubtedly inspired to this conceit by Jan van Eyck's *Portrait*

70

FIG. 27
Gustave Caillebotte
Le Pont de l'Europe, 1876, oil on canvas, 125 × 180
cm. Musée de Petite Palais, Geneva, Switzerland.

It is the master's boldest experiment in naturalistic techniques. "Naturalism" for Velázquez . . . was not essentially a device for describing the world as it is but, rather, for revealing a higher order of visual and intellectual relationships. . . . Supposed ambiguities in *The Maids of Honor* exist only when one assumes that its organization is primarily narrative in structure. . . . The central theme of the painting is the awareness of the royal presence. . . . What is most extraordinary, however, is the complete identification of the imagined position of the king and queen with the real position of the spectator. (Julius S. Held and Donald Posner, *Seventeenth and Eighteenth Century Art* [New York: Prentice-Hall-Abrams, 1979], p. 184)

George Kubler presented an alternate reading of the painting, stating that "the double portrait on the wall is clearly a painting of the royal couple as if seen in reversed position" ("The 'Mirror' in *Las Meninas*," *The Art Bulletin* LXVII (2) [June 1985]: 316).

This notion has not been very "clear" to other observers, especially those who, like Joel Snyder, have studied the perspectival arrangement of the painting ("*Las Meninas* and the Mirror of the Prince," *Critical Inquiry* 11 [June 1985]). Only a painting of such rich constructive properties could have engendered and supported so much carefully contradictory discussion.

114. The inclusion of the viewer within a space of which the painting shows only a part has precedents, some as famous as van Eyck's *Arnolfini Wedding* (also known as the *Portrait of the Arnolfini*), others less celebrated. For example, in the painting *Saints Peter and Dorothy* (c. 1505–1510, Master of the St. Bartholomew Altarpiece, National Gallery, London), Saint Peter's spectacles, held in one hand, reflect the multipaned windows *behind* the observer, thus including the viewer in the space the picture embraces and placing the Saint in the room with the spectator.

of the Arnolfini, which in Velázquez's day was in the collection of the king of Spain.[114] Manet, who used this device, supplanted the royal family with another art-historical precedent (the Annunciation and the "Virgin of Humility") to alter the spectator's relationship to the model, but Velázquez's example furnished the major thematic format of *The Gare Saint-Lazare.*

Manet's choice of spatial arrangement is not as simple as it appears. Manet too, accounted for the furthest distance of a painting that seems so open and accessible. Unlike the obviously confined interior where Velázquez worked in limited light, Manet's apparently open space definitively closes as the painting collides with the far wall of the railway cut. Velázquez considered the rear of the picture, opening it with a burst into a brilliantly lit stairwell, while Manet placed two doors in the upper left of *The Gare Saint-Lazare* to emphasize the closure of the chamber of the painting. Behind those two doors the smaller volumes of rooms await unseen, but *The Gare Saint-Lazare,* despite its outdoor setting, displays only the most restricted precinct. The painting we behold is shut off at the rear. We inspect a volume that, tubelike, opens invisibly at either end, and the spectator enters the pictorial space frontally, although the fence controls penetration into the painting. What seems to be an unrestricted and casual view contrives to restrict us to a narrow, if intense, range.

Few works in the history of Western painting are as difficult to categorize as *The Maids of Honor.* Accordingly, few works so fully declare themselves to be outside the realm of literature. *The Maids of Honor* has few kin; perhaps in its mixture of portraiture, genre, daring intellectual calculation, and suppressed narrative, its equal can be found in Watteau's *Embarcation from Cythera,* or in a work of that same unidentifiable subtlety that escapes the imprecisions of typology: *The Gare Saint-Lazare.*

The marvel of *The Maids of Honor* has been noted by numerous commentators, who have rightly regarded this work as a miracle of spatial construction which summarizes the full expositional possibilities of perspectival design in deep space. For the nineteenth century, the critical, the absolutely central, questions were no longer metaphysical but epistemological. Had Manet lived in the seventeenth century, he, too, would have been bidden to reckon such features of the world those that had moved Diego Velázquez to

115. And we say good-bye to you also,
　　For you seem never to have discovered
　　That your relationship is wholly parasitic;
　　Yet to our feasts you bring neither
　　Wit, nor good spirits, nor the pleasing attitudes
　　　　Of discipleship.
　　　　　　　　　　Ezra Pound, *Amities*

magisterial eloquence. But in the last quarter of the nineteenth century the world was revealed not by optics but by human behavior—psychology. Manet's was an intellectual and conceptual equivalent for the visual and perceptual exercise that captivated Velázquez. Manet engaged his world as a psychological construct. He explored its symbolic presentation in what seems, superficially, to be a somewhat conservative vocabulary, midway between the Academy and the direct apprehension attributed to the Impressionists. Perhaps necessitated by his own self-doubts—or "the pleasing attitudes of discipleship" that he harbored about the past—Manet's resistance to unnecessary change in subject matter mystified his contemporaries.[115] That bland imagery appears to favor, or at least not to question severely, the existing order of either contemporary politics or orthodox art history. Consequently, for generations attention was deflected from a central characteristic of Manet's art. This might have pleased the artist, but he did not labor within his chosen terms to achieve such warmly confused, if earnest, reactions. His approach to the world can be gathered by comparing his efforts to those of his contemporaries.

NOMINALISM: FAITH OF THINGS

MORE STRONGLY THAN THE TESTIMONY OF ANY other evidence, Impressionism itself represented a movement without a manifest style, a movement that set out to capture the world by directly apprehending the impress of light. That the Impressionists appeared when they did indicates the fundamental nominalism that underlay the movement of psychology toward center stage. Theirs was an artistic movement that, more forcefully than anything else the West had known, eschewed abstract concepts, references to philosophy, theology, and apparently politics as well. Our inherited view of Impressionism suggests an art that treated no generalities. It did not posit universals but instead reported on local conditions. Impressionism was quintessentially an art of particulars addressing the products of objectively focused attention and accessible to all without preconditioning information.

The schism with the past, if it seemed abrupt, moved through

116. For example, the transition from Realism to Naturalism, which occurred in the 1870s, traced a subtle course that involved many of the principal players of the current study. Gabriel P. Weisberg noted that

> while condemning other Realists as old-fashioned, Zola conceded that "the movement of the time is certainly Realist, or rather Positivist," even though his manufactured antagonism between Manet and other Realists disguised their actual similarity. (*The Realist Tradition: French Painting and Drawing 1830–1900* [Cleveland, Ohio: The Cleveland Museum of Art, and the Indiana University Press, 1981], p. 3)

stages that are becoming visible. Only gradually was Impressionism weaned of its dependence on symbolic substance.

The Impressionists' debt to Manet was publicly acknowledged, but the nature of that debt is obscure.[116] Art incorporates the basic assumptions of its creators and their societies, and it can signify extra-artistic conditions or concerns. In this regard Impressionism is no different. It conjures for us not only those marvelous summers and winters of the nineteenth century but also the enterprise by which those moments were captured. That high mood in which explorers went forth to fill in the last empty places on the map (as opposed to earlier explorer-conquistadors who were adventurers or traders seeking investments over the horizon) shared the spirit of the Impressionist painters, who went out to capture, to bring back (alive), the effects of light—nothing less.

The scientific imperatives of such a quest are as obvious for this period as were Leonardo's study of the effect of air intervening between the beholder's eye and the object and as manifest as Dürer's examination of perspective. Positivism's insistence on sense perception as the only admissible foundation for knowledge represented as much an assumption of its period, in its attempt to supersede metaphysics and theology, as do the conventions of any other era. Intellectual life had already come to recognize the essential requirements of (scientific) particularity, and against this tenet the academy's limp fables faltered, stunned. Concomitantly, social bonds supporting a mythology of class withered. Communally verifiable data cataloged what was significant about the world. Reflexively, such epistemology questioned the operations by which sensations themselves were gathered and organized. Not only scientists but poets and painters took this campaign as their charge.

For the last quarter of the nineteenth century, assumptions concerning the operations of the mind and our apprehension of the world predicated much of the advanced thinking in art. In a former generation, Velázquez constructed *The Maids of Honor* to display the complexities of mirrored space, and we thereby ascertain the demonstrated power of his mind; in his time Manet constructed *The Gare Saint-Lazare* to mirror the complexities of mind, and thereby we can discover the core of his art and its contemporaneity. If in place of the artist (as in *The Maids of Honor*) we encounter the frank gaze of Victorine Meurent, the entire ensemble of *The Gare Saint-*

117. Michael Fried, "Thomas Couture and the Theatricalization of Action in Nineteenth-Century French Painting," *Artforum* VIII (10) (1970): 45.

Lazare bespeaks the ordering sensibility and intelligence of the artist, an absent figure whose impress is everywhere apparent. That he exquisitely adjusted the subject to appear artless, a seemingly undisguised report of a common scene, relates Manet's naturalness with Realism. In fact, nothing about this picture is as candid as it appears, and another meaning—beyond pure description and seemingly ingenuous exposition—locates the level at which Manet's intentions were stationed.

In order to separate Manet from the realism to which his frank and apparently uncluttered presentation would have him allied, another stream of thought must be invoked. *The Gare Saint-Lazare* does not render the burden of its meaning directly, but through a complex and nearly endless set of mirrored relationships, presenting images in the manner of a Symbolist poem. Specifically, the opacity of the work does not invite the spectator to partake casually of its hoarded meanings, its unexplained symbols, and a higher meaning that appears only to the initiate. All of this makes *The Gare Saint-Lazare* the quintessential symbolist painting, albeit in advance of any such organized movement and hence resembling little that subsequently went by that name.

Certainly, there appears in Manet's own art, in his previous pictures, suggestions that he was building toward this complex reflexive essay on consciousness. Michael Fried noted that Manet's paintings of the first half of the 1860s "may be said to take account of the beholder; in any event they refuse to accept the fiction that the beholder is not there, present before the painting."[117] This proposition has no stronger final flowering than Victorine Meurent as she appears in *The Gare Saint-Lazare,* but her recognition of the spectator identifies but one layer in the diagram of consciousness in which Manet graphs the peaks and troughs of the mind's registration of empirical reality.

When Mlle Meurent looks up at us, she organizes the intelligible pattern presented by the outside world. By comparison, the book from which she had been reading presents the world symbolically, forming an imagery shining in the mind of the reader. A mental landscape requites the symbolic summons of the text. Were she an actress, Mlle Meurent would have to find the plastic expression to communicate to her audience what she is, feels, thinks, or reads. The painter suggests a balance between the outer form of the woman

118. By itself, projection is part of the normal spectrum of nonneurotic adaptive mechanisms in the healthy individual. Paranoid delusions based on the projection of aggressive and hostile feelings typically appear as symptomatic of pathological conditions.

reading and that unseen inner world, unknown to us. A universe of images, called into being by her reading, is now fading when, interrupted, she raises her glance to us.

The equilibrium of the inner psychological and the outer visible worlds is echoed (given plastic expression) in the other figure in the painting (fig. 29). The little girl stares intently at the steam; she looks into a shapeless swirling form and therein makes what figures she will. She projects outward onto the cloud the mental impressions that the shapeless cloud approximates for her. Technically, the vital mental mechanism of "projection" consists of the attribution to others of undesirable personal feelings and attitudes.[118] Projection also supplies the meaningful syntheses by which we organize less meaningful units, positing assumptions about the internal organizational intelligibility of a visual display. The *gestalt*, had Manet known the word, was being fathomed by Suzanne Hirsch. She is pictured in reverie as she alternately integrates complete forms from wisps of steam and then, attracted by a single part, fixes on that as the whole cloud vanishes. Patterns and configurations come and go, namelessly, wordlessly, in her fascination, which we have all known.

Manet precisely pictured the condition of musing on forms. He treated a growing awareness of certain implications whose plastic expression appears in the woman's intense reading and her glance at the spectator, in the dreaming animal, and especially in the child's daydream before the melting steam. A grammar of meanings binds the world's appearance (as another grammar had geometrically ordered the world of Velázquez), and the child visually constructs the outside world. She also personifies and invigorates the cloud. Seeing shapes in it, she organizes and makes meaningful what lacks intrinsic meaning or symbolic intention (in reality and not just in the painting). She enacts Leonardo's well-known prescription for the artist to ignite the imagination by contemplating meaningless smudges in which, after a while, he can "see" the grandest events. Finally, the sleeping dog dreams images that (like those engendered by the book) are not the product of any immediate stimulus depicted in the work but are the exclusive realm of recollection.

Manet treats the patterns by which we organize information (a taxonomy of epistemology). His essay is so thorough that we can apply the very terms of understanding contained within the work as the limits by which we ourselves, and subsequent spectators, will

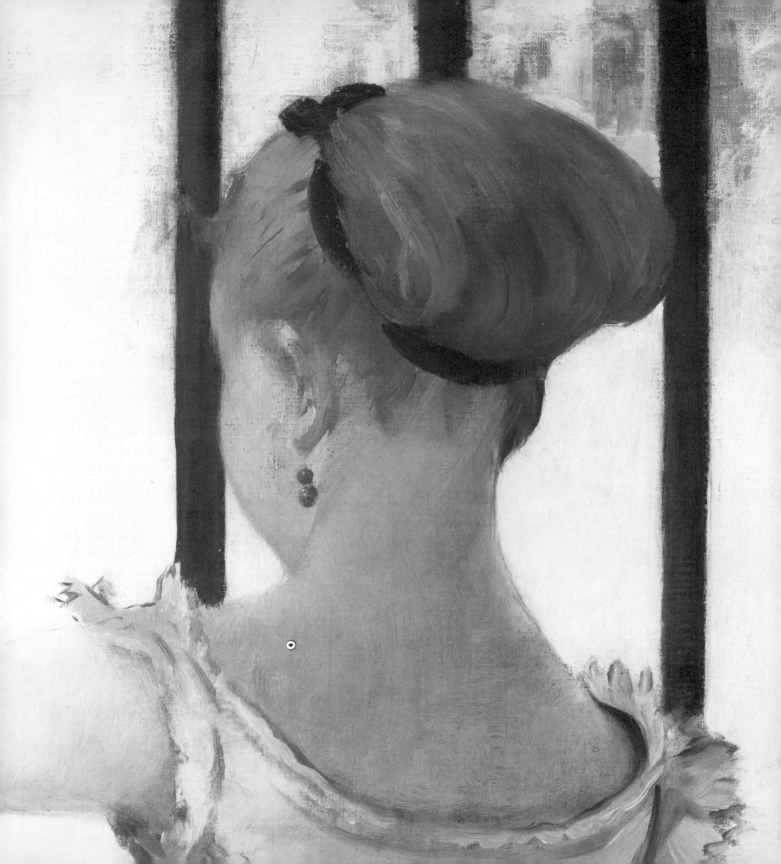

119. Nor was Manet merely reluctant to exhibit with the Impressionists, a hesitancy he might have overcome after their first tentative, if epochal, show together. A total of fifty-five artists exhibited in the eight Impressionists exhibitions held between 1874 and 1886. Manet was alive for all but the last, and if he had the least sense of allegiance to these artists, he could have chosen to display his affiliation with, and support of, them. He never availed himself of the opportunity to show with the group. Clearly, in his own mind some chasm separated the Impressionists from him.

120. A clear distinction should be made in this regard between the "Impressionists," a more-or-less recognizable group, and the larger body of work shown in the eight *Independent* exhibitions that included over seventeen hundred paintings. The exhibition and its catalogue, *The New Painting* (San Francisco, Washington, 1986) has taken us a long way toward understanding the greater web of affiliations within French painting in the years 1874–1886. Many of the larger group of artists shown in the *Independents* were, frankly, both less progressive and less good painters than the Impressionists, and any apparent confederation with these artists would have been enough to scare off Manet, ever conscious of appearances as well as facts.

Thus two separate issues emerge. Manet may not have seen himself as an Impressionist in the terms by which other Impressionists recognized one another. Second, Manet would certainly not have wished to have besmeared his reputation by exhibiting at the *Independent* show for the sake of insignificant artists.

view the painting. For example, as noted, the little girl "recognizes" forms in the ceaselessly swirling cloud through projection; this resembles the manner in which we distill designs from arrangements in the painting when we are performing formal description. (The patterns we distill from representational works to fashion "compositions" are abstracted in just this way.) Regardless of what spatial depth a painting purports to represent, we project designs onto (usually) a single plane in order to ascertain composition. Similarly, amid swirling repetitions we form and re-form designs by which we grasp the parts of an ungraspable (or a hypnotic) whole. As the adult reads the conventional symbology of her book, we are able to dwell upon the subject matter of the painting as the fit vehicle for ratiocination. We weigh the symbolic meaning of the work and "read" the painting in terms of its pictorial language.

The elaborately composed subterranean program of *The Gare Saint-Lazare* begins to hint at how Manet himself viewed his art within the stream of contemporary developments. That Manet never exhibited with the Impressionists has always been viewed as an anomaly. Certain aspects of the history of Impressionism are thrown into question when one of its seeming progenitors absented himself from participation with the rest of the group.[119] One explanation of Manet's disinclination to participate in the Impressionists' exhibitions depends on his conservatism and his desire for general acceptance, traditional respectability through the Salon, and favorable reception by the Academy.[120]

The Academy, whatever else bound it together, continued to sustain itself on the affections, and sometimes the patronage, of a specially prepared audience. Its public shared a taste that was molded (unthinkingly and unknowingly, for the most part) by the long tradition of the church's Aristotelianisms. Personification and allegorical symbolism depended on the assumption that deathless and universal principles could be equally, or more, real than objective data available to the senses. The nineteenth century's waxing nominalism forever banished this realm of belief, although the attendant mental and artistic mechanisms (faith and allegory) continued to enjoy a lively existence even after the appearance of Naturalism and Realism.

That Manet subscribed to naturalism and realism is evident, although the degree to which he exemplifies a practicing Realist is

121. The fruition of this aesthetic is really found in the Edwardian sentiments of Pound and Eliot, in which Manet can be seen to presage the texture of an art of citation and reflexive gesture. There is no direct connection between the two figures of Pound and Manet, except through the influence of Mallarmé, whom Pound did not hold in especially high regard but in whose debt he was, nonetheless. Pound:

> The cult of Poe is an exotic introduced via Mallarmé and Arthur Symons. Poe's glory as an inventor of macabre subjects has been shifted into a reputation for verse. The absurdity of the cult is well gauged by Mallarmé's French translation—*Et le corbeau dit jamais plus*. ("The Renaissance," in *Poetry* [Chicago, 1914], reprinted in *Literary Essays of Ezra Pound* [New York: New Directions, 1968], p. 218)

open to dispute. Certainly the archrealist, the quintessentially nominalist endeavor was Impressionism, which took notice of nothing not apprehensible to the senses. Impressionism's true subject is not even the world, whose presence arrives as light in our seeing. Rather, the Impressionists recorded the act of continually confirming the world by sight. The purposes for which Manet employed a veridical transcription of the world—beyond ascertaining the quiddity of sight—may identify the schism that separates Manet from the nominalist-Impressionists. These distinctions may prove to be the crucial factor that barred Manet's collaboration with the Impressionists. Whatever these differences Manet did not articulate them.

Although he did not exhibit with the Impressionists, he did not repudiate them. Apparently he enjoyed nothing but collegial support and professional respect from them. That Manet labored to record a superficially frank and truthful picture of the world is evidently a goal he shared with the Impressionists. The critical difference between Manet and the Impressionists describes the two paths that bifurcate subsequent modernist art. The Impressionists' art of seeing addressed the world almost as a branch of the natural sciences. Piling up, point by point, a report on the appearance of external reality, the Impressionists paved the way for art until the advent of Cubism (a transcription of the world that tells us a great deal concerning what artist's thought about art and certain aspects of the appearance of things but almost nothing about the artist's extra-artistic, nontechnical beliefs). Manet's art lauds the art of the past and comments upon human behavior. From such art we can reconstitute the artist's thoughts and study his personality across the barrier of time.[121] We ought not to confuse Manet's followers with his defenders.

Because the Impressionists exalted Manet, we ought not to lapse into reasoning that he led them, for they did not follow where he led. With Bazille's death the figure played an ever-diminishing role in the evolution of Impressionism; the analyses of the visual field grew too fine and the optical incidents too small to communicate gesture. (Only Renoir consistently employed the figure, and Fantin-Latour singled him out in his Batignolles group, while placing Monet at the periphery.) At last the blizzard of the Postimpressionist field required the Seurat repair to a lyrical geometry to rescue human forms dissolved in the picture's surface.

122. Understanding the relationships that govern the constitution of *The Gare Saint-Lazare* does not require positing any particular emotional tone for the work. In itself this condition is somewhat novel, and comparable to the Impressionists' coolly dispassionate and precise observations, except that Manet offered a detached view of the symbolism of human perception instead of a disinterested report on the condition of nature as an optical sheath.

123. Michaud, *Mallarmé,* p. 86.

The component of Manet's art treating subject matter did not concern Impressionism, and this element of discursiveness irreducibly separates Manet's undertaking from that of his colleagues. It is possible that by 1872–73 Manet may have become something of a Symbolist—albeit one who sought the most "objective correlatives" from daily life with which to fashion his art.[122] He did not will the evolution of his art according to strict theoretical tenets but allowed his mature personality to preside over its course. The urge to discover the proper channel for his willfulness was a trait that Manet shared with Mallarmé. It appears that both were "revolutionaries in spite of themselves."[123]

The rich symbolic relationships found in a single picture suggest that Manet did not arrive on this complex symbolic territory quickly. The variety of attributes by which subtle states are presented, and by which rather common things come to stand for extraordinary observations, could not have arisen—even in the mind of so talented an artist—on the occasion of this one painting. Manet perfected a report of that world through which he moved, but those descriptions of the everyday were required to serve a remarkable artistic necessity. Something novel marshaled his prowess and descriptive powers in the early 1870s. Many of the works preceding *The Gare Saint-Lazare* intimate that the artist was moving toward this position as he cautiously stalked what would become the highwater mark of psychological investigation—indeed of psychological expression—in the absence of highly emotional distortion. Impressionist painters essayed the mechanisms of perception, but Manet took as his principal charge the objectification (by symbolic means) of the relationships that delimit the psychological processes. And this was neither an easy nor a rapid evolution for him.

SOME FORERUNNERS OF *THE GARE SAINT-LAZARE:* AN EXCHANGE OF GLANCES

VICTORINE MEURENT'S INTENT LOOK IN *The Gare Saint-Lazare* can be said, considering the *Olympia,* to have charted the distance from the gaze as erotic invitation (analogically extended to

124. The allure of *Olympia*'s erotic glance was sufficiently off-putting to Manet's audience that it provoked a considerable part of the antipathy generated in the press. One of the first contemporary reviewers, whether out of genuine disgust or a massive display of reaction-formation (whereby a defense mechanism is set up directly opposite to the underlying impulse), noted in particular that "her greenish, bloodshot eyes appear to be provoking the public" ("Ego," writing in *Le Monde Illustré,* trans. by T. J. Clark in *The Painting of Modern Life,* p. 96).

125. Michael Fried, *Absorption and Theatricality: Painting and Beholder in the Age of Diderot* (Berkeley, Los Angeles, London: University of California Press, 1980), p. 4.

126. We might note at this point that each psychical action with regard to an object that exists (or seems to exist) implies intentionality. The correlation of object and psychical act, the sum of the surroundings, imparts "reality" to the object. Seeing something implies that that something is real to the viewer, and upon that substrate of intentionality the viewer's moral or emotional reactions are founded. The object perceived (the "something") is not a mirage to the viewer, but is "real." Only a secondary questioning of the circumstance of the appearance of a thing in our ken might lead us to question the reality of something. The relationship of object-to-psyche creates the field of mind, within which questions of epistemology and intentionality are played. This image of Victorine Meurent moving her attention from the book to "us" engages just these questions (and sensations of mind, and the "emotion of mind") which also attracted contemporary French writers.

represent possession of the picture itself) to the gaze as discursive exchange.[124] The fixed attention that she directs at the spectator, at our presence and our returned gaze, takes the form of conversation between two parties whose relationship, however brief or prolonged, began when the model's absorption in her book was plucked from the page, by the spectator's act of appearing in her view. Her gaze does not seem to betray amazement at our entry into her world, nor is she vacantly staring past us. With neither alarm nor hostility, Mlle Meurent searches us with some, but not with overly familiar, recognition. She is neither obviously glad nor fearful of our approach.

The uses to which Manet put the act of observing changed, or rather evolved, from what he had previously attempted. In *The Gare Saint-Lazare* we no longer encounter "the alienating, distancing character of the chief female figure's frontal gaze in Manet's *Déjeuner sur l'herbe* and *Olympia*."[125] Instead of distancing the viewer or presenting a barrier, Mlle Meurent's gaze is the principal anchor holding fast the spectator to the internal life of the painting. No longer an off-putting challenge or an obstacle to be averted, the model's intent look is the painting's primary channel of entry. Our scrutiny of the work, and of the model before us, contributes another form of concentration. As spectators of the painting we ourselves assume the role abandoned a moment before by the model: just as Victorine Meurent had been deeply absorbed in her book, oblivious to "our" approach and unsuspecting of the incident that would interrupt her reading, we now intently peruse the depths of the picture. And we do so until we are interrupted to return to our world outside the picture. Just as she weighed the merits of the text, moving between one passage and another, checking correspondences throughout the texture of the writing, we now submerge ourselves in the "text" and content of the painting. We have exchanged places with the picture as it "studies" us.[126] This subject matter is as much a moral inquiry of the spectator as, previously, depicted heroism or martyrdom challenged the viewers' gumption. Our inadvertent participatory scrutiny supplies yet one more species of attention.

Manet so contrived the picture that once we have become aware of the focused assessment of consciousness, we are drawn willy-nilly into a reciprocal relationship with the work, which supplies yet another example of attentiveness. We partake of the work in a manner more akin to the reader of a poem who, becoming the

poet's utensil, invigorates the dormant voice of the poet. Viewers of paintings usually observe an unnoticing and passive object. Manet regarded mental powers, particularly the range of our notice and registration of the world and of art, as a legitimate, natural, and important—if wholly novel—field of deliberation. Now dialogue, unintended and compelled by the painting, is insinuated by our examination of it. We have become part of its description of the range and forms of consciousness.

In this context, Fried's observation of "the alienating and distancing character" of a figure's depicted glance represents a willfully ascriptive attribution. Such unverifiable assignments of emotional states, however tempting, are not the substantial components by which real analysis can be achieved. Attribute by factual attribute, a cumulative understanding of Manet's ambitions reconciles present historical requirements with past criticism. The sitter's attention in *The Gare Saint-Lazare* is part of a circumstantial situation that can sustain what ascription cannot successfully insinuate.

In the past, cognizance of the viewer meant various things in special situations (such as in van Eyck's *Arnolfini Wedding*). A direct glance meeting the spectator's perusal of the painting was a device with which Manet had experimented for some time. At least as early as 1862, he had used this gesture in no less than three pictures that were not traditional portraits. *The Old Musician* stares at us from the painting of that title. In that same year Manet painted Victorine Meurent as being conscious of the viewer when she passes through swinging doors in *The Street Singer,* just as she looks directly at us in *Mlle Victorine in 'Espada' Costume.* In 1863, Manet affronted his spectators with the most notorious plastic invention of his career: the recognition that the naked Victorine Meurent was aware of our examination as she lounges among clothed men in the *Déjeuner sur l'herbe*. Later that year Manet painted the *Olympia,* whose nude (again Mlle Meurent) appears somewhat more classically (with no less scandalous results) redolent of the *Venus of Urbino. Olympia* externalized the situation of the *Déjeuner sur l'herbe,* for now the painting's spectators surrounded the nude.

Manet's interest in the "observed spectator" was not limited to one period of his work. His works are filled with indications of interest in that special state of self-consciousness by which an artist

127. But what if Victorine Meurent should not see us? Then we might surmise (ignoring precedents such as the *Olympia*) that she is depicted traditionally, painted by an "absent" spectator who records the woman's looking up from her book and, still very much absorbed in her text, sees nothing of the outside world. Then *The Gare Saint-Lazare* would picture three versions of imagination's "inward eye": the woman's imagination informed by reading; the child's imagination which (in)forms the world by projection; and the puppy's dreaming. Such an interpretation offers many gradations of possibility. In fact, an equally rich situation can be constructed whether she sees us or not.

For example, the woman emerging from absorption in reading only *starts* to understand the chance for us to appear before her as part of the world outside her book, and so forth. Quickly such variations fill in the thematic possibilities and make *The Gare Saint-Lazare* as complete as if we had started from the assumption that we are espied.

128. Robert Greer Cohn, *Toward the Poems of Mallarmé* (Berkeley, Los Angeles, London: University of California Press, 1980), p. 7.

129. In a discussion more concerned with epistemology than art, David Carrier ("Manet and His Interpreters," *Art History* 8 [3] [September 1985]) argued for the "polysemous" character of Manet's art (p. 322) and stated that

> The attempt to construct one consistent image of Manet may not be true even to how we know ourselves. Like many people, I sometimes am socially concerned and at other times only an aesthete; to assume that Manet could not also be volatile is to imagine him an unusually consistent person. (P. 323)

And Carrier recapitulates his theme even more forcefully:

> Does the existence of many different accounts show that his works can be given any meaning whatsoever? How is the art historians' search for a uniquely true interpretation consistent with the existence of seemingly conflicting interpretations? The attempt to definitively explain the meaning of Manet's work will, I am arguing, fail. (P. 330)

A dilemma arises from the conflict of the absolute, ahistorical experience of a work (criticism)

gains sufficient distance from a conception to reify it as an external sign, autonomous and extant. He experimented throughout the 1860s and into the next decade. By the time of *The Gare Saint-Lazare,* Manet was capable of employing the raised frontal gaze to communicate the highest, most complex scrutiny.[127] With its supporting explicative symbols this picture claims our attentions with its own attentions, which are akin to the roving inspection with which we concentrate on someone who has entered our field of view.

THE SIGNIFICANCE OF *THE GARE SAINT-LAZARE*

I should like to make plain, nonetheless, that I do not believe there are various possible interpretations of Mallarmé: this a view held by individuals who do not, I am convinced, care much about Mallarmé or probably even art (though they may very well care about equally important values), and when Valéry claimed the contrary (Preface to *Charmes*), I can only assume that he was in an unusually insouciant and desultory mood. There is only *one* meaning to a Mallarmé poem, or any other authentic poem. True, the meaning may be exceedingly complex, polyvalent, ambiguous (in the well-known Empsonian sense); it may be constructed in places like music, with overtones achieved through a sort of verbal equivalent to chords.

Robert Greer Cohn[128]

IF IT WERE NEEDED, IT SHOULD BE POINTED OUT THAT THE above declaration more or less states my own beliefs about art and about Manet as well.[129] The absolute rendition of a poem, or the ideal reading of a musical score, has its equivalent in the interpretation of a painting, but none of these operations ought to be carried out when guided *only* by the reader's instincts. More than one lofty opinion (Hegel's for example) has been overthrown when facts got in the way. To approach the complexity of Manet's *The Gare Saint-Lazare* requires that we account for the various conflicting apprehensions of his work by perfectly intelligent and goodwilled spectators. For more than a century we have understood that Manet secreted a special view of art history, and of his own sources, within his art. What this constellation of references might ultimately signify about the artist's ambitions is still very much contested. At least one viewer supposed that Manet's piercingly exact wit was among his works'

with its relativity (art history). Nevertheless, with care we can identify a substrate of intentionality, no less (or more) accurate than any statement about human compulsion.

For a plunge into a discussion of the dimensions that support and distort such pronouncements about art, the reader may consult Robert Greer Cohn's "Derrida At Yale" (*The New Criterion* 4 [9] [May 1986]: 82 passim).

130. Linda Nochlin, "The Invention of the Avant-Garde: France 1830–80," *Avant-Garde Art*, ed. Thomas B. Hess (New York: Macmillan, 1967), pp. 19–20.

131. Nevertheless, there are those who think Manet capable of real knee-slappers, such as when T. J. Clark (*Manet*, p. 166) comments on a difficult optical elision in *Argenteuil, les Canotiers*, 1874: "They are a kind of joke—the word comes awkwardly, but I cannot think of a better one—about false equivalence; about things appearing to connect and then being seen not to; about illusion, about the difference between illusion and untruth." Or, another example is Henri Perruchot's assumption that Manet was deriding the Hanging Committee and the Salon: "The incorrigible practical-joker was trying to mock them once again. Even in the picture they had accepted, *Le Chemin de Fer*, there was not so much as the door of a railway carriage, the hint of a locomotive's funnel to be seen; no more than a cloud of white smoke behind a railway!" (*Manet*, p. 201).

132. Manet hardly ridiculed art history. Rather, he revered it, and when such references to gone epochs are recognized they do not partake of caricature or travesty. Manet avoided humor at the expense of the past. Yet, Rosen and Zerner are correct in their special use of the word *parody* to refer to a limited component of Manet's work.

Rhetorical figures of speech, conceived pictorially, are the idealizing formulas for pathos, the whole repertory of poses and gestures that the Renaissance artists derived from classical statuary and reliefs, and invented in new forms. . . . For the most part, when these Classical formulas turn up in Realist painting, they appear as quotation or as parody (most notably in Manet). In general, however, the traditional idealizing pose is absent; the force

chief motivating forces. While it is difficult to argue for the absence of such wit, it is more than feasible to contest the degree of its presence and the uses to which it was put:

With Manet the situation becomes far more complicated. . . . How can we possibly take Manet at his word—and does he, in fact, wish us to?—when, in the catalogue statement for his private exhibition of 1867, he assures us that it is merely the "sincerity" of his works that give them their "character of protest," or when he pretends to be shocked at the hostility with which the public has greeted them. . . . What has never been sufficiently taken into account by "serious" criticism is the character of these works as monumental and ironic put-ons, *blagues*, a favorite form of destructive wit of the period, inflated to gigantic dimensions—pictorial versions of those endemic pranks which threatened to destroy all serious values, to profane and vulgarize the most sacred verities of the times.[130]

Besides its unsubtle conflation of "wit" and humor, such a vision of his work greatly amplifies, if not misapplies, Manet's keenly honed ability to express the relationship, or similarity, between seemingly disparate and incongruous things. Aligning symbols from the history of art or from the world that moved brilliantly around him, Manet's paraphrases or adaptations was rarely humorous, lighthearted, or sarcastic; he was no prankster.[131] One of Modernism's progenitors, Manet contributed to that growing awareness of the assumptions under whose aegis art presumed.[132] The complexity found in his art rendered Manet subject to the same sorts of misrepresentation that characterized observations concerning Mallarmé:

Criticism long considered [Mallarmé's] work a mandarin's game. But . . . with more care, the critics have noticed that the hermit of Valvins and the talker of the rue de Rome was less withdrawn from life than he wanted, or seemed to affect, to be.[133]

By virtue of the recitation of his predecessors' works in his art, Manet posited a vision of his place within the history of art. This aspect of his engagement with the past prompted some of the most forthright declarations about his work, as when Michael Fried stated, "I interpret Manet's multiple and often overlapping references to the art of the past as evidence of an attempt both to represent a certain vision of authentic French tradition and to surpass that tradition in

of the painting often depends on a sense of this absence. (Charles Rosen and Henri Zerner, *Romanticism and Realism: The Mythology of Nineteenth-Century Art* [New York: Viking, 1984], p. 147)

133. Michaud, *Mallarmé*, p. 167.

134. Fried, "Painting Memories," p. 530.

135. Moreover, Fried's position magnifies Clement Greenberg's remark about Cézanne (another bourgeois with an income) that "Like Manet, and with almost as little real appetite for the role of revolutionary, he changed the direction of painting in the very effort to return it by new paths to its old ways" (Clement Greenberg, "Cézanne," in *Art and Culture* [Boston: Beacon Press, 1961], p. 50). A harbinger of Greenberg and Fried's position might also be found in Elie Faure's much earlier observation about Manet, "It is a revolutionary painting which, in order to return to its sources, in order to temper the art of painting in them once more, dares to suppress certain of its profoundest acquisitions for the purpose of establishing it on fresher ground and of strengthening the tradition" (Elie Faure, *Modern Art,* trans. Walter Pach [Garden City, N.Y.: Garden City Publishing, 1937], p. 379).

136. The literary equivalent for this campaign proceeded apace. The generation that followed Manet, which arose in the twilight of Mallarmé's presence, took up the cause.

(There may be direct, if minor, examples of transmission and emulation between these two generations. Mallarmé's exclamation of vitality in the closing line of *Brise Marine,* 1886:

Mais, ô mon coeur, entend le chant des matelots!
[But, oh my heart, hear the song of the sailors!]

echoes disconsolately in Eliot's *The Love Song of J. Alfred Prufrock,* 1917:

I have heard the mermaids singing each to each.
I do not think that they will sing to me.

The Edwardians answered the same alluring summons for "totalization" and fulfilled its charge, at first imperfectly, in Eliot's *The Waste Land,* and

the direction of universalizing or a *totalizing* of the enterprise of painting."[134] Fried's statement implies that Manet, conserved, embraced the past. In this reading, Manet did not dismiss the past as so much inherited, and often unwanted, excess baggage, as the avant-gardist might. Rather, this reverent, ever-backward-turning glance scans a tradition that must be acknowledged, countenanced, and finally absorbed before the least forward motion is perceptible.[135]

This special view of Manet—as the selector of rare, historical, and disparate achievements that were recast in his own work as modernized images that converse upon the history of art—was especially appealing for presenting the artist as an activist critic. Accordingly, Manet's work was not just a discourse upon the history of painting (as is every great artist's total production) but was also a most explicit, if privately esoteric, exposition. Thus, history—the personal history of art constructed as every artist's principal utensil—surfaced in Manet's work and mingled with contemporary events. The psychological truth of such an enterprise, regardless of its intellectual origins, could not have long escaped the diligently practicing artist. History, as the grand, or meta-, memory, played side by side with transpiring events (personal, social, and political). In at least these two roles, as metahistorian of art and as contemporary iconographer, Manet confounded the commentators who saw in his restrained and meticulous bearing no chance for a turbulent artistic personality. He had adapted and essayed past movements, and he addressed contemporary artistic issues without writing an expository or polemical testimony of his position. We must look to Manet's work itself to judge his relationship to the advanced artistic notions circulating around him.

To whatever degree Fried is correct about the metapainting of Manet—that is, painting intended to subsume all previous French painting (with the implied youthful ardor of such a crusade)—*The Gare Saint-Lazare* marks the end of any mock-historical painting that was based solely on overt citations and references plucked from the past. Indeed, though initially developed to requite a personal intuition, Manet's metapainting can be equally well explained as the convocation of images in a Symbolist construct. The *totalizing* of painting does not necessarily entail the summation of painting's combined entirety as much as it entails the transcendence of painting as it had been.[136] As was true for poetry, "symbolism" as practiced

finally in Pound's *Cantos,* in which literature's summary is fashioned, a synthesis studded with glowing embers of old writing.)

137. Charles Chadwick, *Symbolism* (London: Methuen, 1971), p. 6.

138. Robert Rey asserted that this characteristic represented the keystone of Manet's art. Describing Manet's prestigious family, he observes (*Manet,* p. 7):

> They were models of common sense and respectability, but hardly any ties were left to attach them to other classes of society. They had no respect for the titled aristocracy; they knew the hollowness of their pretensions. . . . They had a tolerant smile for the "naïveté" of the appalling errors of taste of the bourgeoisie, commercial, literary or administrative. . . . Their aspirations were exhausted, only their principles were left: principles of justice, honor and of conscience. They never allowed themselves to boast of these, of course; like the honest men of classical ages, they were without pretensions to virtue. . . . Every day they became more and more isolated; to every other class of society they remained aloof and reserved.
>
> And here was this detachment suddenly expressing itself plastically in paint.

139. Chadwick, *Symbolism,* p. 22.

140. Baudelaire was born in 1821; Manet, 1832; Mallarmé, 1842; and Verlaine, 1844. Separated by eleven preceding years and twelve succeeding years, Manet found himself exactly midway between Baudelaire's age and the generation of Mallarmé and Verlaine. His art seems to bridge these generations.

by Manet "can, then, be finally said to attempt to penetrate beyond reality to a world of ideas, either the ideas within the poet [or the painter], including his emotions, or the Ideas in the Platonic sense that constitutes a perfect world towards which man aspires."[137] To the degree to which Manet succeeded in *The Gare Saint-Lazare* in creating a realm of relationships and ideas parallel to the apprehensible world (not directly *depicted* as much as suggested), his work partakes of the fundamental character of symbolism: to erect a facade made of components of this world but whose fabric, once assembled, suggests another reality of feeling and thought. In this trait, too, Manet revealed his *haut-bourgeois* sensibility for emotional self-reliance and composure. A foretaste of alienation, this cool detachment lies at the very core of *The Gare Saint-Lazare* and, as we shall see, of other works, conspicuously *On the Beach.*[138]

The earliest practitioners of (nineteenth century) Symbolism in the visual arts seem to have employed the tenets of Realist painting to achieve a matter-of-factness for their ensembles. The apparent subject of *The Gare Saint-Lazare* had to be rendered intact, with its superficial meaning and the inventory of what it depicted beyond question. In poetry, an equivalent mechanism can be found in nominal treatments that direct attention *away* from the quotidian presentation:

> It was this extraordinary casual and even conversational tone, which nevertheless achieves the same build-up of emotion as the measured and stately tone of *Les Fleurs du Mal,* that gave Verlaine's poetry its extreme originality at the time it was written.[139]

Perhaps *The Gare Saint-Lazare* is not so much a Realist treatment as one that appears "casual and conversational." This informality allied Manet with Realism, whose precedent sanctioned relaxed transcription of form. Yet, as in specialized conversation (such as that which occurs in diplomacy or between lovers), the apparent topic overheard by the uninitiated has nothing to do with the actual exchange that transpires between knowledgeable associates. Manet strove for an expressive facility that could invigorate, and set resonating, a connotational field far wider than the apparent subject. This goal was shared by those who—like Manet, Mallarmé, and Verlaine—belonged to that generation after Baudelaire.[140] These

141. Fried's grand vision accounts for Manet's incorporation of current thematic materials but not for his own position with regard to his contemporaries and their ideas or for how such ideas, perhaps fostered in literary circles, could relate to an enterprise issuing from a reinvigoration of French painting. Manet's conception of history supplied the standards by which he reckoned his relative accomplishment. Yet his art embraced many of the most energetic ideas of his own day, for which he was a champion when not the inventor outright.

Observers, halted by Manet's persona, which we know from the suave descriptions of him by his Parisian chroniclers, excused him from the possibility of contributing to the active life of the mind in his times. Ultimately, his manners, bearing, breeding, and taste for those decidedly rare pleasures of the upper class and high society distorted our vision of the artist as inherited from his contemporaries. Manet's inventions were sufficiently novel that large parcels of his intentions eluded decipherment for successive generations.

142. Charles Baudelaire, *The Mirror of Art: Critical Studies* ed. and trans. Jonathan Mayne (New York and London: Garland, 1978), pps. 37–38.

143. Fried, "Manet's Sources," p. 28. Fried ultimately rejected the notion of Manet as involved with "subject matter" and "composition."

artists shared basic urges that directed the formation of their arts in surprisingly parallel fashion.

Among the considerations that Manet addressed in *The Gare Saint-Lazare* was painting's presentness and the means by which we apprehend painting. For his endeavor there existed no specific precedent, no formal material that could be adapted directly. At that time these inquiries were appearing on the agenda of art for the first time.

Those gestures that Manet had formerly convened in his art (which may easily be found in, for example, the *Déjeuner sur l'herbe, Olympia, The Old Musician,* or *The Execution of the Emperor Maximilian*) ceased to appear in his work beginning in the early 1870s. This fundamental change is evident in a close reading of that period's pivotal work.[141] The development of his literary equals summons us to grapple with *The Gare Saint-Lazare,* and from this one work we can extrapolate Manet's range and an overview of his preoccupations at the time. For example, as early as 1845, Baudelaire noted the possibilities beckoning to modern art in his review of the Salon:

> We are quite sufficiently choked by our true feelings for us to be able to know them. There is no lack of subjects, nor colors, to make epics. The painter, the true painter for whom we are looking, will be he who can snatch its epic quality from the life of today and make us see and understand, with brush or with pencil, how great and poetic we are in our patent-leather boots.[142]

In Baudelaire's conflicting demands for the vitality of the "imagination" and for realistic "modernity," we confront the twin programs of Manet's art, almost born to requite Baudelaire's call. Although Baudelaire might have admired and endorsed Manet's later art, beginning with *The Gare Saint-Lazare,* strictly speaking that art belongs to a circle of thought, taste, and speculation that was not Baudelaire's. Manet's later works refer to a new basis of appreciation and to a quest that attracted younger writers.

Finally, we confront Manet, the artist rejected (prematurely certainly) by "some historians [who] have argued that for Manet subject matter was nothing more than a pretext for the problems of form and color that alone interested him."[143] By now, it must be clear that the

> accusation . . . that Manet had no interest in his subjects and used them for their formal and coloristic suggestivity . . . is based on the

144. Hanson, *Édouard Manet,* p. 85.

145. Never "straight, factual reporting," Manet's art could be intensely emotional, if we grant that such emotions are not publicly demonstrative or confessional. Openness of emotion was reserved for rare moments of political outburst. Self-restraint marked Manet's class when among other classes, and he also seems not to have been personally outgoing but rather to have been somewhat reticent. Manet was loathe to confront personality, rather preferring to signify it. This resulting aura of concern accounted for the "curious potency" that is otherwise so difficult to assign. Manet's best works are composite rather than expositional in character (except in cases such as *Maximilian* and the *Kearsage*). There is no reason to suspect that the sensibility that fashioned *The Old Musician* and the *Portrait of Zola* should have suddenly altered profoundly in successive stages of artistic development. Rather than being confessional or blatantly autobiographical, Manet's art offered him the chance to gloss artistic and intellectual history. His most potent personal observations were reserved for marginal notes in his pictures.

assumption that emotional concerns can only be expressed through romantic, dramatic, and gestured reenactments of events. Manet's painting, instead is an aesthetic rearrangement of straight factual reporting and, as such, it has a curious potency.[144]

Such "rearrangement" of observation can yield the appearance of spontaneity. In Manet's work nothing is impulsive. What he attempted eschews instinct for its verification, relying instead on reasoned organization. On every level we discover the refinements he introduced to order his works. A pervasive organization thoroughly integrates the materials he drew from widely disparate sources—contemporary, historical, epistemological, and formal. However elusive, the devices he employed lead to, and from, the effects he desired to achieve.[145] That quiet anguish typical of the modern arts slowly evolved away from the histrionics of a now discredited (or merely unfashionable) theatrical aesthetic.

The exquisite gestural range of *The Gare Saint-Lazare* is obvious, whether or not one pursues the subject of the painting. The models' virtual immobility contributes one of the picture's principal qualities, quietude which represents the obstinate subtext of the work. Hardly any movement is depicted, and the most crucial acts, those around which the entire painting orbits, have occurred "off-stage," preceding the moment we see. Before the spectator stopped to notice her, Victorine Meurent's gaze shifted from her book toward us; the passing train that filled the background with steam exited the frame before we arrived. The other critical act occurs "out of sight," when the little girl popped a grape into her mouth (while the puppy dreams). These actions comprise all the dramaturgy of the work.

The Gare Saint-Lazare does not invoke history to supply a cast of costumed characters or fully replete stage sets. Nor do we find heroes and heroines who enact famous moments that inform those national or religious myths by which we reckon our own behavior and the moral progress of the age. Traditional pomp is dismissed without demoting Manet's intentions to produce a work of the highest drama and engagement. Manet balanced depicted acts with implicit acts to treat meditation as rapt as Hamlet's but which lacked high station or general public consequence. This condition of local-

146. The reader will recognize an epitome, if not the expected culmination, of this tendency in the works of Samuel Beckett, where all external references have been stripped from the work. (In the visual arts when the same feat is accomplished representationalism is the first thing jettisoned.)

147. By comparison, Courbet sought out the crucial, the dramatic moments of life, as in *Burial at Ornans,* 1849, or in the depiction of a wayside greeting. (A notable exception might be the *Woman in the Waves* [Metropolitan Museum of Art, New York].) Manet's spectators face pictures with the infinitesimal activity of portraits or still lives. Yet Manet's pictures claim our attentions as do highly charged situations. This reductionist aesthetic locates the threshold of the modern.

148. By 1873, Manet's conservative critics could have savored self-righteous rage if they had become acquainted with Rimbaud's *Une Saison en enfer.* The next year (the year in which Louis Leroy coined the initially derisive word "Impressionism," after Monet's *Impression: Sunrise*), reactionaries could, with mounting horror, have delved into Verlaine's *Romance sans Paroles.* Mallarmé's work, following on the heels of Baudelaire's, would have given sneering readers of the rearguard all the incentive necessary to reject the new writing.

ized urgency precisely identifies Realism, which imbues the everyday with the importance of theater, begging us attend to the commonplace.[146] *The Gare Saint-Lazare* is the first example of a new species of modern drama, which is characterized by grand historical intensity quietly performed, without either micro- or macro-, historical consequence.[147]

Manet may have wished to surpass the abilities of his teacher, Couture, as a history painter. But Manet's approach inhibits a sense of his paintings' gravity. In his early years—and certainly before 1870—Manet attempted to treat conventionally important occasions with dramatic compositions. In no obvious way does *The Gare Saint-Lazare* continue the lineage of *The Oath of the Horataii, The Raft of the Medusa, Liberty Leading the People,* or *The Funeral at Ornans.* Yet *The Gare Saint-Lazare* satisfies Baudelaire's equation as though it had been produced explicitly in response to his summons/charge from the Salon of 1845.

If such a work would have satisfied Baudelaire, this "curious potency" moved Manet's contemporary critics to rage, as we have seen. The apparently rebarbative insult that the painting represented for its public taunts us to find the nature of its offense in its very benignity. Had Manet's critics been in possession of the endlessly reflexive self-consciousness that forms the mainspring of the painting, it would still be hard to imagine such knowledge engendering disdain of the kind that poured forth upon this work. (We can feel secure that his critics did *not* possess knowledge of the painting's organizational logic, for this would certainly have formed a central feature in the writings of Manet's supporters as well as of his detractors.)

What seems to have ignited the wrath of Manet's critics was not so much the painting (whose frank and direct paint handling had been seen before) but the subterranean affiliation of such a picture with a literature that was itself anathema to the reviewers.[148] Perhaps the critics sensed that the propositions examined by *The Gare Saint-Lazare* derived most directly from contemporary writing. More closely than it resembles any other body of painting, this work assumes the considerations and viewpoint of advanced poetry in general, Symbolism especially, and Mallarmé in particular. That alliance of sensibility would have more that supplied the challenge to Manet's critics.

149. Duret, *Manet and the French Impressionists,* p. 5.

150. Guy Michaud, *Mallarmé,* p. 56. It would be as satisfying to find Mallarmé so simply declaring his beliefs as it would be to discover a cache of Manet's notes or letters in which he addressed those problems we have with him. Yet, just for being a writer, Mallarmé was no more prone to anticipating the twentieth century's questions of him than was Manet. Thus, we have to deal with more "secondary" sources than might be supposed, but these opinions serve as useful, competent observations that direct attention toward pertinence.

THE CLIMATE OF A FRIENDSHIP

SUMMONING ALL THE MOST SUPPORTIVE CURRENT scholarship concerning *The Gare Saint-Lazare,* it would still appear difficult to invoke Duret's contention:

> Painting in France in the nineteenth century followed a course parallel with that of the intellectual life of the country; it adapted itself to the various changes in modes of thought; it took upon itself a succession of forms corresponding to those which evolved in literature.[149]

How could *The Gare Saint-Lazare,* a seemingly slender intellectual reed, support Duret's assertion? What evidence could prove this assertion, and of what would such a demonstration consist? Which forms did French painting parallel—the novel, the poem, the prose poem, the essay, or the editorial? Should we look to Manet's composition, paint handling technique, or choice of subjects to find such a parallel? Perhaps the comparison is neither exact nor general but relies solely upon a metaphor within an (art) historical model. Given no further definition of his terms, Duret's statement beckons uneasily, yet alluringly, for some resolution. If it possesses merit, Duret's observation should be demonstrable in the pieces in which Manet deeply invested himself.

At the heart of Manet's enterprise worked a belief that also stirred the art of his great friend, Mallarmé. The revelation, a paroxysm and "conversion," utterly changed Mallarmé's approach to writing.

> The great principle was discovered: each poem, even each word, like each object it represents, must be a meeting place, a point of encounter. A crossroads in an essential liaison with the rest of the world, it can take on meaning only in its proper place and in its relationship to the All.[150]

Yet this discovery was one toward which Manet was tending quite naturally before he met Mallarmé. Mallarmé's conversion to the principle of the allover symbolic content of a work whose every part invigorates every other part—presenting an entirety in which

151. Letter from Mallarme to Verlaine, 1885, quoted in the catalog of the centennial exhibition, Musée de l'Orangerie, Paris, 1932, p. 50 (trans. Alain de Leiris in *The Drawings of Edouard Manet,* [Berkeley and Los Angeles: University of California Press, 1969], p. 22).

152. Daniel-Henry Kahnweiler, "Mallarmé and Painting," in *From Baudelaire to Surrealism* (New York: Marcel Raymond, 1950), p. 359.

153. Mallarmé's rejoinder, in an interview, partially published in Stéphane Mallarmé *Oeuvres Complétes,* ed. Carl Paul Barbier and Charles Gordon Millan (Paris: Flammarion, 1983), p. 433.

> Pour moi, le vers classique—je l'appellerais le *vers officiel*—est la grande nef de cette basilique "la Poésie française"; le vers libre, lui, édifie les bas-côtes pleins d'attirances, de mystères, de somptuosités rares. Le vers officiel doit demeurer, car il est né de l'âme populaire, il jaillit du sol d'autrefois, il sut s'épanouir en sublime efflorescences. Mais le vers libre est une belle conquête, il a surgi en révolte de l'Idée contre le banalité du "convenu"; seulement, pour *être,* qu'il ne s'érige pas en église dissidente, en chapelle solitaire et rivale!

154. "Official verse" survives only vestigially, and the contemporary reader may have some difficulty reconsidering its former vigor.

Contrary to its current status, a country's official verse arises from popular spoken language, which was also the basis for the Académie Français. In its first dictionary of 1694, the Académie eschewed any claim to coin new words or reject others. By the middle of the next century it recognized itself as the servant of changes made by the public.

> The Academy repudiates any assumption of authority over the language with which the public in its own practice has not first clothed it. So much, indeed, does it confine itself to an interpretation merely of the laws of language that its decisions are sometimes contrary to its own judgement of what is either desirable or expedient. (Duncan Maclaren Robertson, *A History of the French Academy,* 1635–1910) [London: T. F. Unwin, 1910]

each element vies with equal fervor for the reader's attentions—had been accomplished before he came to Paris (May 1871) and before he met Manet.

Manet did not spend virtually every day of the latter part of his life in discussion with Mallarmé without having this extended dialogue color his art. Artistic transactions must have formed the core of a relationship they sustained over so long a time, and their friendship, which meant so much to them, was nurtured on the only constant of their lives—art. In 1885, Mallarmé wrote to Verlaine that "for ten years I have seen Manet daily, and his absence today appears unbelievable to me."[151] The constancy of their dialogues and their mutual dependency is not in question, although the specific manifestations of their thinking have gone unexamined. Daniel-Henry Kahnweiler observed that

> few poets have had real contact with the plastic arts.... Stéphane Mallarmé may be cited as one of the very few poets whose writings on the plastic arts have not been transformed into absurdities by time and, like those of Baudelaire, they supply us with intellectual nourishment that nothing else provides.[152]

Painters and poets are presumed to have little substantial to say to each other about the technical aspects of their arts. They are not supposed to share the means by which to realize a movement's broadly set goals, ambitions that may embrace all the arts, politics, and morals. For the next century the increasingly potent agenda of Modernism asserted each art's unique properties. Indeed, Modernism's eventual hegemony strengthened this prejudice. Reinforcing every art's peculiar traits with the concomitant demotion of the arts' shared qualities did nothing to accelerate the probability that Manet and Mallarmé should be examined together. Perhaps paradoxically, Modernism, of which Manet and Mallarmé are central figures, retarded the assessment of one of the great artistic dialogues.

> For me, classic verse—I would call it *official verse*—is the great nave of that basilica "French Poetry"; free verse, it improves the side aisles full of attractions, mysteries, and rare sumptuousness. Official verse must remain, for it was born of the popular soul, it issued from the soil of long ago, it knew how to flower in sublime efflorescences. But free verse is a beautiful conquest, it rose in a revolt of the Idea against

(However much the original stance of the Académie differs from its current position), Mallarmé's sympathy for the role of official verse resembles Manet's respect for the Salon and its officialdom that rejected him. Both artists' apparently deferred to authorized aesthetic institutions, not merely for the power they represented and the authority they conferred but for their *legitimate* roots in the aboriginal artistic substrate. Manet's aspirations seem, on this level, to have been matched by Mallarmé's, and to be explicable without recourse to petty quirks of personality.

155. Mallarmé's fear of suburban isolation, expressed in his phrase, "a rival in a lonely and solitary chapel" was well founded in his own experience. He dwelled at the periphery of French academic life, artistic acceptability, and, when on vacation, on the outskirts of Parisian geography. In that suburban setting his fastidiousness worked—much as did Manet's in Paris—to regulate an artistically serious and personally dignified situation. Ambroise Vollard recalled

> my first meeting with Mallarmé. I was walking in the woods at Valvins with one of my friends. We passed a little grey-haired gentleman who, with a stick at the end of which a nail was fixed, was picking up all the bits of greasy paper and putting them into a little basket.
> "Why, there's Mallarmé!" exclaimed my friend. He went up to the poet:
> "What *are* you doing?"
> "Tomorrow," replied Mallarmé, "I have asked a few Parisians to come to tea. I am cleaning up the banquet-hall."
> (Ambroise Vollard, *Recollections of a Picture Dealer,* trans. Violet M. MacDonald [Boston: 1936; New York: Hacker, 1978], p. 226)

156. Ary Renan, "Gustave Moreau," *Gazette des Beaux-Art* (July 1886), p. 84, trans. by P. S. Falla in *French Symbolist Painters* (Arts Council of Great Britain, 1972).

the banality of convention; only, in order *to be,* it shouldn't posture as a dissident church—a rival in a lonely and solitary chapel![153] (Stéphane Mallarmé) [154]

How well matched in temperament and character were these two when they at last met, and how much each had accomplished to further the thinking of the other.[155] Each possessed an inquiring character moving powerfully among the available alternatives of the day.

THE BASIS FOR A FRIENDSHIP

Baudelaire in *L'art romantique,* used the term *correspondence* for the secret affinity which exists, and which poetry brings to the light of day, between particular states of mind or feeling and a corresponding condition of inanimate nature. Thanks to this form of perception, he declared, the plastic arts enable us, as it were, to conjure up spirits and to define the mysterious aspects of created objects as they are viewed by the human eye. "As a dream possesses a colored atmosphere of its own, in the same way a conception that has been turned into a composition needs a colored medium in which to display itself. The particular tone attaching to any one part of the picture governs the tones of the remainder. . . . The figures and their respective poses, the landscape or interior which provides them with a horizon or a background, their clothing and everything else about them should illuminate the general idea and be imbued with its true color, its livery, so to speak."

Ary Renan, 1886[156]

Manet's friendship with Mallarmé was formed at the very time of *The Gare Saint-Lazare*'s execution, six years after Baudelaire's premature death at the age of forty-six from the combined effects of drugs, overwork, syphilis, and alcohol. Baudelaire and Manet had frequently dined together, and Baudelaire lent his authority to the young painter with supportive criticism; the two formed a friendship that extended to Baudelaire's companionship on sketching trips in the Tuileries Garden. After Baudelaire's death, Manet lacked that sort of collegial relationship until Mallarmé's

157. On 1 July 1872 Manet moved to his studio near the Gare Saint-Lazare; he had met Stéphane Mallarmé by September 1873 at the very latest, by which time their friendship was documented.

Theodore Reff notes that

shortly before beginning the *Gare Saint-Lazare*, Manet moved into a studio on the rue Saint-Pétersbourg (now the rue de Moscou) whose windows faced the place de l'Europe and the tracks leading to the Batignolles tunnel. A year later, a visitor noted that "the railroad passes close by, giving off plumes of white smoke which swirl in the air." (*Manet and Modern Paris* [Washington: National Gallery, 1982], p. 55, cited in Hamilton, *Manet and His Critics,* p. 173)

158. At that time a nine-year-old scion to the old royal family attended the Lycée Fontane: Henri Marie Raymond de Toulouse-Lautrec Monfa. One shudders to think of him as a student of the soft-spoken Mallarmé. Yet, between 1873 and 1875, Toulouse-Lautrec studied at the Lycée Fontane at 8 rue du Havre, where he won prizes for Latin, French, and English, and must have known Mallarmé.

159. Hirsch's garden, just down the street, was not far from Victorine Meurent's later address in the Rue de Douai to the northeast. From November 1871 until January 1875, Mallarmé and his family lived at 29 rue de Moscou, just north of the Gare Saint-Lazare. The family then moved to 87 rue de Rome. Mallarmé's own apartment was laid out so that when he was seated in his study a window to the right of his desk opened on to the rue de Rome and views of the Gare Saint-Lazare.

160. Rather than become mired in Mallarmé's criticism—with its inevitable biographical currents, art-world politics, and questions about the poet's faculties as a critic or his dedication to that craft—we will look at Mallarmé's poetry in which the two artists' reciprocal bond is more than evidenced.

While this essay's principal channel of access to these two personalities lies on a course directly through their art, two conflicting viewpoints can be located in the following statements:

Stéphane Mallarmé was one of the few literary figures who thoroughly understood and pub-

appearance in Paris. Thereafter Manet and Mallarmé were in contact virtually every day, probably beginning in 1872, when *The Gare Saint-Lazare* was first sketched in the studio.[157] By 1873, when Manet was fully absorbed in working on *The Gare Saint-Lazare*, Mallarmé was a regular visitor to Manet's studio. Every evening on his trudge home from the Lycée Fontane (now the Lycée Condorcet), Mallarmé would call. Their discussions were an oasis of quiet sophistication for Mallarmé after a day of instructing rowdy schoolboys in English.[158] (The walk to Manet's studio was fairly short; the lycée was around the corner from the Gare Saint-Lazare and Manet lived up the street from the railway station.)[159] Their friendship grew ever deeper as they learned of the profound sympathies they shared. The next year Mallarmé published his article championing Manet in *La Renaissance artistique et littéraire* ("Le Jury de Peinture pour 1874 et M. Manet," 12 April 1874). A great deal of attention has centered on this work, for it unquestionably cemented the friendship of the two artists as the youthful Mallarmé tied his fate to that of the still unpopular Manet, ten years his senior. Yet the modern reader may bring reasonably elevated expectations to this piece, which, disappointingly, does not illuminate the central questions of Manet's art but essentially attacks the nature of the jurying system at the official Salon.

MALLARMÉ, CRITIC

ALTHOUGH I AM TEMPTED TO ADDRESS DIRECTLY THE obvious and most visible point of their interaction—namely, Mallarmé's criticism of the visual arts—it is his poetry, his own central concern, that must be given primacy.[160] Yet, on his friend's behalf, in 1876 Mallarmé thrust himself into the critical arena once more with "The Impressionists and Édouard Manet," written for the British magazine *Art Monthly Review* (30 September 1876).[161] Assuming that he was discussing the esoterica of modern art, Mallarmé began with a startling declaration:

licly defended the artistic production of Édouard Manet during the 1870s. Unlike Émile Zola, who brilliantly defended Manet's paintings of the 1860s but denounced those of the following decade as hasty and unfinished, Mallarmé had only praise for the painter's mature style, viewing it as the logical culmination of his artistic aims. (Jean C. Harris, "A Little-Known Essay on Manet by Stéphane Mallarmé," p. 559)

Quoting from Harris's article, David Carrier objected that

[identifying] "precisely the qualities Mallarmé understood and admired in Manet's mature paintings" seems overoptimistic in the implied parallel between verbal and visual artworks and misleading in so far as many critics deny that Manet's paintings appear complete. Since we also know that Mallarmé's choice of graphics shows that "his taste was quite different from Manet's as far as pictorial treatment is concerned," have we not reason to question the claim that he "thoroughly understood" that art? (David Carrier, "Manet and His Interpreters," p. 328)

161. Stéphane Mallarmé, "The Impressionists and Édouard Manet," *Art Monthly Review and Photographic Portfolio, a Magazine Devoted to the Fine and Industrial Arts and Illustrated by Photography* I (9): 117–121. This piece, which was translated into English for Mallarmé (although Mallarmé oversaw the text and made corrections as needed), has been lost in its original French draft. Nevertheless, because of Mallarmé's fluency in English there can be no question but that his meaning and intentions were accurately communicated.

162. Kahnweiler, "Mallarmé and Painting," p. 360.

163. Richard Shiff, "Radicalizing Impressionism," *The New York Times Book Review,* 3 March 1985, p. 16.

Without any preamble whatsoever, without even a word of explanation to the reader who may be ignorant of the meaning of the title which heads this article, I shall enter at once into its subject.

The subject of Impressionism and of Manet's role in the movement has befuddled writers for more than a century, and, despite his eloquence, only occasionally does Mallarmé offer us truly useful insights. For example, Daniel-Henry Kahnweiler, whose word on this matter echoes numerous other commentators, noted of Manet that

for him a white is a white before it is a white cloth. The joy of painting is stronger than the joy of imitating. By this fact Manet contributed greatly to the liberation of painting that has been effected by subsequent painters, whose main concern it has been to discover the specific character of their art, and to paint accordingly. . . . The Impressionists, it must be said, did not understand Manet's need to be first of all a painter.[162]

Kahnweiler assumes that the Impressionists' calling differed from Manet's need to discover the "specific character" of his art. Kahnweiler supposes, correctly it seems to me, that, in Richard Shiff's words, "For the Impressionist, what is fleeting is the visual experience, not its object. A painting's form indexes an act of vision."[163] Even such fleeting visual experience was extrapictorial, a sensation conveyed to the viewer, absent from participation in the original apprehension but present before the painting. The Platonic notion of "white" (or *White*) as a concept, an *Idea*, is opposed to recording the momentary or to portrayal. Kahnweiler's notion of "imitation" extends even to the act of seeing, which the Impressionists addressed as the touchstone of their enterprise. He repeats the widely held opinion that Manet saw plainly (or purely, or unthinkingly), and this clarity of vision ennobled his legacy. His inheritors (according to most authors) were the Impressionists, his "followers."

Mallarmé, however, wrote with Manet's confidence in *Art Monthly Review:*

Manet, when he casts away the cares of art and chats with a friend between the lights in his studio, expresses himself with brilliancy. Then it is that he tells him what he means by Painting; what new destinies are yet in store for it; what it is, and how that it is from an irrepressible instinct that he paints, and that he paints as he does.

164. At one point, near the end of his essay, Mallarmé summarizes the situation in a way that, although on the face of it seems ludicrous today, nicely places into context the poet's grasp of the situation at the time and the limits to which we can be guided by his criticism:

> MM. Claude Monet, Sisley and Pizzaro paint wonderously alike; indeed a rather superficial observer at a pure and simple exhibition of Impressionism would take all their works to be those of one man—and that man, Manet.

While we may admire Mallarmé's loyalty to his friend, such a statement does nothing to encourage our trust in him as a careful or perspicacious observer.

165. Jean C. Harris observes:

> From what is known of Mallarmé's theory of poetry at this point in his career [the mid-1870s], we may suggest with much justification that he could have carried on an amicable discussion about aesthetics with Manet. Mallarmé felt that the aim of poetry was "peindre non la chose, mais l'effet qu'elle produit" [from an October 1864 letter, written in London to Mallarmé's editor, Henri Cazalis, in Paris]. The object was important only in terms of an experience of it. Mallarmé believed fully in the necessity for rigorous discipline of his medium. But this discipline was to be so thoroughly enmeshed in the fabric of the work that the reader would be unaware of the mechanics by which the poem was created. In

Mallarmé then confided something grand and strange:

> Wearied by the technicalities of the school in which, under Couture, he studied, Manet, when he recognized the inanity of all he was taught, determined either not to paint at all or to paint entirely from without himself. Yet, in his self-taught isolation, two masters—masters of the past—appeared to him, and befriended him in his revolt. Velázquez, and the painters of the Flemish school, particularly impressed themselves upon him, and the wonderful atmosphere which enshrouds the compositions of the grand old Spaniard, and the brilliant tones which glow from the canvases of his northern compeers, won the student's admiration, thus presenting to him two art aspects which he has since made himself master of, and can mingle as he pleases. It is precisely these two aspects which reveal the truth, and give the paintings based upon them living reality instead of rendering them the baseless fabric of abstracted and obscure dreams.

Mallarmé stated that Manet's art derived its vitality not from life, not from observing the model, but from past art. Specifically, he did not look to the French:

> Curiously, it was to the foreigner and the past that he turned for friendly counsel in remedying the evils of his country and his time. And yet truth bids me say that Manet had no pressing needs for this; an incomparable copyist, he could have found his game close to hand had he chosen his quarry there; but he sought something more than this, and fresh things are not found all at once; freshness, indeed, frequently consists—and this is especially the case in these critical days—in a coordination of widely scattered elements.

Finally, Mallarmé stated the heart of the matter:

> That in which the painter declares most his views is his choice of subjects.

THE FRIENDSHIP

IF MALLARMÉ'S APOLOGIA IN *La Renaissance Artistique et littéraire* does not explicate Manet's art in terms of a theory of symbolism which may have formed the generative matrix from which

other words, the successful poem should impart a sense of completeness and a mood of spontaneity . . . these are precisely the qualities which Mallarmé understood and admired in Manet's mature paintings—sureness and spontaneity. . . . It seems plausible, then, that the similarity between Mallarmé's personal poetic theory and Manet's art helped make the poet exceptionally sensitive to the painter's aims and able to interpret them with justice. ("A Little-Known Essay on Manet by Stéphane Mallarmé," p. 562)

166. Thadée Natanson offers the only dissenting opinion, a view that seems uncorroborated:

> Throughout those ten years of intimacy, always ardent on Mallarmé's part, almost patronizing on Édouard Manet's, Mallarmé had the greater love, gave more of himself. . . . It was always Mallarmé who came to the rue de Saint Pétersbourg; I am not aware that Manet ever went to the rue de Rome [Mallarmé's home]." (Thadée Natanson, *Peints à leur tour* [Paris, 1948], p. 101; trans. Cachin, *Manet,* 1983, p. 379)

167. A rather good description of Manet's reading habits is available in Mauner who demonstrates that Manet was a wide and critical reader, based upon the recollections of Manet's friends and on the literary enterprises he undertook (*Manet: Peintre-Philosophe,* pp. 4–6).

168. Bataille, *Manet,* p. 19.

The Gare Saint-Lazare sprang, such an absence in his statement does not invalidate the current approach. After all, Mallarmé never wrote such a guide to his own complex method of substitutions and correspondences.

The article defending Manet against the Salon jurists firmly bound the artist and the poet in the deepest comradeship. The *Art Monthly Review* piece attempted a more replete explanation of the new art and of its putative leader.[164] Neither piece elevates Mallarmé to the status of a completely trustworthy guide to Manet's art, but in his poetry the careful reader can extract that essence uniting the two artists.[165] Sharing a preference for the most cleanly honed refinement, their first acquaintance blossomed into easy companionship. Their unexpectedly similar personalities were brought together by advantageous circumstances. Indeed, the site for the painting in the eighth *arrondissement* depicts the railway line running through the neighborhood where Manet and Mallarmé lived. Whenever the two visited, they would have passed this spot, their conversation brimming with talk that would have seemed utterly obscure to others.[166] Meeting daily, Manet—hardly the bland realist who blithely and unconcernedly recorded the world—and Mallarmé—the quintessential Symbolist poet—shared family backgrounds, occupations, and temperaments. In the intimacy of the artist and the poet we discover the final, most basic, refutation of that image of Manet as a genial, if thoughtless, artist.

If Manet had been as easygoing and uncomplicated as his critics supposed, his conversations with Mallarmé would have been brief instead of protracted over years.[167] Accordingly, one would suspect that some of Manet's concerns would appear in Mallarmé's work, as well as the reverse. They shared those concerns common to poets and painters: the problems of art in the modern age. Bataille, for example, sensed that "Manet, as I am inclined to think of him, was consumed by a creative fever that literally fed on poetry; that was the inner man, masked by an outward show of urbanity."[168] Here we encounter the formulative, the driving force that shaped *The Gare Saint-Lazare* and much of Manet's later art as well.

SHARED ASSUMPTIONS

Recent art criticism has concentrated on only a few years of Manet's life

169. Cachin, "Introduction," in *Manet,* pp. 16–17. For example, Theodore Reff notes of that crucial work from which Manet derived much of his source material from art history that

> the publication dates of the fourteen volumes it comprises, spanning the period from 1861 to 1876, would seem to place most of them outside the most challenging phase of Manet's involvement with past art, that of the first half of the 1860s. ("Manet and Blanc's 'Histoire des Peintres,'" *Burlington* LXII [July 1970]: 457)

170. The "untranslatability" of Mallarmé's verse can be reckoned by examining these alternatives:

> if those girls whom you explain
> be but an itching in your fabulous brain!

(C. F. MacIntyre, *French Symbolist Poetry* [Berkeley and Los Angeles: University of California Press, 1958], p. 57)

> or if the women you malign
> Configurate your fabeled senses' wish!

(Patricia Terry and Maurice Z. Shroder in *Stéphane Mallarmé: Selected Poetry and Prose,* ed. Mary Ann Caws [New York: New Directions, 1982], p. 35)

Cohn offers the following translation and gloss:

> or what if the women you expound
> Represent a wish of your fabulous
> senses!

The meaning of the *ou si* is somewhat obscure; we might read "[the problem is] whether the women you are puzzling about are a mere wish-dream of your fabulous senses." (Acoustically, the *ou si* is one of those steep contrasts that afford sudden artistic jolts. . . .) *fabuleux*: is both "wonderful" and "the faun is a creature of fable." *femmes dont tu gloses*: the meaning can also be secondarily "women you gossip (unkindly) about" or "complain of." (*Toward the Poems of Mallarmé,* pp. 16–17)

My own preference for "cunning" suggests the complexity of mental states, the impossibly swift unconscious shifts between choices that occur so fast that we can never know the "subsoil" (the "bottom line") of our decisions or our desires'

work—the early 1860s—and neglected his later output, hastily dubbed "Impressionist" after 1870. These studies . . . have shown a tendency to stray into purely iconographic research, to which the work of the first ten years of Manet's career is certainly more amenable.

<div align="right">Françoise Cachin[169]</div>

Manet's sense of "poetry" can perhaps be generally equated with Mallarmé's. Much that truly describes Mallarmé applies to Manet as well, and some of the concerns of one art are translatable to the other—a possibility that cannot have been lost on the two striving artists. For example, the depiction of the dreamstate (contributed to *The Gare Saint-Lazare* by the puppy) does not depend (as it would in the art of a fantasist, such as Fuseli) on the illustration of an immediate apparition. Instead, the dog's gathered recollections recombine in its sleep as images unrepresented by Manet. The accumulated experiences (like the images in the book Victorine Meurent reads, or the focus of Mlle Hirsch's gaze) are absent from the picture, and depicting them would have produced a tableau grammatically akin to Delacroix's *Scenes from the Massacre on Chios,* a massive, synchronic heap of the disparate and multidimensional. This feature, the inability to know what stimulus directly prompts humans and animals, had distinguished Mallarmé's work of the past decade, particularly the verse drama *Hérodiade,* begun in October 1864, and revised and published in 1867. The work begins with a declaration by the Nurse,

> Tu vis! ou vois-je ici l'ombre d'une princesse?
> [You're alive! or do I see here the shadow of a princess?]

which calls fundamental perception into judgment. The question of precisely how to locate a reality upon which to posit faith sufficient to dismiss illusion (pure but without existence) lay very near the heart of Mallarmé's enterprise. From that same artistic moment issued *L'Après-midi d'un faune,* 1865, when the entire scene that appears to the faun may well be a dream shared with the reader. In a line that echoes the exclamation of *Hérodiade*'s nurse, we discover that we cannot know whether the faun really shared the company of the nymphs:

sources. Our conflicts arise from approach/withdrawal and risk/reward, as well as from the subterfuges and defense mechanisms manifested in "reaction formation," which replaces our actual preferences with their opposite.

The epistemological theme arose again in the neo-Romanticism of the "Beat" poets' Buddhism. It propelled Kerouac's *The Scripture of the Golden Eternity* (New York: Totem Press and Corinth Books, 1960), and its most succinct exposition was given by Michael McClure ("The Shape of Energy," originally delivered as part of the Gray Lectures, State University of New York, Buffalo, and reprinted in *Scratching the Beat Surface* [San Francisco: North Point Press, 1982, p. 98):

> but what is more real than a hallucination?

171. Charcot (in Paris), Freud (who came to Paris to study with Charcot), and Mallarmé were certainly among the central figures seeking to give form to these uneasy, and heretofore inexpressible, yearnings; Manet of *The Gare Saint-Lazare* was among their number. Basil Bunting on this point:

> You have read Wittgenstein; you have pondered the limits that language imposes on thought. You know *damn well* that the function of poetry is to enlarge those limits, to make new thoughts possible, to . . . specify what was vague, to render understandable what was not. *Wovon man nicht sprechen kann, darüber muss man schweigen.* (What cannot be spoken about must be consigned to silence.)
> The aim of poetry is to diminish that desert of obligatory silence. ("Lettera aperta a Sherry Mangan Esquire, 1932, trans. from the original Italian, in *Basil Bunting, Man and Poet*, ed. Carroll F. Terrell [Orono: University of Maine National Poetry Foundation, Inc., 1980])

Bunting's historical aptness on this point of the discussion is put to rest if one subscribes to Bunting's description of himself as "the last of the Victorians."

> ou si les femmes dont tu gloses
> Figurent un souhait de tes sens fabuleux!

> [or if these woman whom you criticize
> Appear as but a wish of your fabulous cunning!] [170]

Mallarmé was attracted to that indefinite territory between the conscious, the preconscious, unconscious, the willed, and self-deception which so eludes language. Words have hardly been fashioned to cope with these vague sensations (which are as evasive as the Faun's Nymphs), but in the last quarter of the nineteenth century any number of experimenters were busily addressing this unexploited realm. [171] Manet's works of this period also treat fleeting subjects, without precedent, without names or genre. Naturally, his audiences were perplexed, but Manet offered no explanation to alleviate their misunderstanding. His work paralleled that of Mallarmé, whose own production was intelligible to only a handful of determined readers. These prepared sensibilities were willing and eager to cope with the problems, the "difficulty" of the new literature. Passages such as the one above were savored for a novel sort of literary experience. Like the nymphs who fled the Faun—in reality or in a broken daydream squandered—we are left to question the locus of actuality. Hérodiade herself replies with imperious languor. Or Victorine Meurent—whose gaze invigorates *us* and, usurping our role, confirms the *viewer's* reality in front of the picture, rather than the reverse—could have answered just as well that

> ô miroir!
> Eau froide par l'ennui dans ton cadre gelée,
> Que de fois et pendant des heures, désolée
> Des songes et cherçant mes souvenirs qui sont
> Comme des feuilles sous ta glace au trou profond,
> Je m'apparus en toi comme une ombre lointaine

> [Oh mirror!
> Cold water by ennui frozen in your frame,
> How often, after many hours, made distressed
> By dreams and searching my memories that are
> Like leaves beneath the ice of your great depths,
> I appeared in you like a distant shadow]

172. Finding mere description inadequate, Charcot instituted the journal, *Photographic Iconography of the Salpêtrière* (*Iconographie photographique de la Salpêtriére*), published from 1877 to 1880. (In 1888 the journal resumed publication as the *New Iconography of the Salpêtrière,* edited by Charcot.) At first Charcot and his colleagues relied on contracted photographers but, by the mid-1870s, the need became too great:

> As we were obliged to have recourse to a photographer from outside, our first attempts were not very fruitful; often by the time the photographer arrived everything was finished. To achieve our goal what we needed was someone within the Salpêtrière itself, who was knowledgeable about photography. . . . We had the good fortune to find the devoted and talented man that we needed in our friend Monsieur. P. Regnard. When he came to the Salpêtrière as an intern in 1875 we explained our idea to him and he accepted it with enthusiasm. (Desiré Magloire Bourneville, "Preface," first volume of *Iconographie photographique de la Salpêtrière 1, 1876–77*)

Finally, by the mid-1880s, Charcot appointed a director of photography at the Salpêtrière, the first such position in a mental hospital.

173. The psycho-petitioning, the theatrical, and the editorializing (to which Manet sometimes returned, as in *The Death of Maximilian*), clearly belonged to a sensibility of the past. As a goal for art, soliciting emotional states from spectators—which we might call "psycho-inductivity"—gradually descended from its august position in the critical framework. Finally, what we might call Manet's "psycho-ostentivity" won the day but, at first, the public (and a large part of the critical community), was hardly interested in the direct consideration of thought. Limited only by the sensibility of the times (a "historical epoch"), painting as a self-conscious field of ratiocination could emerge as the conspicuous manifestation of a meditative internal dialogue whose parts were made visible and remained so. Such an advance was too great to absorb in its time.

174. Henri F. Ellenberger, *The Discovery of the Unconscious* (New York: Basic Books, 1970), p. 95. Doctor Charcot held grand rounds which were

This is the very condition of mirroring in which the subject, Mlle Meurent, looks to our eyes for confirmation of her existence (that is, her *action* in the picture is to move from one critical reading of reality to another). Scanned by her, we are thereby distantly confirmed. Another mental activity is thus presented in a chart that compounds the hierarchical elements of stimulus and response in order to describe one more state: higher behavior.

Other vocations felt the surge of the new thinking. Parisian thought of the time followed the channel investigated by a contemporary of Manet and Mallarmé, the psychiatrist Jean-Martin Charcot (1825–93). Charcot attempted sufficiently compelling experiments, using hypnosis to pierce the inarticulateness of hysteria, that in 1885 he attracted the young Freud to his clinic at the Salpêtrière hospital in Paris for four months' study. In the wake of Charcot's influence, Freud returned to Vienna to start work toward his "talking cure." Clearly, as the end of the nineteenth century approached advanced Parisian thought in the arts and sciences pondered the symbolic objectification of inner states.[172] A description, at some depth, of Manet's work reveals those shared concerns that also motivated poets and doctors, although all such speculation met with considerable public resistance.[173] Yet for all three, the situation started to change at about the same time. "Charcot's prestige was still enhanced by a halo of mystery that surrounded him. It had slowly grown after 1870."[174] Likewise

> after 1870 the Mallarmé we know is no longer the anguished outsider, but the calm, oracular visionary, confident that he has achieved ultimate insight in the nature of Being itself. The only torment of this later period will be that of inventing and mastering a poetic vocabulary and technique commensurate with his vision.[175]

By 1870, Manet, too—though hardly immune to bad reviews, ostracism, and massive misinterpretation—had also passed through his worst times, both publicly and artistically. Rarely would he again undertake such abortive projects as *Épisode d'un course de taureaux* ("Episode from a Bullfight") 1864, which had to be cut into fragments, its formal resolution beyond the means of the artist. Rarely would he again be stymied by the indecision that had plagued his project for *l'Exécution de Maximilien de Mexique* (The Execution of

avidly attended: "Tuesday mornings were devoted to examining new, heretofore unseen patients in the presence of physicians and students" (ibid.). Of course, for the artistic elect and intellectually current, Tuesday evenings meant a visit to Mallarmé's apartment.

175. Thomas A. Williams, *Mallarmé and the Language of Mysticism* (Athens: University of Georgia Press, 1970), p. 25. That diminutive "only" unfortunately presides over the bulk, the really important part, of most worthwhile artistic careers. Yet one can endorse Williams's general statement without categorically sanctioning this odd deflection.

176. In an anomalous—perhaps by now an atavistic—situation, Manet in August 1878 began work on a painting of the Brasserie de Reichshoffen. The canvas was cut into two sections, each finished as a separate picture (*The Waitress*, 1879 [Musée d'Orsay], and *Au Café*, 1878 [Sammlung Oskar Reinhart, Winterthur]). Whether this constituted the salvage of two lost projects or the abandonment of a larger one is impossible to say, although the obvious inference is that Manet, even at this late date, still encountered compositional problems beyond his abilities. (See Michael Wilson, *Manet at Work* [London: The National Gallery, 1983], pp. 45–47.) Each of these sections was painted in an additional version, which may (as a method of essaying the possibilities) have preceded or followed (as further studies) Manet's cutting of the initial work.

177. Albert Boime, "New Light on Manet's 'Execution of Maximilian,'" *Art Quarterly* XXXVI (3) (1973): 175. Boime continues, noting:

Manet sympathized with the matter-of-fact realists among the contemporary military artists, including Protais, Guys and Meissonier, and otherwise adopted the prevalent approach toward military events. If later he criticized Meissonier's *Cuirassiers*, 1805—"Tout est en fer, excepté les cuirasses"—Manet nevertheless took over from the artist his cool, passionless view of military experience. (P. 183)

178. This version of *The Execution of the Emperor Maximilian*, 1867, was signed and dated (oil on canvas, 252 × 305 cm.), and is part of the collections of the Kunsthalle, Manheim.

the Emperor Maximilian of Mexico).[176] The work seems to have been sketched in oils in the large Boston version (fig. 30) soon after Manet heard of the death of the hapless Bonapartist emperor who had ruled Mexico from 1863 until 19 June 1867 when the forces of Benito Juárez executed him at Querétaro, along with two of his generals, Tomas Mejía and Miguel Miramón. Soon after the news reached Paris at the end of July, Manet began work on this theme, for which he produced four oil paintings and a lithograph. As he had for his other major compositions, those in which he summed his accomplishments and learning, Manet quoted, challenged, and adapted art of the past to comment upon the present. Albert Boime observed that

like his master [Thomas] Couture, whose ambitious *Romans of the Decadence* was also proof of capacity, Manet had to deal directly with the legacy of history painting both as a test of strength in his battle with his critics and as a supporting medium for communicating personal ideas. *Maximilian* was thus one of the supreme challenges of his career.[177]

The work paraphrases Goya's *The Executions of the Third of May*, 1815 (fig. 31).

Another version of the execution of Maximilian, following hard on the heels of the initial one, accurately substituted French uniforms for the Mexican costumes that appeared in the first. The next version, quickly rendered that same summer, proved too much of a compositional challenge (the parts into which the work was cut posthumously now reside in the National Gallery, London) (fig. 32). Finally, combining elements of his previous expositions of the subject, Manet produced the definitive version of the work which seems to have been painted by September—the entire body of work issued in a creative storm during that summer.[178] Unlike his teacher Couture, Manet failed as a "history painter," either from his lack of compositional skill or from insufficient belief in the traditional enterprise of history painting.[179]

Most of French society was deeply offended by the tragedy, which turned the public against the liberal Mexican government and which so agitated Manet's sense of order, authority, and emotional restraint that he tasked himself to develop a satisfactory presentation of the scene. Boime speculated that "given Manet's state of mind at

FIG. 30
Édouard Manet
The Death of the Emperor Maximilian, 1867, oil sketch
on canvas 195 × 259 cm. (76¾ × 102 in.), un-
signed. Museum of Fine Arts, Boston; gift of Mr. and
Mrs. Frank Gair Macomber.

FIG. 31
Francisco Goya
The Executions of the Third of May 1808, 1815, oil on
canvas, 266 × 345 cm. (105 × 136 in.). Museo del
Prado, Madrid.

Fig. 32
Édouard Manet
The Death of the Emperor Maximilian, 1867, oil on
canvas in three parts: General Miramón, 89 × 30
cm.; the Firing Squad, 190 × 160 cm.; Soldier
Loading the Coup de Grâce, 99 × 59 cm. Trustees,
National Gallery of Art, London.

179. Manet's relationship with Couture has been lengthily examined in several major studies, but for the purposes of this essay it might be fruitful to note something of the continuity between these generations.

Manet did indeed spend six years in Couture's studio; if he had not respected his master, he would surely have left. From Couture, Manet learned a technique, a discipline, and a routine. Some of it stayed with him all his life, and some of it he had to get rid of . . . even if he continued periodically to use devices learned from Couture: a way of stressing a dark contour, perhaps some general compositional formulas, even certain themes that interested his master. . . . Even if Manet continued to employ devices established by Couture, one cannot disregard the fact that he used them to such different purposes. . . . Manet's power to abstract from reality has nothing in common with Couture's idealized world . . . the antagonism of Manet and Couture has been exaggerated. (Rosen and Zerner, *Romanticism and Realism,* pp. 125–127)

180. Boime, "New Light on Manet's 'Execution of Maximilian,'" p. 191.

181. Nor did the dawning of the 1870s signal the end of all of Manet's personal difficulties, especially those arising from his temper and ever-keen sense of dignity. He never really attained a state of ease. In 1874, *Claude Monet, Sa Femme et son Fils au Jardin* was given to Monet, who returned the painting because he was furious with Manet.

182. On his father's death he inherited a considerable fortune, which he proceeded to squander at the rate of about 20,000 francs a year. In 1867, when he asked his mother for an additional 18,000 francs to build his private exhibition pavilion, she balked, protesting that he was heading for financial ruin. (His son Léon Koëlla, inherited his father's sense of money management and as an adult businessman he moved from one ill-fated venture to another, including the establishment of a bank that failed, until he hit upon the oddly profitable notion of opening a store to sell rabbits, chickens, and fishing worms.)

183. Albert Boime, "New Light on Manet's 'Execution of Maximilian,'" p. 193.

that moment, we may assume that the figure of Maximilian is in some way an intimate projection of Manet's feelings about himself."[180] Indeed, Manet's frame of mind was reasonably gloomy then, for the last years of the 1860s had not been a time of much pleasure for him.[181] He had attempted major painting projects without success, and the summer had ended in artistic dissatisfaction; he grieved the loss of Baudelaire; the Salon des Rufusés had set back his plans for official recognition and had made him the senior member of a coterie of adoring, talented, but scruffy junior artists; and a privately mounted exhibition pavilion had been a tremendous drain on his finances.[182] In addition, his father's death had placed him at the head of his family giving him new responsibilities—a new bride, son, and seniority over his two brothers. Small wonder that

> Manet's "aloof" treatment is in reality the complement of Maximilian's brave passivity and of the soldier's indifferent aggression; both the painter and his subjects react to the event with a kind of stoical restraint. When Manet terminated the series, he signed his definitive canvas "Manet 19 juin 1867," the date of Maximilian's execution—for he had in fact relived the tragic episode.[183]

By the 1870s, the demands of his art rarely exceeded his hard-won organizational powers.[184] Practice deepened and concentrated those faculties that found expression in pictures possessed of an internal tension that was independent of outwardly dramatic situations. Manet overcame the need for special protective treatment of his works, such as the 1867 "Exposition particulière de Manet" at the Place de l'Alma. The almost inadvertent acquisition of a band of admiring younger artists eventually buoyed his spirits somewhat. As time went on, this supportive coterie added to his reputation—which was, at first, mainly notorious.

Mallarmé, like Manet, now found himself at the center of Parisian artistic life. In the new decade of the 1870s, Mallarmé established a gathering, his famous "Tuesday nights." In his studio, standing beneath his portrait by Manet, Mallarmé held forth for those who came to talk, learn, and listen. Among those who regularly attended were Yeats, Vielé-Griffin, Rilke, René Ghil, Hérold, Fontainas, Henri de Regnier, Valéry, Verlaine, Heredia, Stefan George, Coppéc, Arthur Symons, D'Annunzio, Verhaeren, Villiers d'l'Isle

184. Unlike Manet's intermittent failed works, Mallarmé's organizational failures accumulated during his lifetime, becoming his posthumous "Book," a naked scaffold for the fabric of a gigantic—unrealized and perhaps impossible—masterpiece. (See Jacques Scherer, Le "Livre" de Mallarmé [Paris: Gallimard, 1977].) This work, if completed (if completeable) would have heralded an organic, wholly modern conception of poetry whose like awaited "the last volume of [Charles] Olson's Maximus Poems—like Mallarmé's unfinished, open-ended Le Livre—[which] is, in part, a poem about the architecture of the poem itself" (Michael McClure, Scratching the Beat Surface, p. 43).

185. To this heavily literary list was added the following annotation, more visual in its makeup:

[To] Les Mardis—the famous Tuesday receptions given by the poet Stéphane Mallarmé . . . came the leading figures of the Parisian art world of the 1880s, poets, critics, novelists, musicians, and artists. A list of the latter reads like a roll call of the masters of nineteenth century art: Manet, Monet, Renoir, Morisot, Gauguin, Rodin, Munch, Whistler, Degas, Redon, Puvis de Chavannes. (Marilyn Stokstad and Bret Walker, Les Mardis [Lawrence: The University of Kansas Art Museum, 1969], p. 5)

No evidence suggests that the ever-aloof Manet attended Les Mardis, although his handiwork, his Portrait of Mallarmé, presided over the gatherings. Manet's discussions with Mallarmé probably recapitulated the themes of the evening sessions.

186. Beatrice Farwell, "Introduction," in The Cult of Images (University of California, Santa Barbara, 1977), p. 13. Yet, Manet painted religious scenes and even angels. It might be more accurate to say of him that he painted the unseeable with the frankness of seeing. (If "seeing is believing," then the implements and occurrence of faith must be shown as if one believed them, in totally committed terms.) Unlike Courbet, he was not above indulging in depictions of what was not real, but Manet's art required the most tangible sort of representation to reciprocally relate one (invisible) entity to a palpable thing. After all, unless experienced personally, an "angel" is a concept, and Manet seems to have been working to represent certain classes of ideas.

Adam, Rodenbach, Saint-Pol-Roux, Charles Morice, Albert Mockel, André Gide, Claude Debussy, Oscar Wilde, and James Abbott McNeill Whistler.[185]

With the dawning of the 1870s Manet, like Mallarmé, achieved a calmness, his powers secure and focused on special goals.

MANET AND MALLARMÉ

Though Realism as it is manifested in painting is difficult to define, one thing about it is reasonably certain: the people and places depicted in it are modern. Courbet, the only major painter regularly and totally associated with the Realist movement, traded on the idea that he would paint only what he could see. Those who followed him in his path—Manet, Degas, and the Impressionists—shared with him, at least from their maturity onward, this iconographic rule. The enemy was history painting.

Beatrice Farwell[186]

LIKE MODERN POETS WHOSE "CLASSICISM" IS OF THAT special sort that has already traversed Romanticism and been colored by it, Manet would banish the words like and as from his vocabulary. No longer was his work "akin" to that of the past by virtue of his adapting passages, poses, figures, or situations from a heritage he felt he could tap at will. (Manet's images would no longer appear with "quotation marks.") His highest ambitions were to be attempted with whatever visual material modernity provided. Manet started to consider the possibility of the very age he inhabited.

We can say of Manet in the 1870s (and thereafter) exactly what has been observed of his new companion:

Mallarmé's genius is concealed precisely in his manner of dealing with seemingly trivial things so that they are endowed with an import far greater than their face value.[187]

The territory charted by Baudelaire's "imagination" and "modernity" (realism) were not so much extended as intensified. Rather than unfolding ever more exotic subjects, the commonplace was delved and relentlessly pursued to a conclusion, however extreme, profound, or hermetic. The exotic, the historical, or the fantastic

187. MacIntyre, *French Symbolist Poetry,* p. 134.

were of no more intrinsic value than the everyday. What counted, and continued to count, was recognizing the relationships between putative subjects and the artist's means as might be sustained in the viewer's understanding. Naturally, the visual artist's means differ from the poet's, and these differences must be accounted in order for the underlying similarities to be understood. The basic stuff of poetry is compounded of, derives from, and appears in three basic modes. The first, mode of nonrepetition, is typified by free verse (and perhaps by the prose poem, depending on definitions). In the mode of exact repetition, words or even whole lines appear more than once, unaltered, in the same poem. In the mode of partial repetition we recognize the domain of rhyme, in which sounds but not necessarily words are repeated. (A usually regular correspondence of terminal sounds in words or in lines of verse produces a repetition of phonemes [sounds], but not morphemes [meanings].) Each of these modes appeared in different historical stages of poetry's evolution in various languages, and each of the modes is associated with a different stylistic moment.

Baudelaire practiced exact repetition to create a world of internal reflections, a palace of mirrors to suggest a transcendent reality. With no exact equivalent in the (nontemporal) visual arts for this hypnotically exact repetition (since any such repeated visual pattern becomes mere decoration), Manet resorted to a single, obstinately sustained subject that was expressed by variously gesturing figures. In *The Gare Saint-Lazare,* Manet's exact poetic repetition sounds a canon on the theme of consciousness, in which a motif is iterated by the different "voices" (of Victorine Meurent, Suzanne Hirsch, and the puppy) overlapping in time. The insistent rhythm of the bars marching across the picture inject an unavoidable cadence that underlies everything else in the work. The effect, just as in the hands of Baudelaire, produces a suprareality that, for Manet, concerns sight and the knowledge gained by seeing. The picture suggests a meta-knowledge of vision. Mallarmé, too, was a master of the modes of repetition, and he considerably advanced their use from anything Baudelaire had known.

Mallarmé twists and turns his syntax so as to cram into the fourteen lines of his poem an astonishing number of words evocative of light and warmth—"flamme," "occident," "diadème," "couronne," "foyer," "or," "ignition," "feu," "joyau," "astres," "feux," "fulgurante," "rubis,"

188. Chadwick, *Symbolism*, p. 40. Cohn, too, has some keen observations on this method of working, as when in one passage of the *Hérodiade*

> the element *ro* is repeated many times in these lines: "robe . . . ivoire . . . arôme . . . porte. . . ô roses . . . arôme . . . arôme . . . os froids rodent" and sounds one of the main tones of the whole poem, as the *ro* (and the letters of *roide*) of Hérodiade; the cluster *ro-or* (often repeated and often connected with Hérodiade's hair) and further, *roi-froide-roide-ivoire*, compare "roide de froid." (*Toward the Poems of Mallarmé*, p. 62)

189. Hayse Cooperman, *The Aesthetics of Stéphane Mallarmé* (New York: Russell and Russell, 1933, 1971), p. 17.

190. Ibid., p. 18.

and "écorche." But what he thus manages to convey by a process of repetition far more intensive than anything Baudelaire and Verlaine had ever used, is an inner feeling rather than an ideal form.[188]

Manet, too, seemed to be striving to saturate his picture with meaning. Here the stuff of subsequent Modernism begins to reveal itself, a universality that starts as a personal vision (and proselytizes by virtue of self-evident quality). In this lineage, Manet and Mallarmé were among the first exemplars. It has been noted that Mallarmé's poetics, his technique, "was novel, because it was founded upon themes that were ultra-personal and 'objective.'"[189] Such may prove a gloss on *The Gare Saint-Lazare,* a work with roots deep in the aesthetic of photography, an 'objective' reference.

Manet's objectivity, his realism of "modern" subjects portrayed without flourish, was more accessible than Mallarmé's obvious symbolism. Specifically, *The Gare Saint-Lazare* seems entwined in Mallarmé's sensibility, which, beginning in 1872, we recognize as Manet's as well. Poetry's almost paralyzing self-consciousness occupies the core of Mallarmé's mature art. Mallarmé wrenched free the self-conscious act of writing (wit, artistic intelligence) while in the process of writing (discovery and recognition). In the throes of making the poem, he directed attention, at least partially, beyond as well as back to the poem. He assigned himself to write about something other than writing even while that was the foremost experience and the very thing with which he grappled. Anything else was programmatic. Painting that was not irreducibly about forms of visual awareness and nonconventionalized symbols—"correspondences"—was anathema.

One of the other hallmarks of Mallarmé's poetry is its fascination with oblivion, "where the dream is the perpetual content of art."[190] As Robert Goldwater observed, "Mallarmé went even further than Gauguin, since, not content with interpretation through a symbol, he wished to do away with this also, leaving nothing but the white page, evocative of all because it contained nothing."[191] In the little girl's absorption in the white cloud of steam, in the sleeping dog, we witness the painter's construction of a poetic vocabulary commensurate with Mallarmé's vision.

We find a key in Mallarmé's great 1893 *Salut* ("Toast"), composed for a banquet run by *La Plume*. In this poem he summed his

191. Robert Goldwater, *Primitivism in Modern Art* (New York: Random House and Knopf, 1967), p. 82.

192. The *rondel* is an exclusively French form of thirteen lines divided into three stanzas of two quatrains and one quintet. Formal variations produce differences of from ten, twelve, or thirteen lines and various rhyme schemes.

193. The *triolet* is a syllabic French form of eight lines with two rhymes and two *refrains*; occasionally, it is separated into a quintet and a triplet.

194. When an artist dons past accomplishment to make something original of that material, at every stage of the process he is subject to judgment concerning his ability to select, arrange, correctly apply, master, repudiate, and adapt the chosen form.

195. *Toile* may literally mean canvas, canvas-cloth, or linen, or sailcloth, or sail, but it is optionally (that is, according to the translator's choice of semantics) rendered here. In its sense as the painter's canvas, *toile* can approximate the same "omnipotentiality" as does the white of the page in whose "care" the poem (human enterprise) is entrusted.
 Exactly this sense—of distinguishing the valuable from the dross of experience—precedes Mallarmé's last line of *Salut* as we navigate to:

Solitude, récif, étoile
A n'importe ce qui valut
Le blanc souci de notre toile.

[Solitude, reef, star
Toward that which was worth
The white care of our sail.]

own entrance into the world of major poetic ambition. He announced his central concerns to the assembled younger writers with the resounding opening line

Rien, cette écume, vierge vers
[Nothing, this froth, virgin verse]

Yet the poem itself was not formless; it was a sonnet. This unexpected character of Mallarmé's personality would doubtless have appealed strongly to Manet, the conservative, who also seemed to be describing nothing in particular but who fervently relied on many levels of formal structure to organize his work. In addition to cycles of sonnets and caudated or "tailed," sonnets (which have extra lines), Mallarmé wrote series of rondels.[192] Mallarmé also composed in triolets, another French form.[193] However seemingly vaporous and unfocused his subject matter, the poet clung to the dictates of inherited poetics. Considering the apparent vacancy of his subject matter, it is surprising that Mallarmé heeded the demands, traditions, and previous accomplishments of such forms. To write in recognizable forms challenges history with the threat of mastering and equaling its most august accomplishments. Nameable forms invite critics and the public to gauge a measurable artistic advance from the past in its own hallowed terms.[194] The artist's challenge then resides in self-representations cloaked by recognizable convention. Manet's quest predisposed him to the deepest allegiance with Mallarmé. They did not convert each other but shared the most natural, mutual, and surprisingly profound understanding. Their common ground of formal conservatism and novel subjects, combined with the most advanced treatment, united them more strongly than any other set of shared assumptions bound Manet to any other painter.

Mallarmé concluded the *Salut* with a line that has become a cornerstone of modern art:

Le blanc souci de notre toile.
[The white care of our sail.] [195]

Like Manet, Mallarmé founded his art—however far it traveled from its original impetus—in the objective world of the senses, in empirical reality. He did sail, and in this passage from a letter to Manet, Mallarmé reports on their common interest in sailing, their

FIG. 33
Édouard Manet
Sketch of the switchman's shed at the Pont de
l'Europe, pencil on paper, for the *Gare Saint-Lazare*.
Courtesy collection J. C. Romand, Paris.

FIG. 34
Édouard Manet
Detail from *The Gare Saint-Lazare*, 1873. National
Gallery of Art, Washington, D.C.

196. Pierre Courthion and Pierre Cailler, eds., *Portrait of Manet: by Himself and His Contemporaries*, trans. Michael Ross (London: Cassell, 1960), p. 79.

Valvins, the summer retreat for the poet during so many years, is a village on the Seine, near Fontainebleau. Mallarmé and his wife and daughter occupied a small peasant's house, situated at just a few kilometers from the river. There he enjoyed the relaxing diversion of a tiny sailboat, his *yole,* which he humorously called his "yacht" and because of which Manet used to address him as *mon capitaine.* (Wallace Fowlie, *Mallarmé* [Chicago: University of Chicago Press, 1953], p. 15)

197. Quite clearly, Mallarmé's place at the head of Modernism is established, although Whitman's contribution colored the supple lines of some unexpected writers.

[Basil] Bunting tells the story that when [Louis] Zukofsky was staying with him in Rapallo in August 1933, the conversation turned to the *sound* of poetry, and . . . they got Ezra [Pound] to read . . . Pound got Zukofsky to read . . . then Bunting. . . . Bunting read Whitman's "Out of the Cradle Endlessly Rocking"—and to his astonishment heard Pound reciting it by heart along with him. [T. S.] Eliot, I recall, called Whitman a writer of prose, and a writer of bad prose at that. That Bunting should have turned to Whitman . . . is not perhaps too surprising. . . . One might recall that when he was fifteen years old Bunting was sought out by Whitman's friend Edward Carpenter, on the strength of a prize essay he had written on Whitman, a "more or less national prize . . . for Quaker schools." (Peter Quartermain, "'To Make Glad the Heart of Man': Bunting, Pound and Whitman," in *Basil Bunting, Man and Poet,* ed. Carroll F. Terrell, pp. 150–151)

198. Walt Whitman's *Song of the Broad-Axe* provides the antithesis for much of Mallarmé's latter imagery. The *Salut*'s nemesis appears in Whitman's *After the Sea-Ship,* 1874 (extract below), whose specificity could not be more different from Mallarmé's generalities. Yet, both treat the subjects of sea foam and sailing:

literary discussions and, inadvertently, his dread of returning to the rowdy classroom.

> There's nothing new here—in the mornings I fill up a few sheets of paper; sail my yawl in the afternoons or get my sails wet when the weather is foul. . . . In short it is just the same old Valvins of every year, from which I shall come back feeling refreshed in mind and spirit.
> I re-read, thinking of you (because you read it last year) the *Confessions* of Jean-Jacques [Rousseau]—yes, it's a grand book.
> Well, dear friend, that's the end of our usual chat—made all the nicer because I don't have to dash off to college; but less nice, because I can't see you.
>
> Stéphane Mallarmé
>
> Monday: (I'm not dating this letter because I daren't look at the calendar and learn how few happy days remain to me.)[196]

(How wonderful to glimpse their dialogue on literature and to witness Manet instructing Mallarmé's reading!) Based on commonplace experience much transformed, "The white care of our sail"—the sailboat propelled by the wind—appears at the same level of emblematic thinking which would propose that a steam engine could be indicated by a cloud of vapor. Manet never did paint a locomotive, although he did not shy from recording such appurtenances of modern life as carriages and steamships. He painted the latter with some frequency, and he even isolated the upper deck with the mechanism of the paddle-wheel housing in *The Departure of the Folkstone Boat,* 1869. The closest Manet came to documenting anything about the operations of a railroad were some sketches he made for the switchman's shed that appears at the right of *The Gare Saint-Lazare* (fig. 33 and fig. 34).

Contemporaries dwelt on the activities of the railroad station, its up-to-date mechanisms and attendant human exchanges. Karl Karger's (1848–1913) painting of *Der Nordwestbahnhof in Wien,* 1875 (fig. 35) dates from precisely the period of *The Gare Saint-Lazare.* Instead of Manet's neutral setting, which happens to adjoin the activities of the railroad yard, Karger echoed Frith in displaying a "realistic" but wholly untrue tableau of miming actors who populate a dramatic and emotion-laden place. The steam engine of this "operetta" appears as the latest advance of a progress that (in Viennese eyes) occasioned a sentimental grace. Manet and Mallarmé were

After the sea-ship, after the whistling winds,
After the white-gray sails taut to their spars
 and ropes
Below, a myriad myriad waves hastening,
 lifting up their necks,
Tending in ceaseless flow toward the track of
 the ship.

Nevertheless, a strange relationship unites them in contemporaneity and (relative) artistic proximity. The two poets formed an unlikely Dioscuri for the emerging Symbolists. In her potent study (*Walt Whitman Among the French* [Princeton, N.J.: Princeton University Press, 1980]), Betsy Erkkila observes:

> Whitman's free verse and organic form, rather than the example of Baudelaire's *Petits Poèmes en prose,* provided the more important model for the French Symbolist writers. . . . Baudelaire would be the central figure to those French writers who, like Mallarmé and Valéry, were concerned with the craft and magic of art; Whitman would be more important to such French writers as André Gide and Paul Claudel, who were concerned with the moral and prophetic function of art. (P. 57)

199. Erkkila (*Walt Whitman Among the French*) notes the

> significant impulse that Whitman's work provided in turning Symbolism away from the more negative, melancholy mood of the early period to the more positive, joyous mood of the later Symbolists. . . . Mallarmé would have found a spirit very different from his own in Walt Whitman. (P. 87)

So wedded to the Symbolist movement did Whitman become that for a later generation repudiation of one meant inevitable rejection of the other. Guillaume Apollinaire ("L'Anti-tradition futuristes," *Manifestes futuristes* [Milan, 1913], quoted by Erkkila [the following translation my own]), stoutly exclaimed

neither heroes nor devotees of modernity, and their attitudes toward progress and technology were sufficiently congruent that we may consider Mallarmé/Manet to be the dual expression of one sensibility. Compared to Caillebotte's vision of the modern city in the *Pont de l'Europe,* Manet's picture is no celebration of industry and its handmaiden, steam. Manet's most unromantic vision of modernity derived from the quiddity of his inhabiting it rather than from a desire to celebrate its driving progressive spirit. Others were captivated by the changes they witnessed.

PROGRESS

WHITMAN, MALLARMÉ'S CONTEMPORARY, WAS ENRAPtured by Progress and exulted in verses that today seem far more contrived in their language and, oddly, more distant from everyday emotions than do Mallarmé's "difficult" evocations.[197] When Whitman celebrated technology's advance as an army of mechanisms sprouting across the landscape, he was sufficiently plain in his meaning:

> The shapes arise!
> Shapes of factories, arsenals, foundaries, markets,
> Shapes of the two-threaded tracks of railroads,
> Shapes of the sleeper of bridges, vast frameworks, girders
> arches,
> Shapes of the fleets of barges, tows, lake and canal craft,
> river craft[198]

Optimistic of a democratic idealism still unbloodied by civil war, Whitman celebrated the human triumph of reason over adversity. Pathetically, political obstacles were not as easily defeated as rivers were forded or mountains tunneled.[199] In these verses of 1856, Whitman saluted hopeful and grimly progressive capitalism. These very images might have coursed through the mind of Caillebotte's musing bourgeois, a spectator in the middle of the bridge at the heart of postrevolutionary Europe (perhaps figuring his profits).[200]

MER . . . DE AUX

>Dante Shakespeare Tolstoy
>>Goethe
>Dilettantismes merdoyants
>Eschyle et thèâtre d'orange

>Inde Egypte Fiesole et la
>>théosophie scientisme
>>Montaigne Wagner Beethoven

>>Edgar Poe Walt Whitman et
>>Baudelaire

(OH SH . . . IT ON

>Dante Shakespeare Tolstoy
>>Goethe
>Blundering dillettanisms
>Aeschylus and the orange
>>>theater
>India Egypt Fiesole and the
>>theosophy scientisme
>>Montaigne Wagner
>>>Beethoven
>>Edgar Poe Walt Whitman
>>and Baudelaire)

200. The sense of precise tallying, a natural (or second-nature) reaction of Caillebote—who was professionally trained to apply scientific principles to practical ends—was echoed in his, somewhat surprising, counterpart, Whitman. French Poets (as did French painters) divided into camps with equivalent sensibilities.

>In his poetry, Claudel seconded Whitman in using the joyous embrace of night, space, and the astronomical universe as a kind of symbolic response to Poe, Mallarmé, Valéry, and other poets of the metaphysical night, who were still haunted by Pascal's fear: "le silence éternel de ces espaces infins" [The eternal silence of infinite space]. (Erkkila, *Whitman Among the French,* p. 130)

The alluring precision of the calculable matched the defuse allure of the incalculable in the two aspects of human nature—"measure" and "maya."

FIG. 35
Karl Karger
Der Nordwestbahnhof in Wien, 1875. Belvedere Palace, Vienna.

201. A final note on Whitman's stance reminds us that "the train [was] Whitman's symbol of motion and power" (Erkkila, p. 197), which injects a specific icon into the French debate in which Whitman was, however unexpectedly, in legitimate Symbolist quarters, fully Mallarmé's equal. Erkkila summarizes,

> These differences between Mallarmé and Whitman, the formal perfection and introspective mood of one and the formal extravagance and life-oriented mood of the other, are significant in that they describe the two major directions that French poetry was to take in the late nineteenth and early twentieth centuries. (P. 88)

Which had its equivalents in painting.

202. Gay, *Art and Act,* p. 87, translation by Gay.

203. Progress, or more precisely, the *notion* of progress, is opposed to the authority of the classics—a division that, starting in the 1600s and continuing into our own day, in the form of the "Two Cultures" debate of Bronowski and Snow, has riven Western society in some obvious, and subtle, ways. Manet and Mallarmé both endorsed the classics and saw themselves as exponents of classical values as well as extensions into the present of the past's best possibilities. Inherently, neither Manet nor Mallarmé could have endorsed the cult of Progress, which has nothing to do with modernism.

For Caillebotte, steam epitomized Progress. If technology was incidental for Monet, it was not for Caillebotte.[201] A lively cluster of nineteenth-century ideas fostered enthusiasm not limited to Whitman's America. In his 1867 book *Entretiens d'atelier* (which Peter Gay notes was dedicated to "l'Amérique"), Manet's teacher, Couture, urged painters to seek out the grand subject of the locomotive. Couture rhapsodized:

> At the moment of departure, all are at their post; the powerful machine lets its copper glitter in the sun; its brazier sparkles, seemingly wanting to light up the route it will travel. Look at the man in the center; he is in control; hand placed on the lever, he awaits the signal. How proudly he stands planted there! his mission has made him grow taller. He knows that the slightest error can endanger the lives of those of whom he is in charge. See the stoker reflected in the furnace.[202]

Neither Mallarmé nor Manet subscribed to the cult of Progress. Mallarmé was equally capable of fashioning his favorite image of mist as an exalted cloud or as a lethal industrial miasma.[203] In *The Azure,* 1864, Mallarmé very consciously reversed the role of his mists and dear fogs and, against "l'eternel azur" (the everlasting Azure) made them into coarse interruptions in the beautifully oppressive world:

> Brouillards, montez! Versez vos cendres monotones
> Avec de longs haillons de brume dans les cieux
> Qui noiera la marais livide des automnes
> Et bâtissez un grand plafond silencieux!

> [Fogs arise! pour your monotonous cinders
> With long tatters of haze in the sky
> That will drown the livid bogs of autumn
> And erect a great silent ceiling!]

He wrote of his favored interlopers' eventual frustration, their intrusion nullified by the sky itself. In a tone that matches the titanic scale, primordial vigor, and confidence of an ancient *Veda,* Mallarmé concluded the poem,

204. The *Sama Veda* concludes with a hymn to the moon (Chandra Gîti):

> Then they suddenly came upon the magic name of the bull, the creator, there in the house of the moon.
> The Moon! The Moon! The Moon! The Moon! The Moon! . . .

205. A concise discussion of fog and steam in Mallarmé can be found in Cohn's essential, *Toward the Poems of Mallarmé,* in which Cohn discusses Mallarmé's *Toast Funébre* (pp. 102–104).

206. This aspect of Manet's work, almost unnoticed until the present time, was also featured in Jane Mayo Roos's analysis of "Edouard Manet's *Angels at the Tomb of Christ.*" Roos noted that this painting too "fuses instantaneity and duration, depicting a moment in time and suggesting the extension of this moment forward" (p. 87).

207. Duret, *Manet and the French Impressionists,* p. 101.

En vain! l'Azur triomphe, et je l'entends qui chante
[In vain! the Azure (sky) triumphs, and I hear it singing]

. .

Je suis hanté. L'Azur! L'Azur! L'Azur! L'Azur!
[*I am haunted.* The Sky! The Sky! The Sky! The Sky!] [204]

THE IMPRECISION OF STEAM

THAT MANET DEVOTED ABOUT ONE-THIRD OF THE SUR-face of *The Gare Saint-Lazare* to the vapor of a steam engine (which had exited the scene) sealed his alliance with Mallarmé. This is not, after all, a sky study by Constable but rather the picture of Parisian types into which has been injected a grounded cloud.[205] Invisible to us, the train obviously passed through the moment before we ourselves arrived, which creates another pseudo-narrative imploded beyond the limits of usual narration.[206] Just as we know what Victorine Meurent had been doing a moment before we approached, we also know that a train passed. The details of its passage have been ousted from the scene, supplanted by an economical indication that it had passed, clanging and rocking, spewing cinders just below the terrace from which we view. *The Gare Saint-Lazare* becomes, on closer examination, a virtual compendium of observations, not just about modern Paris, which served as the quarry for the building blocks of imagery, but also about the most advanced contemporary artistic theorizations. Nor was Manet's penchant unnoticed at the time, only misunderstood. Duret recalls that "Manet had often been blamed for painting his figures in attitudes which were said to be unintelligible because they suggested no very definite action."[207] Imbedded within a situation for which there is no *name,* the figures possessed no compelling associations. Their activities seemed pointless, too trivial to bother with; narrative flow appeared drained from the painting.

Propelled by an artistic faith that he shared with Mallarmé, Manet's concision formed terse commonplaces (apparently exhausted or unimpressive materials) into a subject whose few apparent possibilities were elevated beyond expectation. In *The Gare Saint-*

208. As with so much of Mallarmé's verse this line, hazily evocative in French, is maddeningly complex in possible permutations for the translator. "Au pur délice sans chemin" could be rendered as "pure delight without path" (trackless, spatially open to wandering, a field of sensation) or "delight untracked" (uncharted and pristine, a novel experience). Positioning the modifier after the noun maintains the French word order but renders a meaning utterly different from that of inverting the modifier to follow the preposition in an equivalent English word order. (In addition to this poem Mallarmé wrote another sonnet on the same subject, this one for Mme Mallarmé.)

Perhaps these lines challenge or respond to the final verse of the last poem in Baudelaire's *Les Fleurs du Mal*:

Plonger au fond du gouffre, Enfer ou Ciel,
 qu'importe,
Au fond de l'inconnu pour trouver du
 nouveau.

209. Rémy de Gourmont, "Le symbolisme," in *L'idéalisme* (1893), pp. 24–27. Trans. P. S. Falla in *French Symbolist Painters* (Arts Council of Great Britain, 1972).

Lazare we witness the perfectly objective—reified so banally that it approaches the point of invisibility—correlative to Mallarmé's 1869 declaration in *Igitur* that "I should like to reenter my uncreated and anterior shadow." The "uncreated" dwells both in latency, that is, what has not yet been given form (the mist, for example, or the dream—which is not art), as well as what through transformation no longer exists and, being part of the past, has been "de-created." This anterior shadow could, in its most basic aspect, be childhood itself, with its genuine innocence. Mallarmé continued to give voice to this sensation—so plastically expressed by the young girl's staring—when in 1884 he penned the opening lines of *Another Fan* (of his daughter, Mlle Mallarmé, who was twenty at the time). The poem (a caudated sonnet with extra lines) begins with lines that could serve as a virtual colophon to Suzanne Hirsch's reverie:

ô rêveuse pour que je plonge
Au pur délice sans chemin

(Oh dreamer, that I may plunge
to pure pathless delight][208]

AT THE GARE SAINT-LAZARE: THE IRON FENCE

Ultimately, the absolute is beyond our knowledge and cannot be formulated in symbols. What symbolism aims at is to display what is relatively absolute, to show the eternal in the merely personal.

 Rémy de Gourmont, 1893[209]

T HE LITTLE GIRL STARING INTO THE CHURNING STEAM suggests many equivalents. She supplies the balance and antithesis for the adult concentration of Victorine Meurent's reading. They have the same hair color, so it is not hard to see one as the harbinger—the "anterior shadow"—of the other, with childhood reverie akin to, but not the same as, adult musing. The child's imaginings lack formative experience, and without experience of the world, without planning and failure, all childhood daydreaming is equally

210. In his drama *Hérodiade* (1864–67), Mallarmé framed a poem as a dialogue between Hérodiade and her nurse, just the unit that makes up the company of *The Gare Saint-Lazare,* along with the viewer/reader. When Hérodiade calls to her nurse, "Assez! Tiens devant moi ce mirroir / O miroir!" (Enough! Hold this mirror up to me / O mirror!) she ends her call with the question, "Nourrice, suis-je belle?" (Nurse, am I beautiful?). This question, if it can be framed at all by the little girl, floats in the air between the companions in *The Gare Saint-Lazare.*

fantastic and equally improbable. The child is "innocent," a state without positive moral value. The woman's expectations and anticipations are based on experience and a history of desires. The adult has names for her rages and passions, based on a lived life. She can also distinguish nuances of feeling engendered by reading—other peoples' lived lives, or authors' fantasies. The little girl cannot name what she feels. Childhood emotions often have no names, but they can arise unbidden as overwhelming sensations, without apparent provocation (corresponding to the agitated, frustratingly ungraspable cloud). Finally, the child's functional black hair ribbon "becomes," or finds its equivalent in, the seductive choker worn by the woman.[210] These figures and their suppressed, or nearly minimal, actions are richly promising. They locate a portal to a world in whose service Mallarmé's poetry also labored. One of Mallarmé's chief aims was to fabricate something from the evanescent, and he titled one of his major essays "Action Restricted."

Positioned just behind the precinct of open space and steam in which her sight wanders but which she cannot enter, the child is another surrogate for the viewer of the painting. While Victorine Meurent's gaze indicates a special attention and is a look that mirrors our own conscious and critical encounter with the work, the child's wandering nondiscursiveness suggests one more level of experience. Placed between the book and the grapes, she engages the visual world, one of whose domains is painting. As the girl is separated from what she views, so are we "locked out" of the painting's interior space by the physical picture plane. The child cannot enter the volume she beholds, except visually, and neither can we. As her view wanders, reconfiguring the scene and bestowing attention now here, now there, she shares the condition of the spectator of the painting. Thus, both the adult's "scanning" of our approach and the child's absorption equate to states in which we approach the painting itself.

If the child cannot enter the space into which she stares, that space is radically different from the painting at which we look. The girl's vision is fixed on a shifting, white, *blank* ("blanc") world—nebulous, light, without form or substance (the first condition of the cosmogony in Genesis).

Young Suzanne Hirsch engages in that fantasy play that we give up as adults, and while she is not technically unconscious,

211. These figures erect rich sets of opposing propositions; the two figures, deliberately contrasted on many levels, have also been read as an expression of methodical and balanced composition:

> For all its naturalness, however, the design is classical in its systematic contrast of the two figures: one is mature and has been reading, the other is young and watching a train go by; one is seated and facing us, the other standing and turned away; one wears a blue dress with a white collar and cuffs, the other a white dress with a blue sash and bow; and if both have reddish brown hair, one wears it down in long tresses, the other swept up and tied with a ribbon. (Reff, *Manet and Modern Paris,* p. 56)

212. In fact, as it reaches the upper horizontal cross-member of the iron fence, the vertical just to the right of Suzanne Hirsch actually *thins* very slightly, which contributes a tiny symmetry to the full curve of her dress.

neither is she fully aware in the sense that an adult can be. Victorine Meurent receives visions of a world that issue from her book, and this adult behavior amplifies vestigial (childhood) fantasy. The girl projects and actively molds her world by a process that in an adult would mark a striving or unsatisfied aspiration or wish. Surely no finer image for meditation in general, or for the unconscious in particular, can be conjured. The child is not fully "conscious" of, is not aware of, our approach. She does not turn her attentions toward us, as did Victorine Meurent. Manet constructed a comparison of two levels of attention, of their relative depths and absorption.[211] In periods of intense concentration, we lose track of time and are surprised when recalled to consciousness. The source of our wonder can be a thought, the lineaments of a beloved, a landscape view, a work of art. To a certain degree such raptures constitute autohypnosis, even if they are induced by some object. From that infinitely rich and potential blankness, the child is kept from hypnotically plunging, physically or optically by the iron fence that proved such a bitter amusement to Manet's critics.

All the artist's skill was used to conceal the effort underlying this picture, and the fence's otherwise regular rhythms challenged him to sustain naturalism while introducing numerous alterations to adjust his composition. The thickness of the iron bars varies from one to another as the design of the painting required.[212] The two fence posts between Suzanne Hirsch and Victorine Meurent have iron collars just above a horizontal rail; none of the other verticals has these ornaments. These collars strongly connect the two figures. The same device was used when Manet wished to move the composition from Suzanne Hirsch to the grapes: to do this he added two metal collars between the horizontal railings. More startling, when a fence post cut through the child's right shoulder, Manet interrupted the iron with an extra patch of white [fig. 36]. Conscripted for compositional duty, the cloud itself carries the eye between the two figures. It touches the top of the picture and dips in a concave arc to rendezvous with Mlle Hirsch's hand on the iron bar before continuing on its way to connect with Victorine Meurent. The cloud is entirely contained within the two outermost bars of the fence. The whole composition is made to feel casual, simple, and uncomplicated. It avoids the rickety, creaking structures of academic

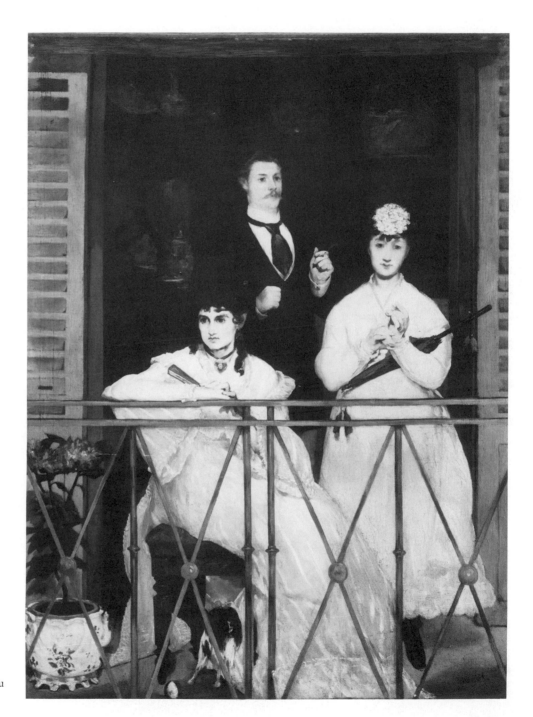

FIG. 37
Édouard Manet
Detail from *The Gare Saint-Lazare*,
1873. National Gallery of Art,
Washington, D.C.

FIG. 38
Édouard Manet
Le Balcon, 1868–69, oil on canvas,
170 × 124.5 cm., signed.
Museé d'Orsay (formerly Galeries du
Jeu de Paume), Paris.

213. Williams, *Mallarmé and the Language of Mysticism,* p. 2.

214. As a boy, Mallarmé seems to have felt the presence of God as a "hymen mystérieux" (Odile Ayda, *Le drame intérieur de Mallarmé* [Istanbul: La Turqui Moderne, 1955]). There could hardly be a clearer image of the transcendence accorded penetration and of our exclusion from a numinous realm that is forever hovering before us. Such separation identifies the essential character of mortal, of sublunary cogitation. We behold the thing before and outside of us, and thinking with symbols we externalize that which when unspoken remains but a vague urge. As communication progresses from the need to express toward a conventionalized message, the separation of the image from our personal, idiosyncratic emotional life becomes more poignant. Only in the mystical state is there a unity of the perceiver and the perceived, and in this high religious state "separation" and randomness vanish.

215. Some commentators have noted the degree to which Manet altered reality to compose this painting. In particular Manet seems to have done everything possible to bring our attention to the iron fence so prominently placed and accented; we ought to be obliged to assess the full significance of this prominent motif. We note, especially, that the fence is composed of vertical units regularly accenting the top of the composition. These metal posts number an arithmetically unwieldly eleven units. It would have been far easier for the artist to position the posts if he had divided the canvas either into ten units or the even more easily divisible twelve units. Indeed, the painting appears to have twelve vertical divisions, but the place where the twelfth post would occur is occupied by the right edge of the canvas. Manet took some trouble that we should notice this unusual and insistent number of accents.

216. Of the commonly found poetic forms, only three exhibit division into eleven units. The *roundel* is an English form of eleven lines broken into three stanzas. The *madrigal,* usually a lyric about love and set to music, is found in both English and Italian poetry and features eleven syllable lines. The *chant royal* is a French form that features eleven-line stanzas ending in a *refrain* (repeated five times, with an added five-line *envoy,* adding up to sixty

composition, but it is composed with the most intense care for balance of detail. Nor is Manet's accomplishment in *The Gare Saint-Lazare* limited to compositional ideas.

His touch in this painting is neither too heavy (as it might be in crusty Courbet-like passages) nor coyly slight and thin (as was Degas's wont). None of his paint handling seems self-conscious. His touch does not feel tentative or premeditated, and Manet eschewed bravura passages that would call attention to themselves primarily as *paint* (as opposed to color). Nowhere in the work does he seem affected by intentional vaguery, or theatrical showiness, and in this painting Manet set a standard for execution that he himself matched in few but his finest works.

Many of this picture's graphic inventions supersede the demands of composition for, as does any really successful work, it exists on many levels at once.

(For example, Mlle Hirsch's arm seems rather long, extended across the space between her and Victorine Meurent. Clearly, the two figures are linked by this extension, which places a flesh tone in the proximity of the woman's otherwise framed face. Likewise, the two figures are connected as the girl's dress touches the woman's, echoing the book's white curve. If the girl had been moved closer to the woman, either her lost profile would have been sacrificed or her arm would have had to bend at the elbow, presenting a tricky bit of fore-shortening. As is, the cloud dips and swings between them, appearing just over the woman's right shoulder, emerging at her left cheekbone in the space below the child's hand and above the child's arm. It arcs down to the top of Suzanne Hirsch's head where it sweeps around again, leaving only a tiny nick (where a figure on a balcony across the street is sketched [fig. 37]) before reconnecting as an extension of Mlle Hirsch's dress's puffed shoulder.)

Mallarmé also strove to devise the plastic means, the "symbolism," to create separations of various kinds, as when he envisioned consciousness itself as limited by a "wall." "For the mystic, very little matters except what lies *beyond* the confining wall."[213] In this reading of the painting, consciousness—and certainly discursiveness—resides on one side of the iron fence (our side), and the little girl's blank, intuitive, and nondiscursive world can be found on the other.[214] Yet, if adult consciousness and discursive formulation resides on only one

lines); technically, it is a *ballade*. If Manet wished to invoke this form for the pleasurable recognition of his poet friend, Mallarmé, the reference would be so obscure as to be virtually unnoticeable to anyone else—not in itself a disqualification. The French language can be used to execute a complex pun of just the sort to appeal to a Symbolist sensibility, for *chant* can have other meanings besides those concerning the lyrical or vocal. In phrases such as "de chant" or "sur chant," the word refers to "la longeur et sur la petite face, dans un plan vertical." This is the very disposition of the upright bars constituting the iron fence that introduces the essential cadence to *The Gare Saint-Lazare*. In this motif Manet could have been combining both a specific poetic reference and a geometric one, uniting the art of the poet with painting—truly a "royal chant." Such a unification represents just the sort of deliciously obscure set of correspondence and replacements which would have been appreciated and savored by Mallarmé. Yet, much more than this one motif suggested that Manet was current with modern literature and imbibed deeply of its spirit, as well as using the specific devices that he and Mallarmé may have evolved in their intense and regular discussions.

217. Cohn, *Toward the Poems of Mallarmé*, p. vii.

218. Also dating from this same period, Manet's *Portrait of Théodore Duret*, 1868 (Musée du Petit Palais, Paris), recites a particular source in Goya's *Portrait of Manuel Lapeña, Marquis of Bondad Real*, 1799 (Hispanic Society of America, New York). Manet sequentially paraphrased different artists, and the late 1860s saw the height of his interest in, exploitation of, and reliance upon Goya.

219. Berthe Morisot—who, perhaps wary of her future brother-in-law, posed accompanied by a chaperone—sits in the foreground; the landscape artist Antoine Guillemet stands in the center; to the right is the violinist Fanny Claus; from the rear of the painting Léon Koëlla enters, carrying a tray. Painting his friends and relatives on *The Balcony*, Manet identified Goya's ancestry for this work.

side of the fence, remnants of childhood's magically silent world can be found on either side, for as adults, as artists, as literate and conscious viewers, we recognize the barely glimpsed continent of the unconscious that is our native country. The iron gate, even more strongly than the two figures, expresses this separation.[215] But without these figures denoting the limits of human consciousness, such a device would have been meaningless.[216]

It has been said of Mallarmé that "practically everything comments on everything in [his] highly unified poetic universe, and ideally he should be read in that spirit."[217] The same can be said of Manet.

AT THE GARE SAINT-LAZARE: THE BALCONY

As EARLY AS 1868–69 IN HIS PAINTING *The Balcony* (fig. 38), Manet possessed that compositional mechanism by which background and foreground could be divided by a railing. This device did not serve the same purpose in *The Balcony* as it subsequently would in *The Gare Saint-Lazare*. The genuine homage Manet paid to Goya's *Women on the Balcony* (fig. 39) exemplifies the conspicuous citations that were absent from his work starting in the 1870s, when he discovered how to extract compelling imagery from the contemporary world.[218] Manet's earlier usage barely hints at how evolved this motif of a dividing railing would become a few years later.[219] Initially, the railing introduced only an interesting spatial concept. The foreground was severed from the rear of the picture, and the spectator's zone was thus separated from the subjects'. Such isolation played a genuinely evocative role in Goya's alluring description of the precincts occupied by Spanish women.

Discovered as a formal device, the railing was drafted into service when Manet required a novel set of symbols in propinquity. The fence could hardly have indicated the complex relationships it came to represent in *The Gare Saint-Lazare* without the other, supporting motifs. The figures, their poses, costumes, and ornaments, the spatial treatment of the setting, the book, the steam, the dog, and the grapes combined in an ensemble of plastic inventions riven

220. Reff, *Manet and Modern Paris,* p. 56.

221. Comparisons emphasized by the division of the painting into front and background sections, each with their own sets of implications, are augmented by the contrast of the palpable and the intangible—most obviously as the bars striate the steam. These adjacent elements suggested another inquiry, specifically engaged in by Mallarmé, who was the quintessential practitioner of "the play between the solidity of the fog and the obscured buildings [which] emphasizes the dubiousness of reality" (Cohn, *Toward the Poems of Mallarmé,* p. 294).

by an iron fence. This schism in the subject matter was a deliberate mechanism, a contrivance by which Manet heightened the desired effect. This point can be argued from the modifications Manet enacted in his picture to alter the actual scene. Reff has noted at length the situation of the figures, and these adjustments bear repetition:

> Their relation to the setting is also more contrived than appears at first. To view the Pont de l'Europe as it appears here, at the right edge, Manet would have had to stand far back in the triangular garden behind Hirsch's building at 58 rue de Rome, near the corner of the rue de Constantinople. But he shows the figures as if they were at the front of the garden, at the very edge of the railroad yard, and he enhances this illusion of immediacy by eliminating the heavy diagonal trellis and vertical fence of the bridge on the other side of the rue de Constantinople, and indeed the width of the street itself, including instead only the thin black fence around the garden.[220]

The picture's integral meaning would have been shattered had the girl not been staring directly into the steam. To achieve this apposition Manet enjambed the garden and the railroad cut, and he eliminated the intervening street. The picture's subject predicated the adjustments to reality. Rendering a mere recollection of this pleasant locale would not have required Manet to alter Paris.

Manet convened all his powers to focus attention upon, and to eliminate every distraction from, the contrast between what transpired on two sides of the iron fence.[221] His critics may have sensed something of the avant-garde spirit in this device: the very representation of the fence, and the hint of separation, of alienation and self-absorption—however incompletely grasped by the earliest reviewers—would have sufficed to trigger the animadversion which poured forth upon the painting.

THE NEW LITERATURE

On coming home, I continued my reading of Edgar Poe. His book awakes in me that sense of the mysterious which used, in former times, to be a greater preoccupation for me in my painting; it fell away, I believe, because of my work from nature, with allegorical subjects, etc. Baudelaire, in his

FIG. 39
Francisco Goya
Women (Majas) on the Balcony, oil on canvas,
76¾ × 49½ in. Metropolitan Museum of Art,
New York, H. O. Havemeyer Collection,
bequest of Mrs. H. O.
Havemeyer 1929.

222. In a letter to Baudelaire in March 1865, Manet reported that he had been reading the *Mystery of Marie Roget,* which he called "remarkable and amusing." The work is an early example of the "deductive" investigator, who, without leaving home, solves a crime based on reported clues. The efficiency of this manner of work and its compression of the narrative may have especially appealed to Manet.

T. J. Clark notes that "It is rare to have the least hint of Manet's reading habits, and good to think of him reading Baudelaire's translation of Edgar Allen Poe" (Clark, *The Painting of Modern Life,* p. 80).

223. Mallarmé's ear for English was not defective, nor should the continental affectation for Poe seem a limitation of Mallarmé's poetic talents. He construed Poe as he needed to (and vulgarity translated into something darkly febrile). Poe's thumping beat surpassed normal poetic measure and sounded grandly declamatory. His woolly vagueness and imprecision could be construed as a summons to hypnogogic half-remembered memories.

224. The centrality of the "American experience" of Poe is summed by Fowlie, who claimed that

> the position of three of the major poets of modern France: Baudelaire, Mallarmé and Valéry, may be defined with some degree of accuracy in terms of their relationship with the American poet, Edgar Poe. All three acknowledged Poe as their master, and their work as derivative in some fashion from his. No American or English poet has felt such allegiance to Poe. (*Mallarmé,* p. 252)

225. Frances Carey and Anthony Griffiths note that "Manet thought of all of the Poe illustrations as 'Japanese' in style; the need to get brush effects would explain why he adopted the unusual technique of transfer lithography" (*From Manet to Toulouse-Lautrec: French Lithographs 1860–1900* [London: British Museum Publications, 1978], p. 41).

In transfer lithography, called *autographe* in French, the artist draws with ink upon a paper that is placed facedown on the lithography stone. This technique offers the advantage of appearing in print without the usual left-right reversal of the image (after the paper is removed from the stone,

preface, says that I bring back to painting the feeling for that so singular ideal which delights in the terrible. He is right: but the disjointed and incomprehensible qualities which mingle with his [Poe's] conceptions do not suit my mind. His metaphysics into the soul and the future life are most singular, and give one a lot to think about . . . to tell the truth it is only the phantom gleam with which he illumines those confused but terrifying figures that make up the charm of this singular and very original poet and philosopher.

<div align="right">

Eugène Delacroix, in his *Journal,*
30 May 1856

</div>

MALLARMÉ, WHO READ ENGLISH WITH EASE AND earned his living teaching it, greatly admired Poe. He enlisted Manet to illustrate his translations of Poe, as well as his own original work in French.

Poe's dark pathology was, and continues to be, enormously appealing to the French. No hint of Whitman's sunny optimism or constructive populism flecks Poe's work, and his plangent vulgarity did not repel the French.[222] For native English-speakers, this peculiarly Gallic tropism for Poe seems unwarranted. For the French, Baudelaire began Poe's beatification, which continues today. For the first generation of Poe's continental admirers, Poe's obscureness (which the American reader encounters as imprecision of thought and a grossly flawed command of versification) appealed to Mallarméan general evocation. Perversely and uniquely, for the same reasons—and to the same degree—that the American reader faults Poe, the French elevate him.[223] Poe's unremitting morbidity, broken by splintered glimmers that shone from tenebrous negativity, embodied the very essence of the new alienation. Poe epitomized the avant-garde's examination of society, an inspection of values that had to be performed from the "outside." Better than any other writer, Poe summed the character of the modern artist's self-destructive calling.[224]

So ideal a personality was Poe to represent the values identifying the European avant-garde that when Mallarmé enlisted Manet to illustrate his translation of Poe's *The Raven,* Manet employed a brushy treatment in Chinese ink derivative of Japanese *sumi* ink

as a finished print). In addition, it seems that Manet rubbed down the stone with acid to smear the dark and heavy shapes, and thus more closely approximate the appearance of an ink painting done directly on the paper.

Mallarmé's 1888 edition of his translated poems of Poe (finally published without Manet's illustrations) was dedicated to Manet's memory.

226. Manet to Mallarmé, quoted by A. Tabarant, *Manet et ses oeuvres*, p. 417 (trans. Alain de Leiris in *The Drawings of Edouard Manet* [Berkeley and Los Angeles: University of California Press, 1969], p. 20).

227. De Leiris, *The Drawings of Edouard Manet*, p. 19.

228. Nor was such a sensibility widespread or automatic among practicing artists of the time (and other factional divisions persisted besides the notorious academic/avant-garde controversy). An exact contemporary of Manet's, Rossetti shared no portion of this aesthetic. His letters contain the following diatribe:

> Bye the bye, my own memento of O'S [O'Shaughnessy] is a huge folio of lithographed sketches from *The Raven*, by a French idiot named Manet, who certainly must be the greatest and most conceited ass who ever lived. A copy should be bought for every hypochondriacal ward in lunatic asylums. To view without a guffaw is impossible. (J. Bryson, ed. *D. G. Rossetti and Jane Morris, Their Correspondence* [Oxford, 1976], p. 174. Cited in Carey and Griffiths, *From Manet to Toulouse-Lautrec* [London: British Museum Publications, 1978], p. 42)

Once again, censure placed madness in proximity to Manet.

229. De Leiris, *The Drawings of Edouard Manet*, p. 20 n. 15. This letter is quoted in Tabarant, *Manet et ses oeuvres*.

painting as the style he felt most appropriate to this "modern" work. Indeed, for their generation, a formula of Poe (as a model of subject matter) and *Japonisme* (as style) constituted a recipe for Modernism.[225] In 1875, Manet produced the vignette drawings for *L'Après-midi d'un faune* and in that same year he illustrated *The Raven*. Always preferring to work either from a present model or an art-historical precedent, Manet was not initially an eager collaborator in these projects that treated pure fictions. In failing health, he responded to Mallarmé's request that he illustrate the translations of Poe:

> You know how much I like to embark with you on any endeavor; but today it is beyond my strength. I do not feel capable of doing well what you ask. I have no model and especially no imagination. I would do nothing worthwhile.[226]

These illustrations were chores that Manet did not willingly undertake; only his great affection for Mallarmé allowed him to bear such onerous levies of his time. As Leiris remarked,

> Manet always reserved the liberty to give a personal interpretation to the text chosen for illustration. This being the case, we would normally expect few if any works of illustration from him, since tradition usually requires a relatively close collaboration of the illustrator with the writer or editor of the book, and the acceptance by the artist of a certain number of directives and limitations applying to the technique to be used and, to a lesser degree, to the interpretation of the text.[227]

Deference born of mutual respect bound the sensibilities of these two artists.[228] Although Manet at first declined to undertake the illustrations, he finally wrote to Mallarmé,

> Versailles—My dear friend, I am full of remorse and am afraid that you might be a little angry with me, because, as I reflect on it, it is selfish of me not to have accepted in spite of everything the work which you proposed to me. . . . If it is possible to renew this affair on my return to Paris, I shall try to do honor to the poet and the translator, and I shall have you there to give me momentum.[229]

Thus, the Manet illustrations of Poe locate a nexus that links Mallarmé to Poe, Poe to the French avant-garde, Manet to Mallarmé,

230. Once more the myth of American objectivity in the arts is confirmed by this comparison, for myths, after all, are "true." Let a reader simply take the measure of this chapter by Melville—written a score of years before the French toiled "beneath the white care"—and the inherent concentration on "things" (as opposed to ideas that arise from things) will be apparent. Melville set out a catalogue of meanings and associations. For Melville white is hypnotic, dreadful, something upon which the eye fixes with terror.

and, in his execution of them, Manet to the *Japonisme* that so characterized the avant-garde of its day—and which we have seen so crucially informing the *Portrait of Zola*. Poe's work presaged and confirmed Mallarmé's striving. Yet, Mallarmé may also have been aware of the general trends that moved American literature at the time.

A generation before the Parisian painter and poet met, Herman Melville published his masterwork, *Moby Dick* (1851), containing its breathtaking chapter XLII, "The Whiteness of the Whale." Typically for an American, Melville discourses upon whiteness by employing the most objective and substantial (not to say massive) objects of contemplation. In contrast, Manet and Mallarmé, made of whiteness something ethereal and filmy.[230] In *The Gare Saint-Lazare,* the little girl's lost profile and unwavering gaze teem with a universe of suggestions. The whiteness—the blankness—and its smothering and masking cloudy form mean nothing; they obscure rather than reveal. For the French, for the lyrical Mallarmé, whiteness was (more benignly than for Melville), classic because it was unchanging, ideal. As the attribute of any substance, white changes with inspection. Snow changes under observation—knowledge that comes to us as a gift of the Impressionists themselves—and the clouds constantly alter their shape and color, but *white* as an exemplar, is beyond degradation or amendment. Had Manet wished to illustrate lines of Mallarmé's which treated this theme, or had Mallarmé wished to pen lines to illustrate *The Gare Saint-Lazare,* could they—in managing to assuage the imperious demands of "imagination" and "modern life"—have been better served than by:

> Le Faune
> Ces nymphes, je les veux perpétuer.
>
> > > Si clair,
> Leur incarnat léger, qu'il voltige dans l'air
> Assoupi de sommeils touffus.
>
> > > > Aimai-je un rêve?
> [The Faun
> These nymphs, I would perpetuate them.
>
> > > So clear,
> Their incarnate buoyancy, that it tumbles on air
> Sleepy with drowsy tufts.
>
> > > > I loved a dream?]

231. The poem *L'Après-midi d'un faune* written to be declaimed as a dramatic monologue for Coquelin aîné prompted a set of four wood engravings by Manet for its publication (in an 1876 edition of 195 copies, each signed by Manet and Mallarmé; the work was republished in 1887, with Manet's small illustrations photographically reproduced). In addition, Claude Debussy, a younger member of Mallarmé's circle of talented friends, composed his orchestral tone poem on the same theme (1894), which in turn occasioned the choreography of Nijinsky, sets and costumes by Bakst, and the direction of the ballet music by Sergei Diaghilev (1912). Moreover, countless attempts at translation have added to the train of works engendered by this poem.

232. The next great excursion into this theme was Rilke's fifth *Duino Elegy,* dedicated to Picasso's *Les Saltimbanques,* and beginning,

> Wer aber *sind* sie, sag mir, die Fahrenden, diese ein wenig
> Flüchtigern noch als wir selbst
>
> [But tell me, who are these wayfarers, even a bit
> More transient than we ourselves]

The correspondence of the two works to paintings is purely coincidental, if fortuitous. In the Picasso, a group of itinerants moved Rilke to mirror our own condition before the painting. (An earlier generation had purged painting of injected action to disassociate ambitious painting from history and ambitious poetry from narration.)

At the same moment—the first years of the 1920s, that Rilke was composing these Elegies—Basil Bunting's *Villon* (1925) includes the following in section II:

> "We are less permanent than thought."

233. In 1869, Manet had executed an etching to illustrate Philippe Burty's *Sonnets et eaux-fortes.*

In these fabulous opening lines of *L'Après-midi d'un faune,* Mallarmé might have described, formulated, or incarnated the very substance of *The Gare Saint-Lazare.* However tempting to treat the painting as a possible "Illustration" of the poem, the painting, completed some three years before the poem, probably represents the first expression of the shared sensibility that Manet discovered in his newfound author friend. Manet, the more mature artist, had a greater battery of plastic means at his disposal with which to devise thematic material. The poem might serve as a startling independent colophon for the painting, or the painting as a demonstration of the poem.[231] If the woman and child in *The Gare Saint-Lazare*—sandwiched as they are between the wandering, momentarily arrested spectator and the drifting cloud—relate to their world as do the nymphs to their poem, then Manet, as much as Mallarmé, attempted (by siphoning action from them and reducing their motions to the minimum) to perpetuate them. Their actions, finally, are only interior, are mental actions. Thought becomes the protagonist in actual (portrayed) space.[232]

Specific relationships in the painting echo in Mallarmé's verse associated with the "Faune" theme. For example, without entering into the debate about whether the faun sees, wills himself to see, or involuntarily imagines the nymphs, it is possible to observe that his question ("I loved a dream?") addresses that fleeting frame of mind from which Victorine Meurent arises at our approach. For a different generation, this moment of transition from wakefulness to sleep (the hypnagogic) as from sleep to wakefulness (the hypnopompic)—as from the surrender of reading to full consciousness—would prove endlessly captivating, but neither Manet nor Mallarmé was a Surrealist. Instead, they shared a beginning moment of the study (as opposed to its ostensible depiction) of psychological states as the material of which high art can be made. A work in Mallarmé's "Faune cycle" of 1874–76 (the series of preparatory poems which preceded the final version) is known from a manuscript given to the great Japanophile Philippe Burty, a comrade Mallarmé and Manet held in common.[233] The *Monologue d'un faune* contains the following passage:

234. Mallarmé, *Oeuvres Complètes,* p. 180. (Of course, at this point the faun, perhaps dreaming the whole incident, is innocent, is "guiltless," for the pubis/moss is dry.) In another of the "Faune" cycle (*Oeuvre Complètes,* p. 564), Mallarmé addressed an independent quatrain of 1876 to Manet's wife, Suzanne, who was an accomplished pianist:

> *Offrendes A Divers Du Faune*
>
> Exemplaire de Mme Edouard Manet
>
> Le Faune rêverait hymen et chaste anneau
> Sans les nymphes du bois s'il s'avisait d'entendre
> Au salon recueilli quand le grand piano
> Tout comme votre esprit passe du grave au tendre

235. Manet delighted in the sensuality of women, a penchant he shared with Mallarmé. He painted them with a masculine pleasure that has hardly been equaled in its adult appreciation of the feminine, as opposed to some ideal dependent on aesthetics or fashion. Manet never strayed from the adult facts of womanly beauty in favor of a mythologized form or deportment (romanticism), and his frank pleasure in women offended the initial spectators of the *Olympia.* (See T. J. Clark, *The Painting of Modern Life,* 1985, chap. 2, "Olympia's Choice," passim.) Mallarmé shared this candid maturity, although the style of his poetry does not render his affections as easily available. An example of the great erotic acceptance permitted by his work occurs in *Le Tombeau de Charles Baudelaire* (1893), a sonnet that contains the following passage, beginning with line 7:

> Il allume hagard un immortal pubis
> Dont le vol selon le réverbère découche
>
> [He kindles untamed an immortal pubis whose flight follows the reverberating all-nighter]

236. Hamilton, *Manet and His Critics,* p. 186. Manet furnished six lithographic illustrations for Mallarmé's translation of Poe's *The Raven* and four drawings for wood engravings illustrating Mallarmé's *L'Après-midi d'un faune.* The two also discussed other collaborative projects:

> At the time of the publication of "Le corbeau," some of the posters announcing its appearance were issued with a mention of another col-

> Dormons: je puis rêver à mon blasphème
> Sans crime, dans la mousse aride, et comme j'aime
> Ouvrir la bouche au grand soleil, père des vins
> (avec un dernier geste)
> Adieu, femmes[234]
>
> [Let's sleep: I can dream my blasphemy
> Guiltless, in the dry moss, and like I like
> To open my mouth to the great sun, father of wine
> (with a last sign)
> Bye-bye, ladies]

These lines describe the situation of the puppy, sleeping his innocent and necessarily pagan dream, in the dry moss of Mlle Meurent's lap, under the sun, balanced in the composition by a bunch of grapes.[235] These grapes figure as massively important in the poem when the faun, drowsy, frustrate with undefined and general lust, muses,

> Ainsi, quand des raisins j'ai sucé la clarté,
> Pour bannir un regret par ma feinte écarté,
> Rieur, j' élève au ciel d'été la grape vide
> Et, soufflant dans ses peaux lumineuses, avide
> D'ivresse, jusqu'au soir je regarde au travers.
>
> [So, when I've drained the grapes of their splendor,
> To banish a regret my pretense averted,
> Laughing, to the sky of summer I lift the used-up bunch of grapes
> And, puffing into their bright skins, crave
> Drunkenness, until the night I look across.]

Then, in the last moment of the poem's pagan lassitude the faun exclaims:

> Ouvrir ma bouche à l'astre efficace des vins!
> Couple, adieu; je vais voir l'ombre que tu devins.
>
> [My mouth open to the effectual star of wine!
> Couple, farewell; I'll see the shade that you became.]

That *The Gare Saint-Lazare* and the cycle of poems on the faun were composed at about the same time by the closest of friends might prove only circumstantial regarding any possible similarities. However, when such massive congruences start to appear, we must

laboration by the two men, an illustrated translation of Poe's poem, "La cité en la mer." Although this particular project was never carried out . . . the idea of collaboration on another project occurs in the correspondence between the two men quite often until Manet's death. (Harris, "A Little-Known Essay on Manet by Stéphane Mallarmé," n. 30)

237. In addition to the motif of the Virgin Annunciate reading, the motif of the reader in modern art probably has its roots in images of the apostles and specifically in title pages of medieval gospels, where the author-Evangelists are shown composing their texts (and these figures ultimately derive from Roman and subsequent Carolingian figures). The paintings by Rembrandt of his mother (*Reading,* and *Biblical Prophetess,* both 1631) opened the role of the reader to women, although the strongest renditions of the motif in paintings then attributed to Rembrandt are still the solitary *A Scholar in a Lofty Room* ("St. Anastasius"), 1631, *A Scholar in a Room with a Winding Stair,* 1633 (Louvre), or *A Hermit Reading,* 1630 (Louvre).

Manet was not the first among the Realists to utilize the motif, which can be found in Whistler's 1858 *Reading by Lamplight.* Daumier, Courbet, and even Monet also exploited this motif, but the present essay argues that Manet's selection of the theme excluded its casual occurrence as genre—or, more specifically, that in borrowing from genre, Manet intensified its use, as he did with so many other themes. A more immediate similarity can be found in Claude Monet's *Beach at Trouville,* in which a woman reads.

238. For *In the Garden,* 1870, Tiburce Morisot posed reclining on one elbow, in the position of Manet's brothers. Although Manet frequently painted recumbent women, they are posed supported semi-upright on a chaise rather than resting on one elbow (as in *Lady with Fans: Portrait of Nina de Callias,* 1873–74 [Musée d'Orsay, Paris]). Manet's only exception to this rule for posing women appears in *Women on the Beach,* 1873 (Detroit Institute of Art), which almost certainly followed directly after the work depicting Manet's wife and brother. In *Women on the Beach,* the bather in the foreground takes a modified version of Eugène's pose for *On the Beach* (which varies only slightly from its first appearance when struck

give the most serious attention to the images that surface in both works. It is difficult to overemphasize the depth and seriousness of these comrades' dialogue. As Hamilton recounts, "Their relationship soon developed into an enduring friendship; upon Manet's death Mallarmé declared that he had seen the painter 'almost every day for ten years.' And it led to an interesting artistic collaboration."[236]

ON THE BEACH

IF *THE GARE SAINT-LAZARÉ*'S SUBJECT, THE DEPICTION OF the gradations of the sensations of awareness, had been a novel excursion (a coincidental alignment of suggestive details), we should not expect to find another such arrangement among Manet's works. Immediately following his first essay of the subject, however, Manet again attempted to treat the realm of consciousness and the conventions of art. *On the Beach* (fig. 40) was painted in the summer of 1873 near the ocean (sand is caught in the paint), during the three weeks that Manet and his family spent on the coast of Normandy at Berck-sur-Mer. The artist's wife, Suzanne, reads.[237] Her brother-in-law, Eugène Manet, leans on his elbow. Looking out to sea, he rests in the same pose that his brother Gustave struck for the *Déjeuner sur l'herbe*—a pose based, ultimately, on Raphael's River God (in *The Judgement of Paris*). Manet reserved this relaxed position for his brothers, although he painted many reclining figures, both male and female.[238] In the *Déjeuner sur l'herbe,* Gustave gestures philosophically before the pool with its bather (directly recalling the river god's realm), while in *On the Beach* Eugène looks out to the ocean. Both figures are thus related to nearby water.[239] The two reclining figures differ in that Eugène's pose in *On the Beach* was rotated into the depth of the picture and away from the picture plane, while Gustave lies parallel to the surface of *Déjeuner sur l'herbe.* Manet's willingness to think in three dimensions, to turn a figure on axis while maintaining its pose, recalls how in *The Gare Saint-Lazare* the traditional pose of the startled reader, the "Virgin Annunciate," was spun around so that the viewer assumes the viewpoint of the angel Gabriel.

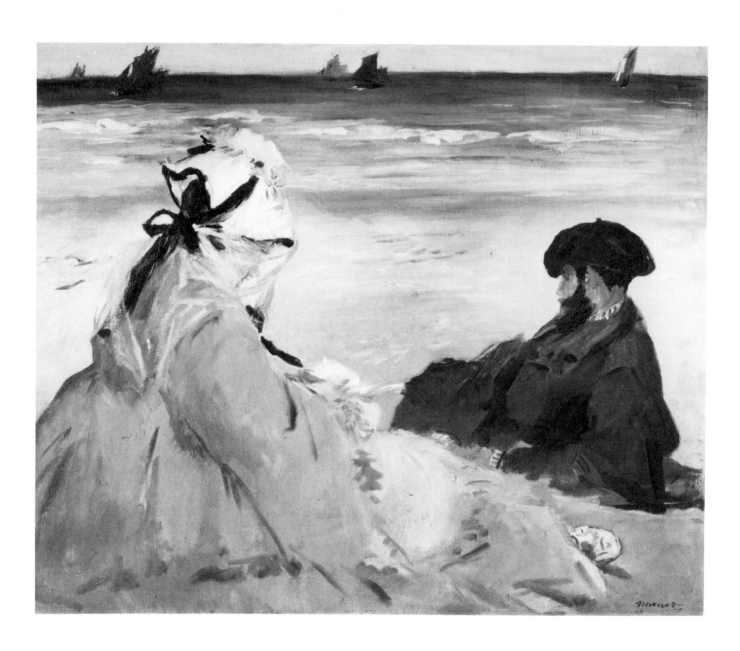

F<small>IG</small>. 40
Édouard Manet
On the Beach, 1873, oil on canvas, 57 × 72 cm.,
signed. Museé d'Orsay (formerly Galeries du Jeu de
Paume), Paris.

by his brother Gustave in 1862). In fact, *Women on the Beach* appears to be a gloss on the *Déjeuner sur l'herbe* in that the reclining woman assumes the pose of Manet's brother, Gustave, while the standing figure on the right takes the bending, leg-touching pose of the distant bather. Despite what seems a concrete relationship between *Déjeuner sur l'herbe,* and *Women on the Beach,* Reff believes that in the later work

> both figures are reminiscent in their poses and their stability of ancient sculpture, the reclining one resembles a specific type, the Sleeping Faun or Bacchante, who lies just this way with one arm supporting the body and one encircling the head. (Reff, *Manet and Modern Paris,* p. 164)

239. Within *Déjeuner sur l'herbe* the hidden relationships found in classics (the works of old masters) were expressed in modern life; for Manet, as Baudelaire had postulated, modern life was not a stripped-down version of the past but was equally rich in possibilities. The present was not, therefore, an updated version of history but an extension of the past's potential, with all its occasions for allusive meaning intact—even if the mechanisms of classical allegory had perished.

240. See the entry on *Le Liseur* in Weisberg, *The Realist Tradition: French Painting and Drawing 1830–1900,* pp. 172–173.

241. In a remarkable painting of 1868—in many ways as crucial a work as *The Gare Saint-Lazare* itself, as well as being its forerunner—Manet convened many of the images that were to occupy him during the next decade. *La Lecteur* ("Reading"), 1868, (Musée d'Orsay) positions Mme Manet at the center of the picture, facing her husband (the viewer), while behind her, reading, stands the couple's son, Léon Koëlla. The spectator cannot know whether the boy reads silently or to entertain his mother during the tedium of posing. Yet I feel strongly that the circumstantial, extrapictorial sense suggests that the boy reads aloud. Manet's earlier picture, *Liseuse* ("Woman Reading"), c. 1862–65, situated a solitary reader parallel to the picture, recalling Fragonard (and anticipating the steadfast pose of Whistler's *Arrangement in Black and Gray: The Artist's Mother,* 1871).

Renoir also used the theme of reading—in

Suzanne Manet may be reading silently in *On the Beach.* In 1861 Manet first essayed the solitary reader in *Le Liseur* (fig. 41).[240] For more than a decade Manet evolved the reader's role to include it within a multifigure composition of considerably more complexity than its predecessors.[241] The silent reader and her brother-in-law would each muse on different stimuli—the openness of the ocean or the tightly delimited entrance and focus of the book.[242] The book opens to an invisible world that counterpoises the vast, mute, frank ocean. The limitless ocean was made the target of Eugène Manet's projective musing, just as Suzanne Hirsch's reverie was directed at the steam in the *Gare Saint-Lazare.* Such silent and balanced figures, the reader and the gazer, might represent two poles, two extremes on a continuum. Manet's powers dilated as he pursued a host of implications already discovered to be coursing silently through other pictures.

Suzanne Manet, her face turned into her book, may not be reading silently but aloud to her brother-in-law, which would radically alter the nature of the scene we behold. A consummate instrumentalist, she would bring her accomplishments as a pianist to her sense of reading. Now, in that pose borrowed from Raphael, Eugène gazes steadfastly; the spoken words he hears combine with what he sees to form a single complex sensation. (The painter, absent from the picture—and the surrogate for the spectator-as-audience—also hears the recitation of the text.) Related varieties of focused mental powers converge at points that are alternately distal (the horizon), proximal (the spoken text blending with the sound of the waves breaking on the shore), and internal (the construction of images bidden by the text). As Mme Manet follows the text, she is aware of the ocean, as she would be aware of the city's background noise were she in Paris. But breaking waves at the shore are neither a nuisance nor a permanent distraction. The pitch and rhythm of her voice suggests counterpoint with the ocean; Manet proposes a kind of *concerto* for voice and nature. About this relationship Mallarmé was quite eloquent:

> in reading, a lonely, quiet concert is given for our minds, and they in turn, less noisily, reach its meaning. All our mental faculties will be present in this symphonic exaltation; but unlike music, they will be rarefied, for they partake of thought. Poetry accompanied by the Idea, is perfect music, and cannot be anything else.[243]

FIG. 41
Édouard Manet
The Reader, c. 1861,
oil on canvas,
38½ × 31½ in.
Saint Louis Art Museum,
Saint Louis, Missouri.

fact when he depicted his younger brother. (Edmond Renoir, a journalist who frequently collaborated with his brother, used this drawing [fig. 42] to illustrate an article of his "L'Etiquette," in the 15 December 1883 issue of the Impressionist's favorite vehicle for their illustrations, *La Vie Moderne*.) Though Renoir's *Portrait of Edmond Renoir*, 1881, could easily have benefited from Manet's work, Renoir does not invoke Manet's elaborate supporting matrix. Instead, Renoir's drawing seems a portrait that *happens* to depict a reader in a pleasant spot—a hotel's summer garden at Menton, Côte d'Azur.

242. Manet's divergence from Realism can be gauged by considering how his readers differ from Gustave Courbet's *Seated Model Reading in the Studio*, 1845–47, for example (fig. 43). Courbet so posed his figure—denuded of pretension or any engagement with precedent—that we behold merely the obvious, a woman who reads to pass the time as Courbet works. We share the artist's viewpoint and this moment of unself-conscious realism, which records no situation as complex as Manet contrived. Instead, we are offered a catalogue: the girl wears a smock and thin veil over her shoulders, her ruffled bow and striped dress are draped on a caned chair, a piece of sculpture behind her echoes the position of her back, and so forth. Courbet's treatment, unlike Manet's, does not extend tendrils of meaning beyond the work.

We might think of Courbet's position as the "psycho-fugitive," midway between the earlier psycho-petitioning art and Manet's psycho-inductive constructions. The viewer of a Courbet can only *inspect* the presented scheme. Somewhat petulantly, perhaps, Courbet retracted the petition of the viewers' emotions. The resulting "blankness" so extravagantly disregarded the viewer that, in and of itself, it constituted a gesture of revolt. (Thomas Eakins, too, was given to presenting figures with the psychology of newel posts.)

Manet created a scheme to dwell on the pleasure of discourse and on the pleasurable texture of thought realized; he offered an ostensible meditation. Manet's special form of engaging the spectator can be distinguished from Courbet's, almost cavalier—perhaps even haughty—dismissal of the viewer. Realism, in this special sense (with regard to Courbet), represents a particular form of detach-

FIG. 42
Pierre Auguste Renoir
Portrait of Edmond Renoir, 1881, conté crayon, pen and ink, 38 × 28.5 cm. Art Institute of Chicago, Joseph and Helen Regenstein Collection.

ment, while Manet proposed a special form of limited and channeled engagement.

243. Stéphane Mallarmé, "The Book: A Spiritual Instrument," 1895, trans. Bradford Cook in *Stéphane Mallarmé: Selected Poetry and Prose,* ed. Caws, p. 83.

244. There is a delicious difference between text-as-words and text-as-images, and we find this difference exquisitely distinguished in Manet's works treating reading. (Moreover, this essay argues Manet's position allied him with the aesthetic we find driving Mallarmé's poetry.) That Mallarmé was keenly aware of just what separated the artist's from the poet's vocation can be illustrated with an anecdote recorded by Paul Valéry:

> Degas left us about twenty remarkable [sonnets]. . . . I have no idea why he took this fancy. . . . The poet's task, where it consists of a search through successive approximations, for a final version which satisfies certain precise requirements, must have seemed to him akin to that of the draftsman as he conceived it. . . . He told me that, dining one day at Berthe Morisot's along with Mallarmé, he gave vent to his feelings about the agonies of poetic composition.
> "What a business!" he lamented. "My whole day gone on a blasted sonnet, without getting an inch further. And all the same, it isn't ideas I'm short of, I'm full of them, I've got too many."
> "But, Degas," rejoined Mallarmé, with his gentle profundity, "you can't make a poem with ideas, *You make it with words.*" (Trans. David Paul, Paul Valéry, *The Collected Works in English* [New York: Pantheon-Bollingen series, 1960], XII: 62).

245. Stéphane Mallarmé, "The Book: A Spiritual Instrument," trans. Bradford Cook in *Stéphane Mallarmé: Selected Poetry and Prose,* ed. Paris, 1982, p. 82.

Alone in the mind, which, without location or extension, may still engulf any volume, the poem takes form. It is no longer silent but becomes a sonic object with a spatial component as well. What had been mere latency in the book is performed even by the silent reader who quickens the lines, giving them relationships undreamt until the sound of the performance adds the dimension of musical energy. Another scale of forces, parallel to but independent of the imagery, is introduced. This "quiet concert"—because its component of imagery can assume the form or sensation of any memory—may simultaneously awaken "all our mental faculties." Mallarmé's summons to poetry of the very highest ambition invoked all the senses, all the mental faculties. And, in this present reading, Manet also tried to enumerate and be answerable for the role of every sense. For example, the entire content and range of *On the Beach* undergoes a massive dilation if Suzanne Manet is not reading silently but is reading aloud to her brother-in-law.

Her (subvocalizing) silent reading supports her spoken words, her reading aloud. Her scanning of the page (as opposed to Victorine Meurent's interrupted reading) differs from the way in which we peruse a picture. The text issues instructions to Mme Manet's imagination, and she fashions images that we cannot know but whose interiority occasioned this painting for Manet. The promptings of the text, colored by her phrasing and emphasis—with potential variety of pitch, timbre, dynamics, and cadence—are conveyed to Eugène Manet in her speech. His imagination dwells as unseen as the distant author. He listens, conjuring according to commands imparted by the book, which specifies the images to be built into a whole.[244]

In addition to hearing the text's instructions, the representative of all who listen, Eugène Manet, gazes at the horizon, and discharges the burden of meaning offshore. As in *The Gare Saint-Lazare,* an apparently simple, "straightforward" situation unfolds with endless reverberations. For his own art Mallarmé formulated the unfolding of the plastic incident to its furthest reaches:

> The book, which is the total expansion of the letter, must find its mobility in the letter; and in its spaciousness must establish some nameless system of relationships which will embrace and strengthen fiction. . . . There is nothing fortuitous in all this, even though ideas may seem to be the slaves of chance.[245]

246. Kahnweiler, "Mallarmé and Painting," p. 362.

247. To demonstrate vividly how Manet's use of this pictorial situation blossomed, one has only to compare *On the Beach* with its predecessor by only a few years, *On the Beach at Boulogne,* 1869 (fig. 44). In the earlier painting Manet combined numerous sketches into a synthetic design whose particulars derive from his drawings. The result, however, rather than being richly suggestive, seems to be merely an accumulation. *On the Beach at Boulogne*'s strongest components are its fresh brushwork and its brave attempt at the extended placement of shapes across the three horizontal registers that divide the painting. But major ambition and the intensity associated with later treatments of this scene are absent. Thus, we see the threshold that Manet crossed between the late 1860s and the 1870s, during the period that corresponds to his growing friendship with Mallarmé.

In comparison, we might think of a work like Eugène Boudin's *Beach Scene at Trouville,* 1880 (fig. 45) which—though spritely in its painthandling and brushwork, and vividly documenting the light and activities of a pleasant situation—must convince us that this fountainhead of Impressionism maintained no similarly ambitious intellectual programs. The comparison is especially instructive since the Boudin dates from the next decade when, if the ideas were in circulation, Boudin could have availed himself of Manet's inventions.

Although written in 1895, more than a decade after Manet died, this passage exhibits the lingering quality of what the painter and the poet shared, for even Manet's death did not substantially diminish his towering influence on Mallarmé. Indeed, Manet's presence was never far from Mallarmé. Between 1885 and 1890, Mallarmé's main literary activity was composing love poems to Manet's other favorite model and former mistress, Méry Laurent, whose favors Mallarmé then enjoyed. Partners in their artistic struggle, the two men became sequential lovers of the same woman. Speaking for his own poetry and authoritatively for the nondeclarative Manet, Mallarmé illuminates something fundamental about the propositions by which both his art and Manet's came into existence. Kahnweiler notes that

> there are periods in which poetry is at the forefront of the struggle and others when painting takes the lead. And sometimes it is a master, already dead, who belatedly exerts dominant influence on the sister art. I do not believe that Mallarmé influenced the Impressionist painters or that they influenced him. The example of Manet, however, had shown him that one safeguards the purity of an art by taking cognizance of the implements of that art.[246]

Mallarmé's aesthetic opens before us a view into the depths of the apparently commonplace and "realistic" situations that Manet compounded from observations of the modern world as well as from art history's precedents and forms. *On the Beach,* which seemed conventional, diffuses its symbolic material to embrace a surprisingly magnified field of concerns.[247] Manet's labors extended painting to thoughts about painting and references to the frame of mind within which painting is born and to which it is hopefully consigned at the hands of an appreciative audience. *On the Beach* surveys an alignment that runs from the horizon back through the hearer to the speaker and disappears back into her text. The work's final interiority strikingly opposes the scene's initial appearance of spaciousness. Even in the midst of a limitless out-of-doors, we can be absorbed in our imagination's "inward eye," and that vision may be borne forward on the force of a text. As in *The Gare Saint-Lazare,* no physical action is depicted, but a rich transaction does occur, a series of "events" whose focus is literature (the subject is books and reading) and which is textured like language (as insubstantial as speech and as

248. Each form of attention corresponds to a depicted antecedent. A flow of anteriority and succession supplants the role of narrative, or rather occupies the position that narrativity, storytelling, would have. Forms of alertness align in a graceful continuity that supposes a temporal order, a miniature procession that supplies the reduced narrative with subtle actions. This network begins with the woman's concentration in what she reads—a form of attention that only partially, or intermittently, admits the regular cadence of the sea breaking behind her.

249. Trans. Hamilton, *Manet and His Critics,* p. 180.

discursively affiliated).[248] Yet the overall effect of both *On the Beach* and *The Gare Saint-Lazare* is not bookish; Manet did not render a subject more appropriate to literature, and hence *literary,* as opposed to visual or theatrical.

Lack of overt action did not go unnoticed by the critics. In the 19 June 1874 edition of *L'opinion nationale,* Armand Silvestre found Manet's principal fault in *The Gare Saint-Lazare* to be his choice of subjects:

> It is not Manet's ability as a painter which is disputed, but the selection [of subject matter] of his paintings, which continues to be severely censured. On that score certainly, there has been a misunderstanding between artists and public too long drawn out. If Manet had entitled his painting *Clytemnestra and the Young Iphigenia,* as Bonnat has designated as *Christ* his commonplace figure of a tortured criminal.[249]

In fact, what actually vexed Silvestre (about the public's reception of *The Gare Saint-Lazare*) was Manet's nondescript *title* which afforded neither useful information to laud nor adroit allegory that might prove disdainfully excessive. Likewise, Mallarmé's poems—some of the most fantastic and far-wandering excursions—are introduced by simple titles (such as *Sea Breeze, A Fan,* and *The Azure*). Once they initiated the situation these titles then distantly roam among the evocations of the senses and apparently away from their putative subjects. Manet's invitation is no less, although it was hardly understood as such. Indeed, no one quite knew what to make of *The Gare Saint-Lazare* when it was first exhibited; there was no convenient category within which to place it. Rather than supposing that Manet was prompted by seriously considered plans, viewers assumed, as I have already noted, that he meant nothing by this painting, that it was vacant and mute. The *Revue des deux mondes* carried this harsh notice by Duvergier de Hauranne:

> Is Manet's *The Railway* a double portrait or a subject picture? . . . We lack information to solve this problem; we hesitate all the more concerning the young girl, which at least might be a portrait seen from the rear. Manet has introduced so many innovations that nothing he does should astonish us. It is apparent that in spite of his revolutionary intentions Manet is an essentially bourgeois painter. We might

FIG. 43
Gustave Courbet
Seated Model Reading in the Studio,
1845–47, charcoal with white
areas scraped into ivory wove paper,
22¼ × 15⅞ in. (562 × 390 mm.),
inscribed in charcoal in lower left:
G. Courbet. Art Institute of Chicago,
Simeon B. Williams Fund.

FIG. 44
Édouard Manet
On the Beach at Boulogne, 1869, oil on canvas, 12¾ ×
25¾ in., signed lower right. Virginia Museum of Fine
Arts, Richmond.

250. Ibid., p. 179.

251. Manet's *Street Pavers* is not the direct ancestor of Seurat's *Stone Breakers,* although Manet's endeavor was endorsed and empowered by the fact of Realism.

even say that he is the most profoundly bourgeois of all the contemporary painters who have succeeded in stirring up a little excitement on their own account. Doubtless he belongs to a school which, failing to recognize beauty and unable to feel it, has made a new ideal of triviality and platitude.[250]

This remarkable review attests, simultaneously, to the credit rendered Manet for "so many innovations" and to such a restricted confidence in his powers that his work could only be viewed as "platitude." Thus, his contemporaries' understanding is precisely delimited; we confront the exact border they could never cross and over which Manet and Mallarmé had already crossed.

This new form of heroic painting owes its existence to a willingness to engage humanly scaled events as worthy of investiture in art. The direct precedent for such historically "puny" subject matter lies in the art of Courbet, whose coarse peasantry dwelled somewhere beyond the reaches of the universe Manet inhabited.[251] That Manet had played a role in the evolution of Realism is beyond question, but that his own sensibilities had by the 1870s become something utterly transformed, devoid of the usual Realist social component, is also beyond doubt. Nothing in *On the Beach* proposes the alteration of society, but the work captures the social condition of a group of people at a given moment. Their engagement in their situation exists only through Manet's, and our, delectation of the inconspicuous.

The Gare Saint-Lazare is an essay in self-consciousness and in the submergence of consciousness. In the surrogate of Victorine Meurent, we have come to consciousness. In this painting Manet invented forms to express the appearance of discursive contemplation and wordless, egoless meditation (Suzanne Hirsch). The painting so thoroughly refines the terms of artistic context that it engulfs those conventions upon which its presentation and appreciation of the painting itself depends. It solicits that self-consciousness overcome in order to fashion art (that is, when the quotidian self is submerged in the conventions of an art). Instead we must allow ourselves another form of self-consciousness, one whose texture is the act of criticism. Above all, the figures in this work are savoring the features, the grain and character of the experiences through which they are passing. The incremental growth of the picture is nonlinear and results in a long-reverberating visual chord. This subdued and out-

252. Cited and trans. in Moffet, *Manet 1832–1883*, p. 530. Zola lived at 23 rue de Boulogne. Édouard Manet died on 30 April 1883 and was buried on 3 May.

253. Paris, Bibliotheque d'Art et d'Archéologie, Manet archives, ibid., p. 379.

254. The poem is part of a triptych of three sonnets, beginning with the image of smoke.

> Tout Orgueil fume-t-il du soir
> Torche dans un branle étouffée
> Sans que l'immortelle bouffée
> Ne puisse à l'abandon surseoir!
>
> [All pride is smoke at evening
> A torch in a flip snuffed (out)
> Without that immortal puff
> Unable to abandon its postponing!]

The beginning resembles Mallarmé's poem about cigar smoke; the soul (l'immortelle bouffée), now a torch, was later a cigar. *Une dentelle s'abolit* is the third poem in the triptych.

255. The poem begins with these astonishingly compact lines:

> Une dentelle s'abolit
> Dans le doute de Jeu suprême
> A n'entr' ouvrir comme un blasphème
> Qu'absence éternelle de lit
>
> [A lace curtain self-destructs
> In the doubt of the supreme Game
> To half-open like a blasphemy
> Lacking only an eternal bed]

The first line shifts our focal length through the curtain (phenomenology); the second calls into question our sense of all knowledge (epistemology); the third assumes the existence of a God—as does the capitalization of the word *Jeu* (Game, hence rules, perhaps theodicy)—who can be insulted; and the fourth line does not necessarily imply sex but the deathbed also. What is actually being treated, despite a strong sensual strain through the rest of the poem, is the quality of transition itself, of transformation, which makes of writing a divine enterprise, akin to God's own occupation. Finally, Mallarmé treats the vocation as

> Cet unanime blanc conflit
>
> (This unanimous white conflict)

wardly immobile world replaced narrative and history painting which had been the highest aims of painters. Small wonder that it was misunderstood utterly.

The *Portrait of Stéphane Mallarmé*

Letter from Eugène Manet
to Émile Zola
7 May 1883:

I called at the rue de Boulogne with my wife to convey thanks from my sister-in-law and our entire family for your kind support in the funeral ceremonies on Thursday. Please express my appreciation to Madame Zola for the touching tribute she rendered with you to the memory of our poor friend.[252]

Letter from Suzanne Manet
to Stéphane Mallarmé
21 October 1883:

You really were his best friend, and he loved you dearly.[253]

RICHLY ORCHESTRATED MOMENTS OF SILENT INTROspection distinguish *The Gare Saint-Lazare* as an early exercise in accreted symbolic types. Later, Manet's symbolist pictures became more economical as he shunned the obvious. He shared with Mallarmé this standard for rarefied images. By 1887, Mallarmé had actually written the poem treating the subject of Suzanne Hirsch's meditation.[254] His sonnet *Une dentelle S'abolit* begins with the image of a lace curtain vanishing into nothingness or, as we would say today, "self-destructing."[255] Manet, for his part, had previously formulated an objective equivalent for such an image of substance becoming transcendent (or, for Mallarmé, of words becoming even less material).

For his *Portrait of Stéphane Mallarmé*, 1876 (fig. 46) Manet produced one of his most remarkable and economical works.[256] (As

FIG. 45
Eugène Boudin
Beach Scene at Trouville, 1880, oil on panel, 8 × 14½
in. (200 × 370 cm.), signed lower right, *E. Boudin,*
inscribed lower left, *t 880*. British Private Collection
(photo courtesy Picker Art Gallery, Colgate University,
Hamilton, New York).

He does not use the word *universal,* which would relegate the activity to the realm of nature and perhaps to the domain of God. Instead, he refers to a world of volition and mind, and grants to the living the command of circumstance.

Again, in a close reading we witness the proximity of Mallarmé's sensibilities, aims, and interests to those of Manet.

256. When Manet returned to Paris on 2 September 1876, from a visit to the seaside and a stay at Montgeron, he began work on this portrait of his friend. Their intimacy was immediately reestablished after Manet's absence.

257. T. J. Clark, *Image of the People* (Boston: New York Graphic Society, 1973), p. 160.

258. Courthion, *Édouard Manet,* p. 122. Courthion based this section on his earlier work, *Portrait of Manet* (ed. Courthion and Cailler, trans. Michael Ross). That translation, somewhat different from the one above, includes the following (pp. 74–75):

> Manet had friendships which consoled him in large measure for the vexations that he suffered. I want to speak here of his ties with Stéphane Mallarmé. Mallarmé was a timid and modest man. Armed with the sublime instincts of a poet, in love with beautiful prose and passionately fond of the harmony of pure elocution, he pursued his dreams, conceived by an imagination which found pleasure in everything, but which was satisfied with nothing. . . . Well-read in the highest sense of the term, in love with philology, he enjoyed evoking pagan themes, reconstructing lost Olympus, and he liked to express himself in well-balanced archaic phraseology, but in a manner so individual, that one page written by him, when one has learnt to read it, tells more than volumes of learning which please the public of today.
>
> *Memoirs of Antonin Proust*

soon as it was completed the painting was presented to Mallarmé as a gift, and it hung in his dining room until his death in 1898. The public did not see the painting until 1884, when a posthumous exhibition of Manet's work was held.) When Manet had painted Zola's portrait a decade earlier, he had inserted into the work a constellation of emblems for those concerns that the artist and author shared. If Zola was cognizant of their meaning, he never indicated that understanding in his writings. The precedent for the injection of significant signs into a portrait of one of Manet's literary friends was thus established, and when the time came to render Mallarmé's image Manet resorted to a similar strategy. Now, with a vastly more powerful, matured, artistic intelligence than he had had in the previous decade, Manet fashioned a concise motif for those considerations that bound him to Mallarmé. Their bond and shared aesthetic would be expressed subtly, without insistence, unlike the *Portrait of Zola,* "where the critic sits in his studio, elegantly dressed, cunningly posed, the wall behind him filled with images of a deadly refinement."[257] While Zola's portrait was a virtual shrine in paint, in Mallarmé's portrait Manet saluted the writer with the subjects of the writer; Mallarmé's portrait does not seem to include the concealed symbolism of postrealism.

> In his *Souvenirs,* Antonin Proust recalls visiting Mallarmé for the first time in Manet's studio in the rue de Saint-Pétersbourg: "He was then young and handsome. He had large eyes, a straight nose above a thick moustache underlined by the clear accent of his upper lip. His thick hair crowned a high, prominent brow. His beard ended in a sharp point against a dark cravat. . . . We talked of the poems of Edgar Allen Poe, which he had just translated and for which Manet was then doing the illustrations."[258]

Mallarmé, thirty-four years old at the time of the portrait, reclines on a divan. Behind him the walls are covered with Japanese wallpaper patterned with flowers and ibis (after the painting was done, Manet added a small strip to the right-hand edge). Mallarmé's left hand slipped into his pocket while the poet's his right hand (his writing hand) holds a lighted cigar and rests upon an open text. The conjunction of the cigar, text, and writing hand—the other hand shielded as if a somewhat secretive component of personality—was no more happenstance than the associations within Manet's other

FIG. 46
Édouard Manet
Detail from *Portrait of Stéphane Mallarmé*, 1876, oil
on canvas, signed and dated, 27.5 × 36 cm. Museé
d'Orsay (formerly Galeries du Jeu de Paume), Paris.

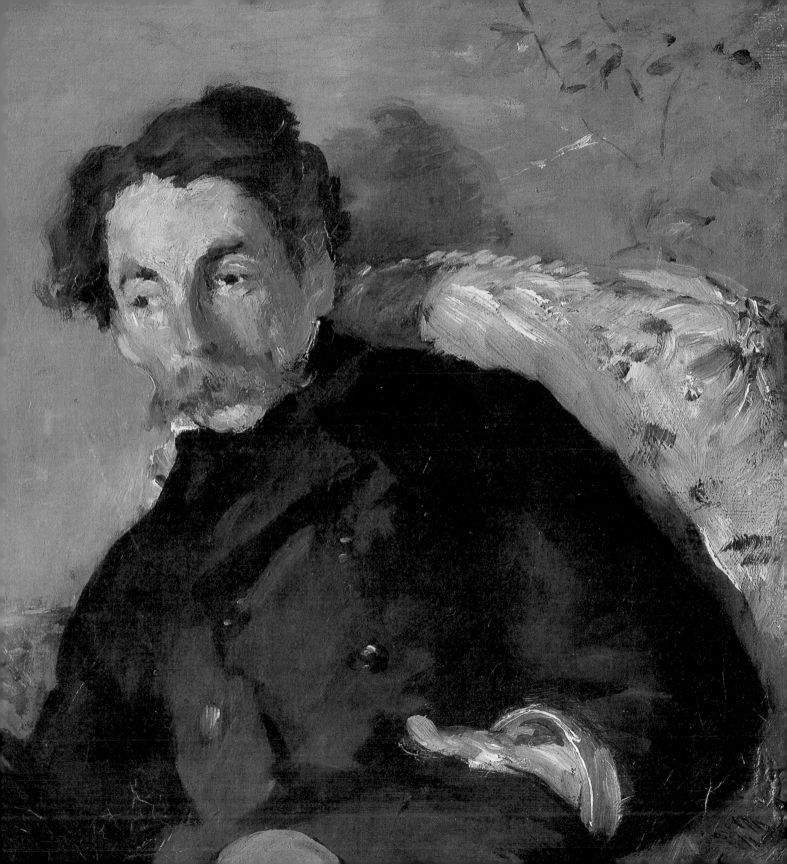

259. An untitled sonnet, this poem was first published in the 3 August 1895, *Le Figaro-Supplement littéraire*. See *Mallarmé, Oeuvres Complètes* pp. 432–433.

works. The force of the manuscript seems to travel up through the author's hand into the cigar, and the text appears to transubstantiate through the cigar into little wisps of white smoke. The poet looks on this process of transformation with pleased and profound attention. A cigar has been substituted for his pen, as though Mallarmé wrote in smoke. This is the poet of mists, fogs, clouds, and endless white expanses. Mallarmé is no less attentive to what he beholds than Manet's brother to the text that passes through him outward, discharged to the endless sea in *On the Beach*. Manet composed this arrangement of symbols to announce a temperament and a vocation. Again, the commonplace, the objective spur to imagination, replaced the product of imagination as the painter strove for the concrete sign, the plastic image with the fullest expressive possibilities.

Moreover, Mallarmé supplied a text to parallel the painting:

> Toute l'âme résumée
> Quand lente nous l'expirons
> Dans plusiers ronds de fumée
> Abolis en d'autres ronds
>
> Atteste quelque cigare
> Brûlant savamment pour peu
> Que la cendre se sépare
> De son clair baiser de feu
>
> Ainsi le choeur des romances
> A ta lèvre vole-t-il
> Exclus-en si tu commences
> Le réel parce que vil
>
> La sens trop précis rapture
> Ta vague litérature[259]
>
> [The entire soul collects
> As we slowly exhale it
> A few smoke rings
> Annulled by other rings
>
> Any cigar vouches
> Burning sagely for a bit
> That the ash separates
> From its clear kiss of fire

260. Cohn, *Toward the Poems of Mallarmé,* p. 189.

261. Ibid.

So: the chorus of the songs
To your lips it flies
Refrain from it if you start
The real because shoddy

The too precise meaning of rapture
Your vacant literature]

Just as Manet's work is understated in the extreme, hardly seeming to locate the arena of seriously ambitious enterprise, so, too, the poem

> by its very modesty tells us something of Mallarmé's aesthetic. It is discreet, almost inaudible, extremely precise . . . yet gracefully supple. It is airy as "smoke," yet sensual as a "kiss," or a bright red glow. The humble, everyday bourgeois-artistic reality ("cigar") once again belies the myth of Mallarmé as the blankly cold, starry-eyed neo-Parnassian turning away from us all.[260]

Despite the relaxed pose of the subject, there is nothing casual about the *Portrait of Mallarmé.* Indeed, the difference between the lassitude of the pose and the tautness of the underlying organization is not only this work's most prominent feature but could also be said to be the most prominent feature of Mallarmé's art. The gentle torpor of the *Après midi d'un faune* can never be confused with its author's amazing intelligence. "The poem's first line, *Toute l'âme résumée,* reminds us that Mallarmé—who said of his friend Manet that he hurled himself at the canvas each day afresh, as if it were his last chance—gave his all, *toute l'âme,* each time, *summed it up* (*résumée*) in each of his serious productions."[261] An apparent indifference, or a seeming lack of alertness, which might be termed *détendre,* a slackening or relaxation, is not at the heart of Manet's work. The absence of the usual signals for high attention (such as some dramatically depicted event, which is the sign of the traditional history painting) and the diminished activity in Manet's fastidious work do not indicate any lack of ambition. Here we find the last parcel of that reciprocal relationship between Mallarmé and Manet.

Duret's assertion that painting somehow followed "a succession of forms corresponding to those that evolved in literature" can at last be treated in terms of specifics. In the last quarter of the nineteenth century the paths of literature and the visual arts inter-

262. Courthion, *Édouard Manet,* p. 34.

263. As Baudelaire prefigures symbolism in poetry, Manet may prefigure the movement in painting. The traits were long anticipated.

> The terms *"symbole," "symbolisme"* and *"symbolique"* were used early in the nineteenth century long before their adoption to designate a particular school. Alexandre Guirard used them as early as 1824. . . . Jouffroy referred to symbolism in . . . 1843. . . . It was only toward 1885 that they began to be used to refer to a group of poets under the influence of Baudelaire, Verlaine and Mallarmé. It had become by this time a name adopted by young poets in order to distinguish themselves from rival groups such as the *"Hirsutes"* and the *"Décadents".* ("Endymion in France: A Brief Survey of French Symbolist Poetry," in *Les Mardis* [The University of Kansas Arts Museum], p. 21)

264. Marcel Raymond, "Introduction," in Kahnweiler, *From Baudelaire to Surrealism,* p. 25. Raymond continues in a vein that presages Fried's claims for Manet:

> No French writer before him would seem to have conceived such lofty ambitions, to have endowed Art with this ultimate mission of summing up Creation, as it were, and by the same token of justifying it to the human spirit.

sected in the person of Manet, who for so long had been thought to be the unthinking painter, the unliterary, the mere bourgeois. Intuited by Courthion, "this wide gulf from Zola to Mallarmé, which Manet alone bestrides," represents an anomaly.[262] The whole burden of both modern painting and writing's evolutionary crisis converged on Manet's career. The Realists, Naturalists, Impressionists, Symbolists, all felt affinities with his work, all drew succor from it.

Although calling Manet a Symbolist may appear to be a premature usage of the term, we ought to recall that the progenitors—particularly of literary Symbolism—are not often as closely associated with their creation's rubric as are those who followed and took up the (already defined) movement.[263] As the forebears of Symbolism do not mark the zenith of the movement, Manet may reside beyond the terms by which his art is conventionally described. Remarkably, in Manet's art can be found the seeds of modern painting as well as the sensibility that gave birth to modern writing. Clearly, he did not arrive at this position in isolation. In Manet's work, and in *The Gare Saint-Lazare* in particular, painting gave form to ideas shaped with literature. By and large, Manet's painting itself did not become "literary." Neither a hybrid nor an illustration, *The Gare Saint-Lazare* represents a special aesthetic in proximity to the tenets of Mallarmé's art while advancing from the precepts and precedents of Manet's earlier works.

To name or describe the yearning in whose service Manet placed his art poses a serious difficulty. Manet tried to summarize the history of painting, mainly by means of citation. His works are strewn with these adaptations from the past, and scholarship continually uncovers more of these references. Manet's gesturing to the past, a willful imbedding of his work within the fabric of history, is well described by Fried's notion of "totalizing." Yet this process represents but one of the referential anchors by which Manet attached his work to history and experience. Like Mallarmé, whose love of philology connected his poetry with the most subtle references to the past, Manet's form of artistic cogitation was not obvious, easily accessible, or intended for general consumption, nor was it narrow in conception. Indeed, the best description of Manet's ambition may have been coined by Marcel Raymond, who described "Mallarmé's striving for hyper-consciousness."[264] It may prove futile

FIG. 46
Édouard Manet
Portrait of Stéphane Mallarmé, 1876, oil on canvas,
signed and dated, 27.5 × 36 cm. Museé d'Orsay
(formerly Galeries du Jeu de Paume), Paris.

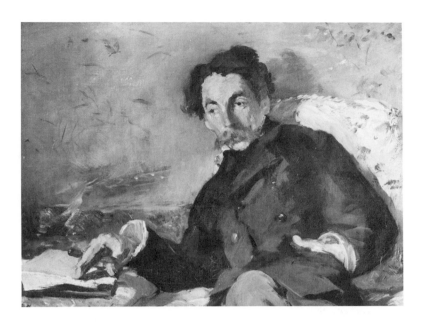

to account for the state of alertness which we are intended to feel before a work whose subject is simultaneously present and an echo, an adaptation (or multiple adaptations) of the past, whose forms relate in a manner that is supposed to seem nonchalant but whose composition upon inspection reveals itself to be meticulous, whose means of execution constantly pulse between declaring themselves and vanishing into convention, and whose every relationship exists not as a series of degrees along a single axis but as the instantaneous correspondence of all the parts. Manet's accomplishment in *The Gare Saint-Lazare* indicates his ambitions for other challenging works. We know this ideal as the beacon by which Mallarmé navigated. Such hyperconsciousness, finally, presages the hypercriticism that is the hallmark of modernism. More than in any of its formal constituents, it is in this sensibility—that strains to apprise itself of the fullest bounty of relational possibility and the implications of its every assumption—that we discover exactly toward what Manet was leading.

INDEX

Designer: Dana Levy
Compositor: Prestige Typography
Text: 10/12 Galliard
Display: Galliard
Printer: Malloy Lithographing
Binder: John H. Dekker & Sons